MANY HANDS

THE FIRST 40 YEARS OF THE
AUSTRALIAN TAPESTRY WORKSHOP

THE TAPESTRY FOUNDATION OF AUSTRALIA

Aboriginal and Torres Strait Islander people and communities are respectfully advised that some deceased people are mentioned in this text, or their photographs or images of their work are reproduced in this book, and this may cause distress.

HarperCollins*Publishers*

Published in Australia in 2016
for the Australian Tapestry Workshop
ABN 88 005 758 056
262–266 Park Street, South Melbourne, Victoria 3205
www.austapestry.com.au

by HarperCollins*Publishers* Australia Pty Limited
ABN 36 009 913 517
www.harpercollins.com.au

Copyright © Australian Tapestry Workshop 2016

HarperCollins*Publishers*
Level 13, 201 Elizabeth Street, Sydney NSW 2000, Australia
Unit D1, 63 Apollo Drive, Rosedale, Auckland 0632, New Zealand
A 53, Sector 57, Noida, UP, India
1 London Bridge Street, London, SE1 9GF, United Kingdom
2 Bloor Street East, 20th floor, Toronto, Ontario M4W 1A8, Canada
195 Broadway, New York NY 10007, USA

National Library of Australia Cataloguing-in-Publication data:

Many hands: the first 40 years / Australian Tapestry Workshop.
 ISBN 978 1 4607 5316 3 (hardback)
 Australian Tapestry Workshop – History. Tapestry – Australia – Pictorial works.
 Tapestry – Australia – History. Tapestry – Themes, motives. Weavers – Australia –
 Pictorial works.
 Australian Tapestry Workshop, author.
746.3994

Front cover image (and rear cover detail): *Gordian Knot*, 2016, Keith Tyson, woven by Chris Cochius, Sue Batten, Pamela Joyce and Milena Papliska, wool, cotton, 2.4 x 2.4m. IMAGE BY JEREMY WEIHRAUCH

Endpapers: detail of *Perspectives on a Flat Surface*, 2016, John Wardle Architects, woven by Chris Cochius, Pamela Joyce, Jennifer Sharpe and Cheryl Thornton, wool, cotton, 1.92 x 3.84m. IMAGE BY JEREMY WEIHRAUCH

Cover and internal design by Agave Creative Group
Editor: Mark Butler. Co-editor: Jenny Port
Printed and bound in China by RR Donnelley on 128gsm Matt Art

8 7 6 5 4 3 2 1 16 17 18 19

CONTENTS

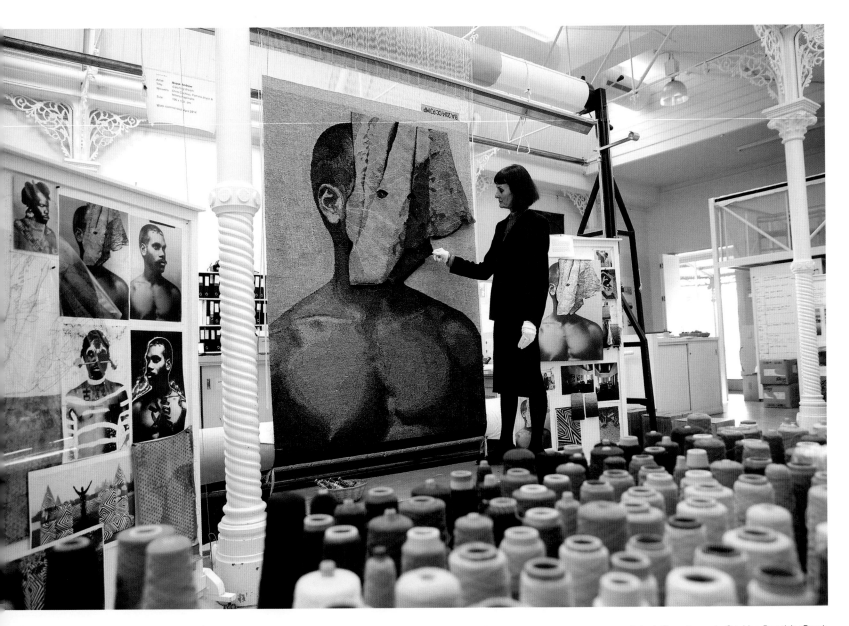

Antonia Syme inspects *Catching Breath* by Brook Andrew, which now hangs in the Australian high commissioner's residence in Singapore.

A VISION REALISED

This publication celebrates the first 40 years of the Australian Tapestry Workshop (formerly the Victorian Tapestry Workshop).

The original vision of Lady Delacombe and Dame Elisabeth Murdoch AC DBE, John Blanch, Baillieu Myer AC and many others was realised in the establishment of the VTW in 1976 under the inspired leadership of Sue Walker AM. Since then the organisation has become a world centre of excellence in contemporary tapestry, which is an extraordinary accomplishment and a tribute to Australian creativity and innovation.

Sue Walker has commented that the existence of tapestry workshops is inherently tenuous. Handmade tapestries are very labour-intensive to produce and therefore costly, and by their very nature they are susceptible to the challenges of changing economic climates and art world trends. So reaching our 40th milestone is very significant. During the past four decades, the staff, the board of the ATW and the Tapestry Foundation of Australia (TFA) have been unstinting in their commitment to maintaining and building on the vision of the founders.

The generosity of spirit, financial support and hard work of many people across many years has created an exciting, dynamic place where artistic weaving skills are developed to a very high degree in collaboration with artists, architects, designers, curators, clients and weaving colleagues worldwide.

Our supporters have shown great commitment to nurturing the ATW: our donors, clients, sponsors, volunteers, advocates and the staff, the ATW board, the TFA and the government of Victoria are the many hands that have created this remarkable organisation. I feel very privileged to be at the helm at this exciting time.

More than 500 tapestries have been created by more than 80 weavers, ably supported by specialist yarn dyers, and these tapestries hang in a diverse range of public and private collections in Australia and overseas.

Crucially, the ATW has worked with Indigenous artists from its beginning, from the tapestries we wove for the Victorian Arts Centre to our tapestries for Australia's embassies and high commissions.

The quality of our work is exceptional, and we continue to seek opportunities to push the boundaries of contemporary tapestries within the constraints of running a not-for-profit business.

I would like to pay tribute to all the people who have worked hard to build strong, robust and sustainable foundations for the organisation to enable it to take its place as a world leader in contemporary tapestry.

My sincere thanks go to the TFA, which has commissioned this book to celebrate our 40th birthday, to our editor Mark Butler, to our publisher HarperCollins, to our esteemed writers and photographers who have helped generate this tribute to our first 40 years, and to Jenny Port and Josephine Briginshaw, who have made this publication possible.

Lastly, my heartfelt thanks go to Sue Walker and all the weavers and dyers who have created these memorable tapestries.

Antonia Syme
Director, ATW

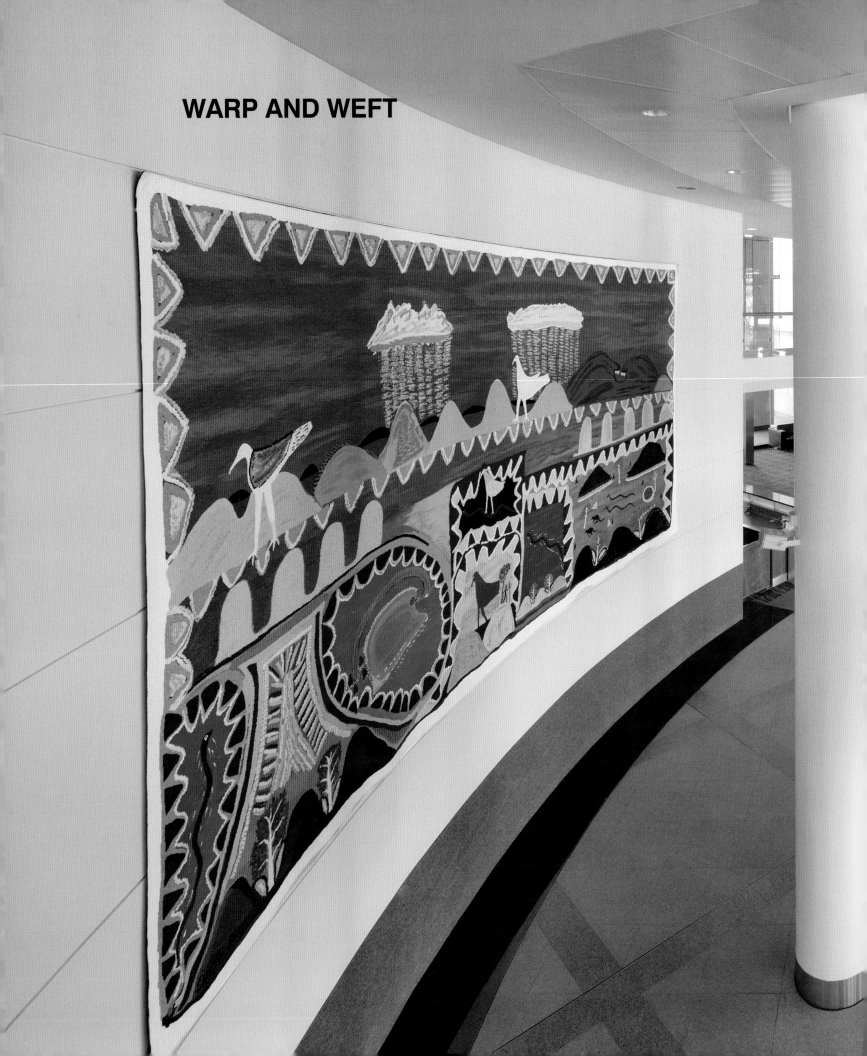

WARP AND WEFT

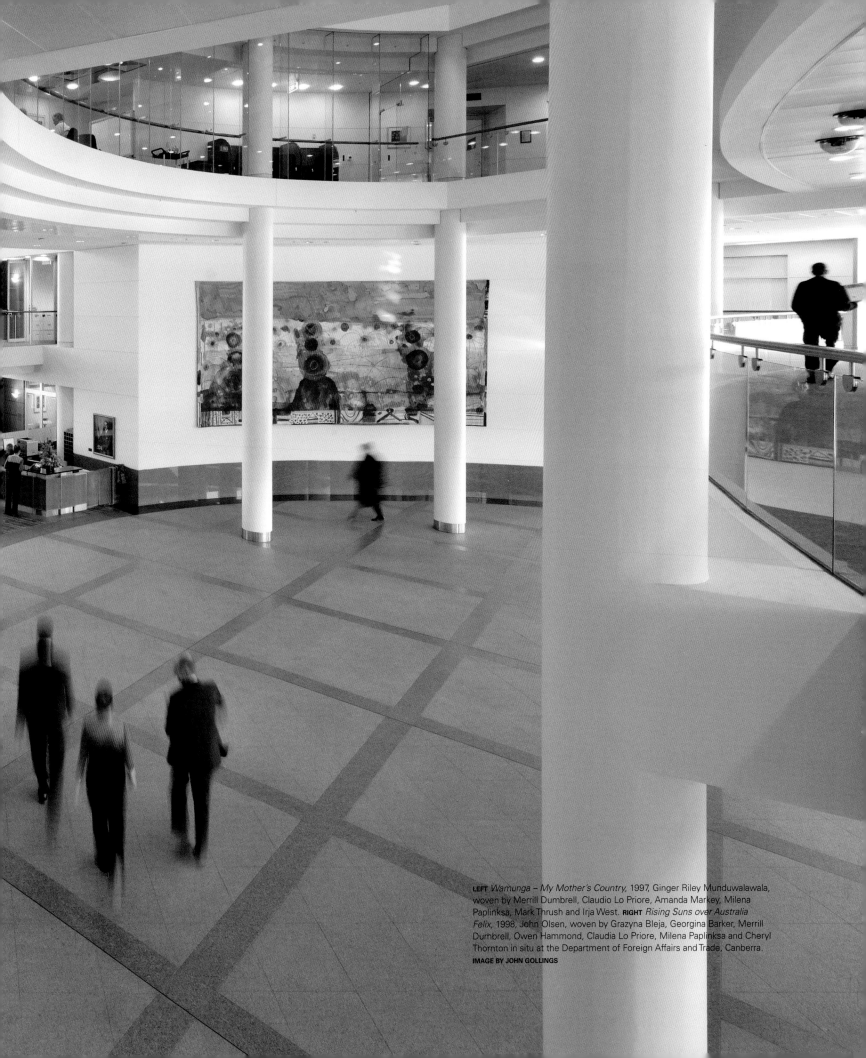

LEFT *Wamunga – My Mother's Country,* 1997, Ginger Riley Munduwalawala, woven by Merrill Dumbrell, Claudio Lo Priore, Amanda Markey, Milena Paplinksa, Mark Thrush and Irja West. RIGHT *Rising Suns over Australia Felix,* 1998, John Olsen, woven by Grazyna Bleja, Georgina Barker, Merrill Dumbrell, Owen Hammond, Claudia Lo Priore, Milena Paplinksa and Cheryl Thornton in situ at the Department of Foreign Affairs and Trade, Canberra.
IMAGE BY JOHN GOLLINGS

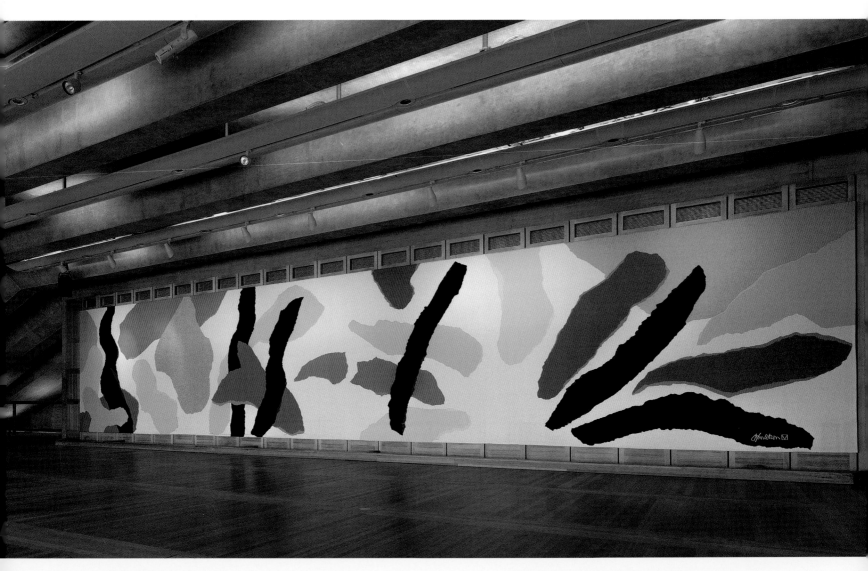

ABOVE *Homage to Carl Emmanuel Bach*, 2004, designed by Jørn Utzon, woven by Grazyna Bleja, Cheryl Thornton, Chris Cochius, Pamela Joyce and Milena Paplinska, in situ in the Utzon Room at the Sydney Opera House. **IMAGE BY JOHN GOLLINGS**

RIGHT *Great Hall Tapestry*, 1984–1988, designed by Arthur Boyd, woven by Leonie Bessant, Sue Carstairs, Irene Creedon, Robyn Daw, Joanne Feder, Owen Hammond, Kate Hutchinson, Pamela Joyce, Peta Meredith, Robyn Mountcastle, Jennifer Sharpe, Joy Smith, Irja West and Iain Young, in situ at Parliament House, Canberra. **IMAGE BY JOHN GOLLINGS**

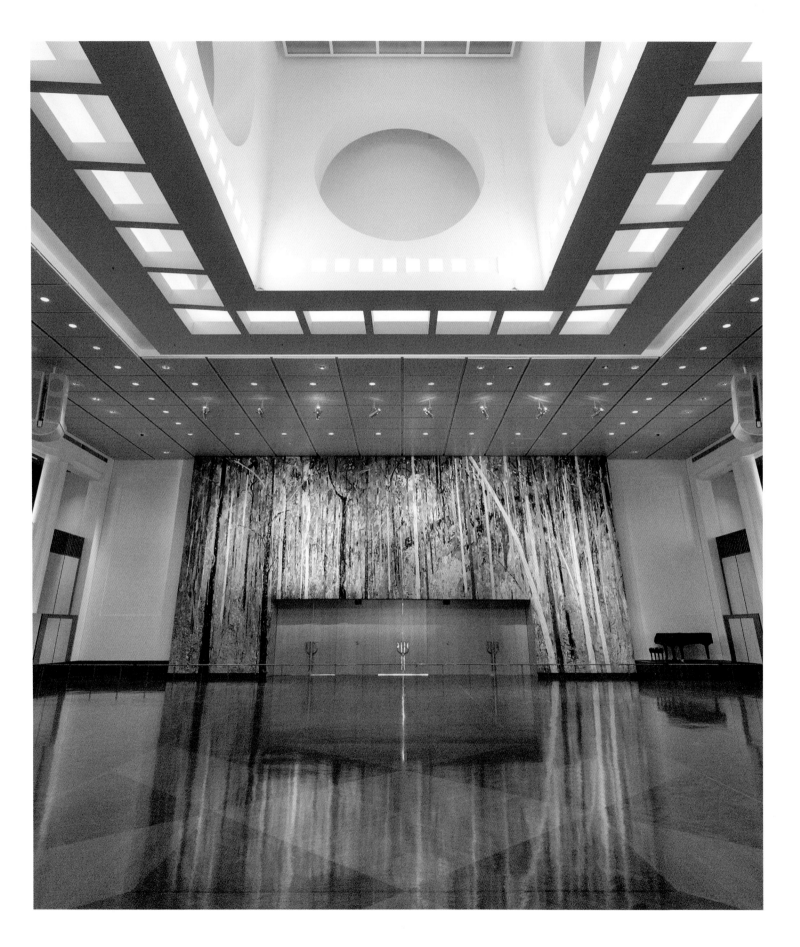

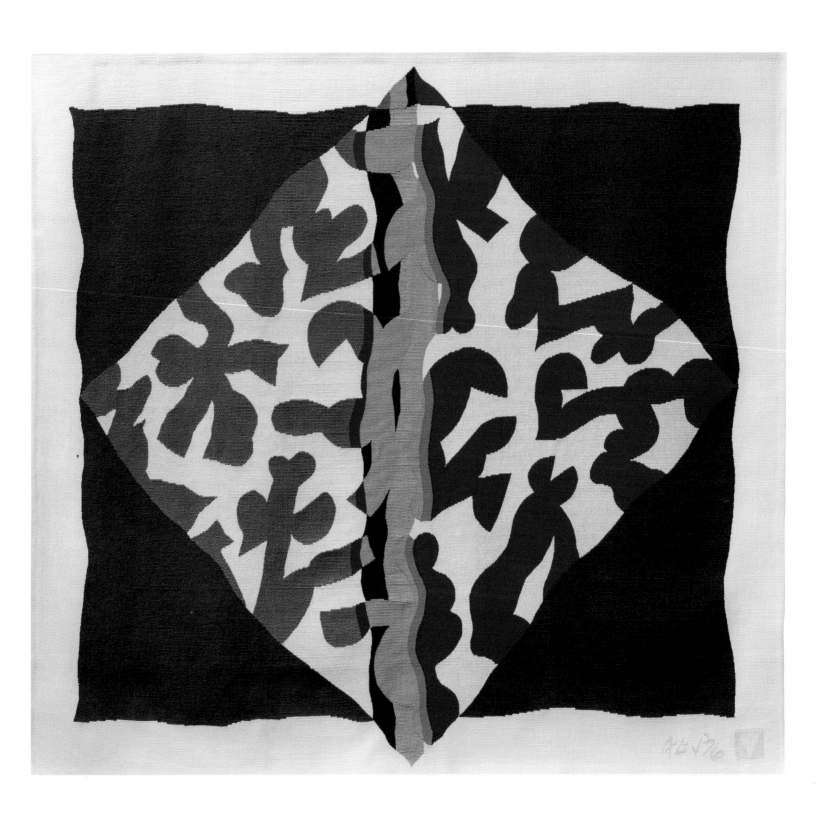

ART ON THE LOOM:
A HISTORY OF
THE AUSTRALIAN
TAPESTRY WORKSHOP

The first tapestry to be completed at the Australian Tapestry Workshop. *Emerald Hill Yellow*, 1976, Alun Leach-Jones, woven by Merrill Dumbrell, Cresside Collette, Marie Cook, Sara Lindsay and Liz Nettleton, wool, cotton, 2.5 x 2.3m. Australian Tapestry Workshop Study Collection. IMAGE BY JEREMY WEIHRAUCH

Forty years! It is fascinating to consider how a group practising a centuries-old woven textile art form can operate so successfully during this time, and with such continuing relevance in our diverse and changing society.

From its beginning in 1976, the VTW reflected a contemporary art and design aesthetic while offering a professional model of exemplary weaving knowledge, skills and technologies. Renamed the Australian Tapestry Workshop in 2010, its record of innovative, collaborative working relationships between weavers and artists includes the completion of more than 500 tapestries representing commissions for private, corporate and government buildings and collections. Significantly, the production of these works has not only involved many leading Australian and international artists but has also been integrated with the ideals and practices of contemporary architects.

At the same time the workshop has provided opportunities for employment and training to weavers and dyers and, through its example and its experienced staff, has contributed to the establishment of textile courses in tertiary institutions and the expansion of professional individual studio tapestry practice.

But whatever prompted the establishment of a tapestry workshop in Melbourne? Who was behind it? How did they work out how to go about it? Who has been interested in what was made there? And, significantly, how has it evolved along the way?

Why and when?

The workshop was launched in Melbourne in 1976 as the result of considerable research and planning during the previous five years, and brought together several influential strands of interest. This was an exciting time for many reasons. The difficult war years of the 1940s had opened out in the 1950s and 1960s into opportunities that offered better education and employment, overseas travel for Australians, changing recognition of Indigenous Australians and hopes for a new life for skilled migrants bringing different experiences with them. Artists across all fields were to benefit from these changes.

Following examples from elsewhere, many architects in Australia were interested in including tapestries in their contemporary plans, while a number of well-known artists were keen to work with them, motivated by the opportunity to make large works for public spaces and for

the different textures offered by working with coloured fibres. Apart from often expressively adventurous projects made by individual weavers in their own studios, from the 1960s commissions for tapestries as public artworks had also been sent by Australian artists such as John Olsen AO OBE, John Coburn, Leonard French OBE and Arthur Boyd AC and their dealers to well-known international workshops such as those at Aubusson in France or Portalegre in Portugal.

Critical to the period was the strong contemporary studio crafts movement that had emerged in the postwar years and which included independent tapestry weavers —such as Ian Arcus, Diana Conroy (later Wood Conroy), Margaret Grafton, Fay (now Fahey) Bottrell, Garry Benson, Nicole Johnson, Pru La Motte, Kay Lawrence AM and Belinda Ramson — and other fibre and textile artists, among the many potters, glassmakers, woodworkers, jewellers and metalsmiths who set up studios and formed specialist organisations. These enthusiasts also established a national network of multi-crafts organisations including the Craft Association of Victoria (1970) and the national body, the Crafts Council of Australia (1971), while craft courses increased in scope and number in tertiary education institutions in all states.

A federal funding body, the Australia Council for the Arts, was established in 1973, and included a Crafts Board among those of other art forms. The states also increased their involvement in the arts, with the Victorian government setting up a ministry for the arts, also in that year. This body responded positively to new ideas, encouraging individual and organisational development, as well as assisting major projects such as awards, exhibitions and festivals. It made productive commitments to state and regional galleries and museums, and was responsive to ideas for new organisations; following the VTW, it also supported the setting up of the Meat Market Craft Centre in North Melbourne in 1978.

Among the galleries and museums that were central to these developments was the National Gallery of Victoria, where director Eric Westbrook CB, often in collaboration with interstate gallery directors, encouraged the production and importation of challenging and informative exhibitions. An exhibition of contemporary tapestries from Aubusson was toured by the Art Gallery of NSW as early as 1956, while another, which opened at the fifth Adelaide Festival in 1968, included tapestries from works of four Australian artists. These were followed in 1970–71 by a touring exhibition of 17th- and 18th-century French tapestries, and in 1974 of work by French designer Jean Lurçat, woven at Aubusson, reflecting his prominent role in contemporary tapestry in the 20th century.

Influential visitors included Mary Jane Leland from California who, in 1974, gave public lectures and classes focusing on tapestry; Marin Vabanov, from the Academy of Arts in Sofia, Bulgaria, in 1975; and Magdalena Abakanowicz, who came from Poland with an exhibition of woven three-dimensional forms in 1976. Of lasting significance was the extended stay in 1975 of Archie Brennan, director of the Dovecot Tapestry Studio in Edinburgh. Australian weaver Belinda Ramson had worked with Brennan in 1967 and 1973, and he was subsequently offered a Creative Arts Fellowship in 1975 at the Australian National University. He returned to Australia in 1976, and ran teaching workshops at Armidale in NSW and Steiglitz in Victoria, inspiring many emerging professional weavers.

1971–1975: Developing the idea

The idea of establishing a tapestry workshop in Victoria grew out of this broad professional context of example and experience. A number of serious enthusiasts started to argue a case for an Australian enterprise employing local weavers and using Australian materials, in anticipation of cultural and economic benefits.

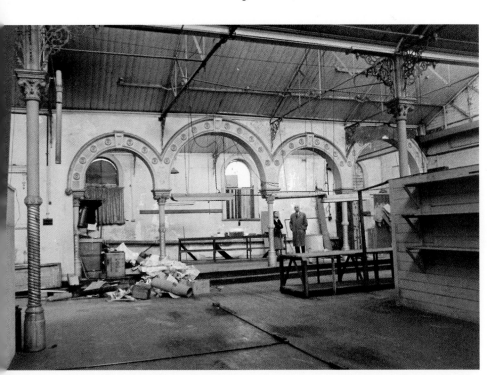

BOTTOM LEFT Sue Walker and her father, architect Hume Sherrard, inspect the former Harcourt & Parry Emporium at 260–264 Park Street, South Melbourne, prior to its renovation into the ATW headquarters.

RIGHT The wives of some of the leaders attending the 1981 Commonwealth Heads of Government Meeting in Melbourne showed keen interest during their visit to the workshop.

BELOW Inspirational models for the ATW were Scotland's Dovecot Tapestry Studio and its director Archie Brennan, seen here with Ruther Schuer and Sue Walker at the International Tapestry Symposium, Melbourne, in 1988.

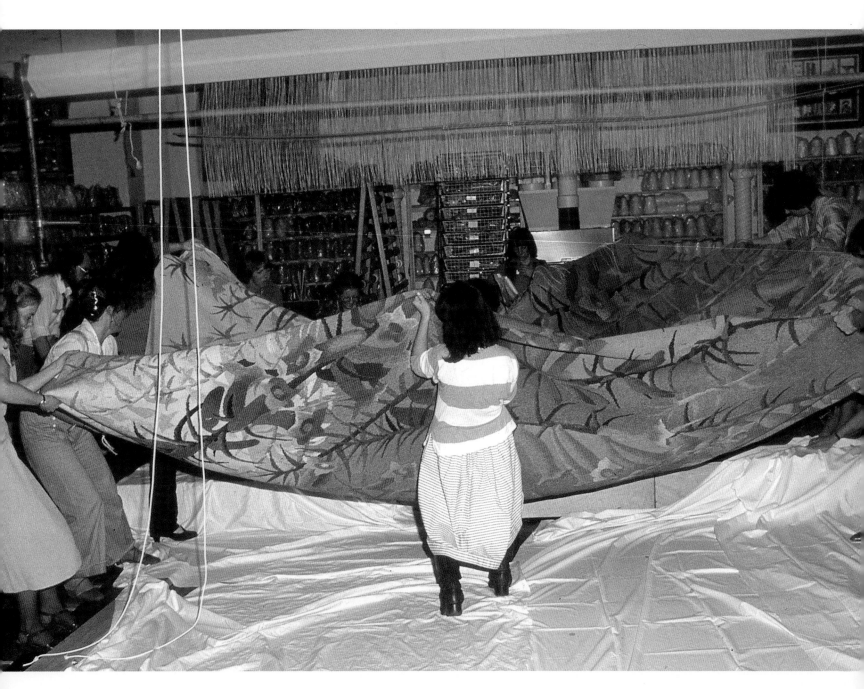

Cutting off Marie Cook's *Pink Heath* in 1979, now hanging in the foyer of the Sofitel Melbourne on Collins.

A central figure was Lady Delacombe, wife of the then governor of Victoria Sir Rohan Delacombe. Conscious of current practice in tapestry weaving and supportive of the idea of Australian initiatives in the arts, and having seen the touring exhibition of French tapestries in 1971, she started talking to friends and colleagues such as Dame Elisabeth Murdoch AC DBE, then a trustee of the NGV, and Marion Fletcher, assistant curator of decorative arts at the gallery. They approached premier and arts minister Sir Rupert Hamer, who saw value in their proposal to establish a tapestry workshop and referred it to his new ministry for the arts, where Eric Westbrook was now director. An interim committee was appointed by the Victorian State Government in 1973 and it decided in mid-1974 to fund the commissioning of a researcher to investigate the feasibility of such a project.

John Blanch was appointed to the task, and during a four-month period he interviewed those artists, weavers, dealers, guilds and industries with relevant experience in Australia and also visited a number of key international tapestry workshops. He found the most important of these to be the Dovecot Tapestry Studio, considering director Archie Brennan's practice and philosophy to be most appropriate for an Australian venture. Blanch also recommended that an executive officer be appointed and considered a number of potential sites for a workshop. The committee took its proposal to premier Hamer in November 1974 and he agreed that $40,000 should be granted to enable a tapestry workshop to be established in 1975. Brennan, at that time living in Canberra, was engaged as an adviser, and a further commitment for $83,000 was secured for the development of the workshop during 1976–77.

1976: Launch and location

In May 1975 Dr Sue Walker AM, a weaver and also president of the Craft Association of Victoria, was invited to join the interim committee and shortly after, the Victorian Council for the Arts. She quickly became very familiar with all the issues associated with setting up the workshop, and consulted regularly with Brennan. The interim committee was succeeded in November 1975 by a board chaired by Lenton Parr, from the Victorian College of the Arts, who remained in that position for 10 years.

In February 1976, when the workshop was formally founded, Walker was appointed director. At first the organisation was run from an office in the ministry of arts, while a number of weekend workshops at the VCA with

Ramson provided training for potential weavers, most of whom had already completed art school study, which was considered to be a prerequisite. Five weavers were appointed — Merrill Dumbrell, Marie Cook, Sara Lindsay, Cresside Collette and Liz Nettleton, with a further three in 1977 after a second training course — Irja West, Cheryl Thornton and Sue Batten. More weavers were employed each year, often reflecting the workload, with an average total of 15–20 and an extraordinary count of 27 in 1987–88, for the final year of weaving a tapestry by Boyd for the new Parliament House in Canberra.

A number of the weavers spent many years of their career in the workshop, while some left to work independently and others were involved in tapestry courses for tertiary education, such as Marie Cook in Warrnambool from 1987 and Kate Derum at Monash University from 1990. In 1979, weavers from the VTW were included in the *Biennale Internationale de la Tapisserie*, in Lausanne in Switzerland, an event in which Australians had participated from the early 1970s.

Walker was to be director of the workshop for 27 years, from 1976 to 2004 and, among many other publications, she wrote a comprehensive history of the workshop, *Artists' Tapestries from Australia 1976–2005* (The Beagle Press, 2007). She was followed as director by Susie Shears from late 2004, and by Antonia Syme, who was appointed in 2009. The workshop was incorporated as a company limited by guarantee in 1981, and the business name, Australian Tapestries, was registered in 1985. In 2010, to reflect what was now evident as its national role, it was renamed the Australian Tapestry Workshop.

A primary task in 1976 was to find an appropriate site for the workshop, and the board followed Blanch's advice in selecting 260–264 Park Street, Emerald Hill, in South Melbourne, part of a large building that had been empty for some years since its most recent use by the Gloria Glove Company. A large central atrium with natural light was fringed with small streetfront shops, making it an ideal location despite the badly run-down condition of the building. Built in 1885, and a National Trust and Heritage listed building, it was originally the Harcourt and Parry Emporium, a drapery establishment, and later adapted as the Patross Knitting Mills. As part of an area known as the Emerald Hill Estate, it had been acquired by the Victorian government in the early 1970s with assistance from the federal government in order to preserve the heritage value of the precinct.

The Victorian Tapestry Workshop was officially opened by premier Hamer in November 1976; looms were set up in the central space and some of the small shopfronts were to become a wool shop and display spaces, while a stairwell was soon transformed into a dye shop. Ten years later, in 1985, responding to an increasing workload, the workshop expanded its rental arrangement further into 258 Park Street at one end and the corner space in 266 at the other, while a central mezzanine viewing floor was built for visitors. By 1992, in response to economic changes, the board decided to consolidate activity into the original space.

However, the determined Tapestry Foundation of Victoria acquired the entire 258–266 Park Street area in 1998, assisted by a private donation from Dame Elisabeth Murdoch and some government funding, and commissioned its renovation by Williams Boag Architects to include a library, storage and retail area. The workshop was enthusiastically relaunched in 2000, now renting its premises from the foundation.

Making and presenting

Equipment was gradually acquired and, while initially being limited to appropriate Swedish yarns, research was soon carried out into the availability of local materials. Walker chose to use a high-warp loom system and included Brennan's innovation, where the weaving is carried out from the front rather than the back. They soon settled on an Australian Corriedale-cross fleece, because pure Merino wool was too fine, with a seine twine, at that time made locally, for the warp thread. With advice from dyer Horrie Corker, they decided on a permanent library of colours that could be blended in the weaving process rather than making separate dyes to match artists' designs.

After initially sourcing dyes from Geelong, Corker assisted in setting up the dye shop in 1979, and continued to offer advice for more than 25 years. A number of dyers, such as Reg Peters, were employed in the dye shop, to be followed in 2009 by Tony Stefanovski, who supervised the renovation of what became the Colour Lab. By 2016 about 370 colours in wool (now a Border-Leicester and Merino cross), as well as about 200 in cotton, also used for its silky vibrancy, were available for use in the workshop.

The first tapestries were made as examples to demonstrate the scope of the weavers and the workshop, but when the possibilities became better known,

tapestries were made to commission. These drew very largely on the work of contemporary painters, some of whom made paintings specifically for translation into tapestry, a practice that raised controversy in various sections of the art and weaving communities. At first there was criticism ranging from the use of commercial colours and fibres (contrary to the prevailing 'natural' aesthetic), to questioning whether the workshop was merely copying paintings rather than carrying out original woven works. However, from the outset the philosophy of the workshop was clearly intended and agreed to be one of creative collaboration between weavers and artists.

The first mural-scale work woven was Alun Leach-Jones' *Emerald Hill Yellow*. By late 1978, during the *Arts Victoria '78: Crafts* festival, the exhibition *Tapestry and the Australian Painter* at the NGV showed tapestries made in the first two years, resulting from collaboration with 14 of the 25 artists worked with to that date. In the catalogue, Walker emphasised that the works were collaborations, not copies, and that the weavers had to interpret the colours and textures in a new way, 'to invest the artist's original concept with the specific qualities of tapestry'.

Several milestones occurred at this very early stage, setting a pattern for future projects during the subsequent 40 years. In as early as 1977, the VTW started on its first major commission, which was for four tapestries to hang in the Saskatchewan Centre for the Arts in Canada, and won from worldwide competition. In 1978 the first collaborations were made with Indigenous Australians, starting with artists from Papunya Tula and their designs from the Western Desert, while the Queensland Parliament commissioned *Sun Tapestry* by John Coburn, at 3.48m x 9.9m, the first large-scale tapestry to be woven. Also in that year, the art galleries of Western Australia and Victoria were the first state institutions to acquire tapestries from the workshop.

By 1979 the workshop was carrying out its first commissions for corporate collections, beginning with the National Australia Bank, which eventually commissioned 10 tapestries. Artbank began commissioning works for government buildings in 1981, and in 1983 discussions were started regarding a tapestry by Boyd for the new Parliament House in Canberra, to be completed in 1988; at 9m x 20m, and in three sections, it remains one of the largest in the world. The largest single tapestry to be made in these years was *Aotea Tapestry* by Robert Ellis for the Aotea Centre in Auckland, New Zealand.

Commissioned in 1989, a new loom was acquired for the project, and the tapestry was installed in 1991.

Throughout the 40 years of its operation the workshop has continued to make large-scale works designed for public spaces such as corporate foyers, museums, art centres, embassies and high commissions, banks, hotels, schools, universities, hospitals and churches. Commemorative tapestries have been commissioned to celebrate anniversaries and special events, while private collectors also continued to commission tapestries for homes and offices. One notable later project, in 2003–2005, was *Homage to CPE Bach*, a 14m-long tapestry for the Sydney Opera House, designed by the building's architect, Jørn Utzon.

As part of the celebration of its public profile, the workshop has also participated in and mounted exhibitions. Starting in 1978 with exhibitions in Melbourne, Queensland and Adelaide, these events increased in

ABOVE All the way from the USA: a new 8m loom arrives from John Shannock in 1989. IMAGE BY JOHN SHANNOCK.

BELOW From left, Pamela Joyce, Sonja Hansen, Irja West and Leonie Bessant weaving *Organic Form* designed by Roger Kemp as part of a collection of tapestries made for the Great Hall at the National Gallery of Victoria, Melbourne, in 1990.

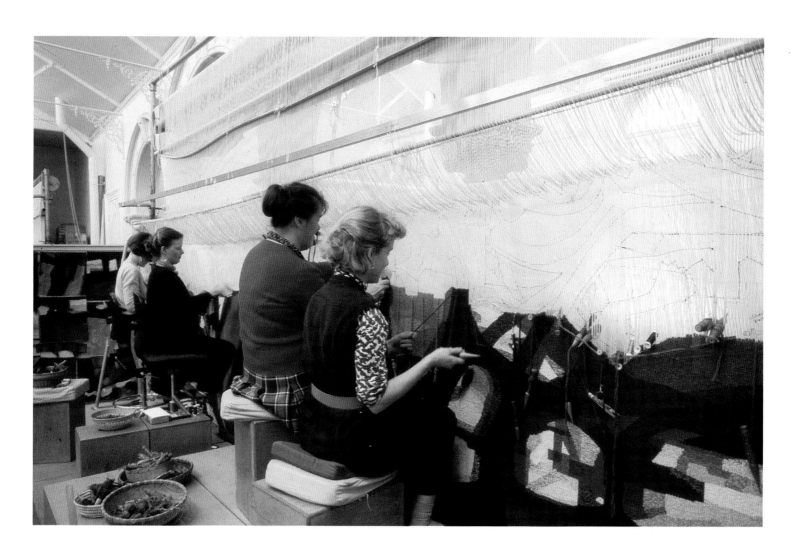

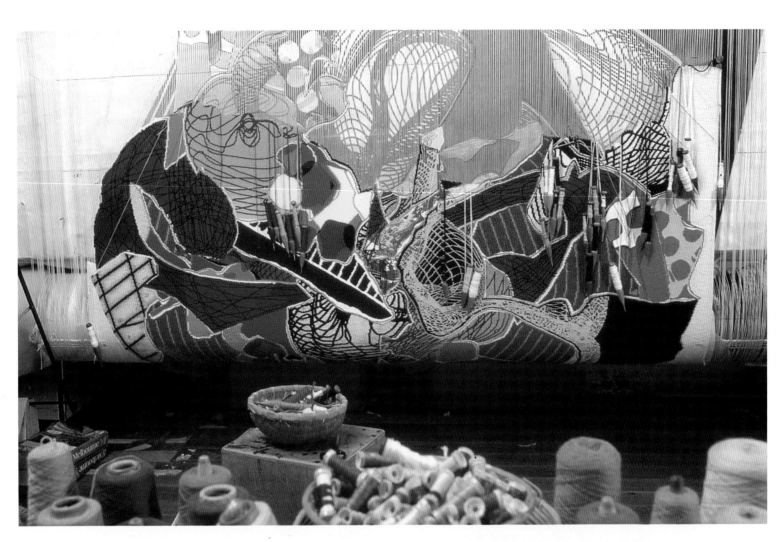

ABOVE Tapestry in progress; *Untitled*, 1996, Frank Stella, woven by
Hannah Rother, Sue Batten and Joy Smith, wool, cotton, 2.2 x 2.01m.
Commissioned by Tyler Graphics Ltd, New York.

RIGHT Chris Cochius, left, weaves while Milena Paplinska searches for the
best bobbin for *The Talk* by David Larwill during 2002.

number and location within Australia, often associated with events such as festivals. In that year the title of the Victorian government's annual arts festival was *Arts Victoria 78: Crafts*, and the workshop took part in a complex program of craft activities and initiatives during the whole year. The first exhibitions to be sent overseas went to Port Moresby (where Brennan was now teaching) and New York in 1980, and subsequent works and exhibitions have been sent to many venues in the UK, Europe, USA and Asia.

In an important expression of its public profile in Australia and strong international connections with related organisations and individual weavers, the workshop organised and hosted an International Tapestry Symposium in Melbourne in 1988. Co-ordinated by weaver and later workshop manager Derum, it attracted more than 220 delegates from 23 countries to a conference supported by a range of 11 exhibitions.

The director and workshop staff have continued to participate in and speak at festivals, conferences and exhibition events in Australia and elsewhere. Today, among many other affiliations, the ATW is a member of the Australian Craft and Design Centres, a group of peak organisations from all states and territories.

As well as establishing its profile and reputation around Australia and in other countries, the workshop has always participated in Victorian arts events. From the late 1980s it often took part in the Melbourne Art Fair as well as the annual Melbourne Festival, while in recent years it has joined in the Open House Melbourne weekend and collaborated with others in events such as Print/Weave/Make with the Australian Print Workshop and Craft Victoria, and Craft Victoria's Craft Cubed event. For these efforts, in 2015 the Australian Tapestry Workshop received the Victoria Day Award for the Arts.

Associated with the wide range of exhibitions has been the consistent production of catalogues, and the workshop has also published books that were often associated with a particular occasion. These include *Modern Australian Tapestries from the Victorian Tapestry Workshop*, edited by Sue Walker, in 2000; Walker's book in 2007; and *Contemporary Australian Tapestry*, edited by Ian Were, in 2010.

In 2002, in collaboration with Monash University, the workshop took on the role of editing the *International*

Tapestry Journal, first published in Alaska following the 1988 Tapestry Symposium in Melbourne, and subsequently edited by Sally Brokensha in Adelaide. Weaver and former deputy director Derum, by then teaching a tapestry course at Monash University, was seconded to the workshop as editor and in 2004 transformed the journal into its final issue, as the *International Tapestry Yearbook*.

From 1984 a record of each year's achievements has been published annually as *ATW News*, later *At the Workshop*, with Issue 32 in the anniversary year, 2016. In recent years, information and publicity has also expanded to a website and on-line social media and the circulation of a monthly *ATW News* e-newsletter.

As well, from the start test samples made during the development of each tapestry have been filed and documented as a research collection. All these items contribute to a valuable archive, not only of what has been made and carried out, but also of the context in which the workshop has operated along the way, and those who made it all happen.

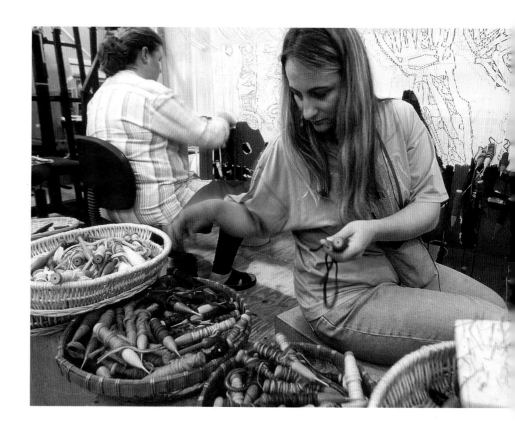

Generous support: time and money

From the beginning, board members of the ATW have represented a range of professional experiences in the creative, business and philanthropic fields across which the workshop functions. As well as contributing their knowledge to policy development, fundraising and working with state and federal governments, many have provided financial support for specific projects. Among those invited to be patrons have been Lady Delacombe, Sir Rupert Hamer, Dame Elisabeth Murdoch and, currently, Sidney Baillieu Myer AC.

At the same time, volunteers have consistently taken on many roles and responsibilities, starting in 1988 with 16 voluntary guides who had participated in a pilot project run by guides from the NGV. They, and many others since that time, have provided information to visitors through tours and talks about the workshop's history and the weaving process. A Busy Bees group of volunteers was also set up at an early stage and today continues to assist with many necessary administrative tasks.

A vitally important associated body is the Tapestry Foundation of Australia (formerly of Victoria), which was established under former board chairman Arnold Hancock in 1995. The purpose of this small initial group of four (later eight) trustees was to foster relationships with government and private organisations and individuals, and to attract tax-deductible donations to complement funding from the state government in supporting the VTW's infrastructure and programs. Significantly, the trustees of the TFV soon began negotiating to acquire the building in Park Street, a project that was completed in 1998, when architects were commissioned to upgrade and refurbish the space for relaunching in 2000.

During its first 20 years the foundation has enabled the commissioning of many tapestries and the purchase of equipment and has underwritten the costs of publications and films. It has provided grants for the professional development of weavers, and contributed to awards, prizes and artist residencies as well as the workshop's participation in Australian and international events and exhibitions. Among its many achievements are the Tapestry Foundation Embassy Collection and the Artist in Residence program where, by 2016, a record number of 79 applications were received with the 16 practitioners selected coming from across the visual and performing arts. The Hancock Fellowship residency program, established in 2000, brings international experts to give lectures in the workshop, with the first recipients being Archie Brennan and Susan Maffei.

In 2012 the ATW, through its foundation, launched a successful continuing public appeal, Give an Inch, by gathering funds to contribute to the cost of weaving several significant tapestries and to enable a number of public outreach programs. Recent achievements have included *Catching Breath*, by Brook Andrew, for the Embassy Tapestry Collection in 2014, *Current Exchanges*, a joint exhibition in 2014 of contemporary tapestries with Dovecot Tapestry Studio in Edinburgh, and support of the ATW's Artists in Residence program.

From 2011 the biennial Kate Derum Award for small tapestries, supported by Susan Morgan and the TFA, has honoured the memory of this important weaver, while the family of Irene Davies instigated an award for weavers within their first five years of practice. In 2015 the inaugural ATW Tapestry Design Prize for Architects was launched in the Utzon Room at the Sydney Opera House. This proposal invited architects to create a tapestry design for a specific location. Open to architects, design collaborations and architecture students, the first hypothetical site as context for the tapestry design was the Australian Pavilion designed by Denton Corker Marshall, in the Giardini in Venice.

Outside the workshop, dealers such as Stuart Purves from Australian Galleries have also been active in encouraging and establishing relationships with artists and potential clients.

Recognising that some supporters wanted to be very closely involved, a Friends of VTW (now ATW) organisation convened by Fiona Caro was launched on the 20th anniversary in 1996, with 319 members and 20 life members. Its extraordinarily valuable efforts towards promoting the understanding of contemporary tapestry making continue through organising special events and frequent public talks by artists and weavers.

Continuity: relevance and influence

Throughout its 40 years the ATW has played an exemplary role in integrating the sometimes differing sensibilities of contemporary visual arts, crafts, architecture and design through imaginative expression of the professional interaction that is possible between them. The visions and

Cresside Collette, Sara Lindsay, Former ATW Director Dr Sue Walker, Former ATW Director Susie Shears, Liz Nettleton and Merrill Dumbrell at the launch of *Artist's Tapestries from Australia 1976–2005*.

hopes of the ATW founders and those who have worked at the 'loom-face' in many capacities during this time have not only been met but taken further.

Events around us continue to affect all cultural activities, from wider economic crises to changing arts funding priorities and declining education provisions, with some significant organisations and programs disappearing or altering radically. At the same time, many are celebrating anniversaries, not only recalling their origins and evolution but also reminding us of the strong effects they continue to have on our cultural life. Among these, the ATW is a model of excellence, maintaining its continuing relevance and influence in an often changing and challenging context.

Grace Cochrane AM

ARTISTS
AND WORKS

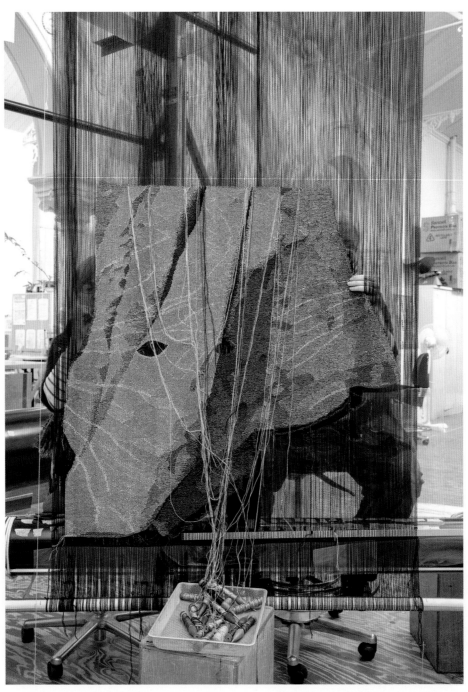

Weavers' hands weave together the intricate
architecture of Brook Andrew's *Catching Breath*,
2014. IMAGE BY JEREMY WEIHRAUCH

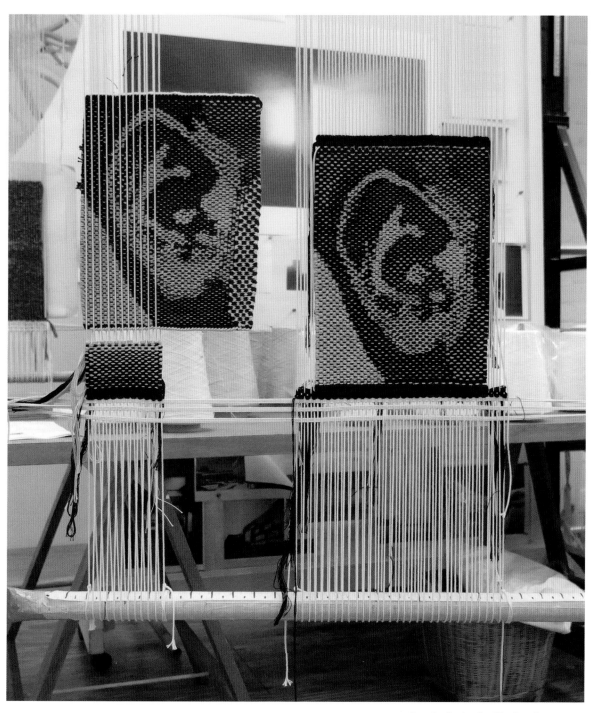

Samples for the *Catching Breath* tapestry designed by Brook Andrew.

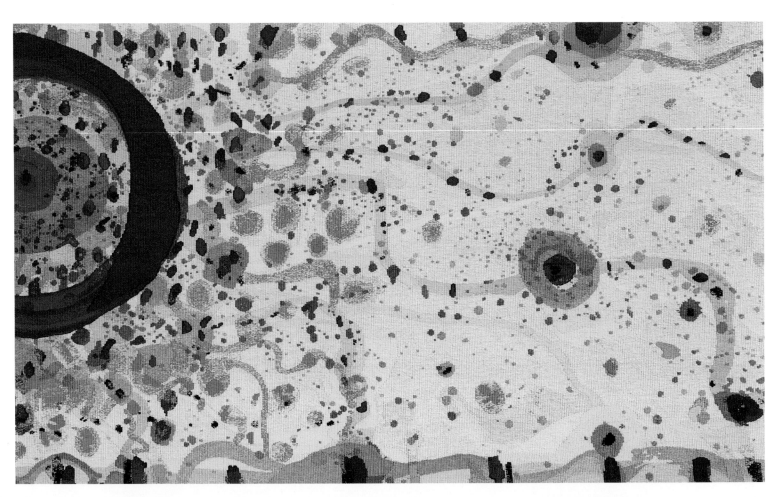

Detail of *Life Burst*, 2016, designed by John Olsen.
IMAGE BY JEREMY WEIHRAUCH

LIT FROM WITHIN

John Olsen AO OBE was one of the first contemporary Australian artists to design work especially for tapestry, and after a period of early experimentation in Portugal and France, it was in collaboration with the ATW that he created his greatest and most memorable tapestries.

Olsen is not only one of Australia's most popular and highly regarded artists, but also one of its most prolific and diverse. Best known as a painter and printmaker, Olsen loves the challenge of a new art form, whether this is working on monumental murals on walls and ceilings, in ceramics or with tapestries. In each instance, Olsen's approach is that of a local, rather than that of a visitor. He needs to know the medium from the inside out, regardless of the extent to which he employs expert technical assistants to realise the goals he has set for himself. If the final product is a collaboration, Olsen feels that he needs to decisively steer the process.

In his 30s Olsen was drawn to the art of tapestry, and travelled around Europe visiting some of the most famous tapestry workshops. These included the fabled Manufacture des Gobelins in Paris and the Aubusson tapestry ateliers in the upper valley of the Creuse in central France, as well as the Manufactura de Tapeçarias de Portalegre in Portugal that had been established in 1948. He was particularly pleased with the workshop at Portalegre, where his *Joie de Vivre*, 1964–65, tapestry was woven and which, shortly after its display at the Clune Gallery in Sydney, entered the collection of the Art Gallery of New South Wales in 1965. Olsen noted in his journal in 1966 that '[t]he work produced in Portalegre, in Portugal, seemed . . . outstanding, particularly in its adaptable response to the artist's palette'.

The Paella, 1981, was the first of nine tapestries Olsen undertook with the ATW. In the late 1950s, he spent much of his time in Spain, where he said he 'came of age artistically' and apart from absorbing the work of Antoni Gaudí, Spanish modernism, especially that of Joan Miró and Antoni Tàpies, as well as the work of the CoBrA artists, plus a growing understanding of Zen Buddhism, he also learned how to cook. The paella is not only Spain's national dish, it also became one of Olsen's favourite concoctions, which he would cook for many years to come. The etymology of *paella* is the pan in which the food is cooked.

In Olsen's study for the tapestry design the paella becomes an epicentre, like a vortex into which nature's bounty seems to be drawn as if through invisible forces. In the tapestry, the sense of surface dynamism has been accentuated, as rabbit, fish and fowl become wondrous creatures with swirling tails. The composition exploits a two-point Cubist perspective, with the pan shown frontally, as if from above, while the rest of the composition is in profile, seen from below and from the side.

The year 1981 marked considerable change in Olsen's life. He met Noela Hjorth and moved with her to Clarendon, a small hamlet within easy commute of Adelaide, and here he resumed a rural and bucolic existence. Olsen at this time revisited a number of Spanish themes in his art, and *The Paella* is one of his finest works from this period. This large wool and cotton tapestry, measuring 152cm x 366cm, radiates an inner luminosity, as a series of red hearts dance across the surface of the work in a celebration of happiness and love.

Olsen had long been an advocate and supporter of the ATW and during his Clarendon years collaborated with the workshop on three further commissions: *Lily Pond*, 1984, *Untitled*, 1986, and *Rising Sun*, 1987. In these works Olsen's focus had shifted from the allegorical celebration of food to a celebration of the Australian outback. In an Olsen landscape, add water and the whole environment bursts into a festive polyphony of fecundity, with waterways teeming with life and pulsating with energy. Olsen creates landscapes that are good enough to eat, creating an ambiguity between a culinary feast and a joyous landscape. These tapestries radiate with light and energy and with a sense of profound spirituality.

In the late 1980s Olsen moved back to New South Wales, initially to Sydney then to the Blue Mountains, to live with Katharine Howard, whom he married in early 1989. In the past 25 years, Olsen, aged in his 60s to his mid-80s, has produced some of his most memorable work, including five tapestries with the ATW: *Light Playing with Evolution*, 1989, *Happy Days*, 1994, *Rising Suns over Australia Felix*, 1997, *Sun over the You Beaut Country*, 2014, *Life Burst*, 2016.

Of these, the largest, most impressive and most memorable is *Rising Suns over Australia Felix*, which was commissioned by the Department of Foreign Affairs and Trade and hangs in the foyer of its building in Canberra. Measuring 4m x 7.77m, and woven by Grazyna Bleja, Merrill Dumbrell, Claudia Lo Priore, Georgina Barker, Milena Paplinska, Cheryl Thornton and Owen Hammond, the tapestry, conceptually and in its execution, is Olsen's most ambitious to date.

The artist points to his source of inspiration as the moment when, returning to Australia on a flight, he saw a sunrise over the Australian continent. The composition is divided into the two bands of the earth and the sky with both teeming with life and lit from within. Here Olsen poses for himself one of the most difficult problems in Australian landscape art: how to convey the vastness and monotony of the space, but also to capture the intricacy and preciousness of detail. In this tapestry there is the sense of a sprawling landscape, punctuated with wonderful calligraphic inventions and colouristic outbursts. There is a celebration, richness of invention and also a deep lyricism that can also be interpreted as a profound Zen meditation.

A challenge that faced Olsen and his weaver collaborators was how to express in fibre the translucence of Olsen's watercolour washes and splashes, yet remain true to the nature of tapestry. The linking of lines, the movement, the textures and the very delicate treatment of the breathing background creates a wonderful kinetic surface so that the whole space envelops you as you experience the joy and miracle of the rebirth of the land at sunrise. Although the tapestry has an immediate visual impact, at the same time as you enter into the work there is also a profound contemplative quality, so that you can spend the rest of your life being slowly nourished by the piece.

Sasha Grishin AM FAHA

LEFT John Olsen with the *Rising Suns over Australia Felix* tapestry in progress.

TOP *Light Playing with Evolution,* 1989, John Olsen, woven by Andrea May and Peter Churcher, wool, cotton, 2 x 2.5m. University of Melbourne, Department of Zoology Collection. **IMAGE BY JEREMY WEIHRAUCH**

BOTTOM *Lily Pond,* 1984, John Olsen, woven by Iain Young, Chris Cochius and Sonja Hansen, wool, cotton, 1.5 x 4.42m. Private Collection.

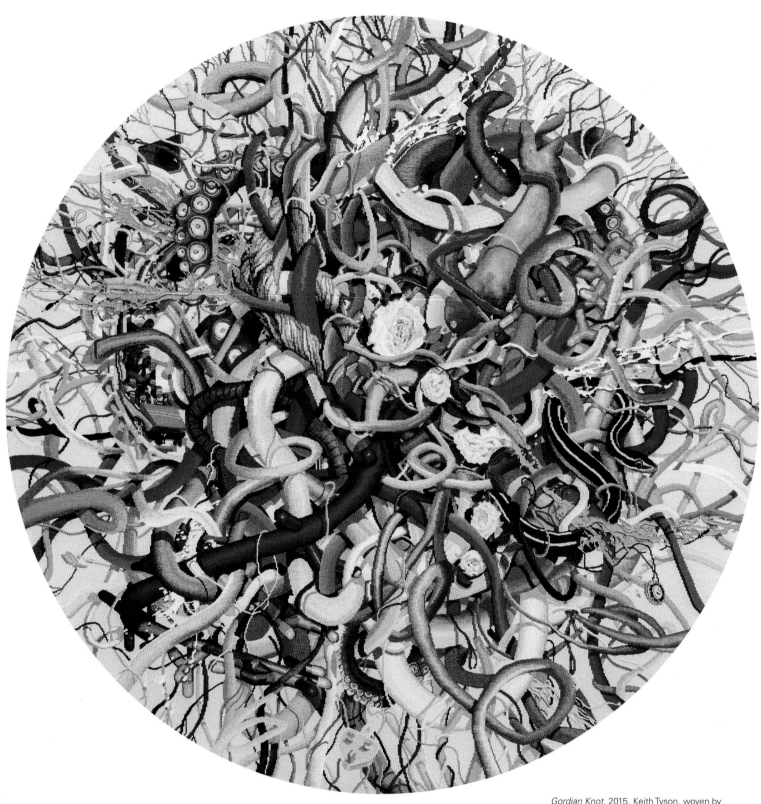

Gordian Knot, 2015, Keith Tyson, woven by
Chris Cochius, Sue Batten, Pamela Joyce and
Milena Paplinska, wool, cotton, 2.4 x 2.4m.

EXTRAVAGANT
COMPLEXITIES

There is something more than a little daunting about Keith Tyson's magnificently exuberant oeuvre: the dazzling colours, the insanely detailed drawings, the bizarre sculptural formations, the hallucinogenic visions, the crazed leaps from medium to medium, subject to subject. To understand the breadth of his interests one need only consider Tyson's attempts to summarise influences on his output: he lists horology, labyrinths, floristry, cosmology, electromagnetism, mathematics, psychopathology, cryogenics, combinatorics, philology and geometry, among others.

There is a creative energy in his work here that can only be described as Tysonesque, a boisterous and animated approach that leaves the viewer's head spinning. And to the list of media that have succumbed to Tyson's feverish imagination can be added tapestry.

In 2014 he joined forces with ATW weavers Chris Cochius, Sue Batten, Pamela Joyce and Milena Paplinska on what can only be described as an adventure for all involved. Given its remarkable intricacies, it is apt that the work is called *Gordian Knot*. 'Gordian knot' means an intractable problem. It relates to a legend about the people of the city of Gordium, the ancient Phrygian capital, who had no king, so they consulted an oracle, who predicted that the next man to enter the city in an ox-cart would be their king. The man who fitted the bill was a peasant farmer, who duly became king.

His son Midas had the ox-cart secured by an intricate knot to a post in the middle of the city as a memorial to his father and as a power symbol. It was believed that whoever could loosen the knot was destined to become the ruler of Asia. However, such was the knot's fiendish complexity that it baffled all who tried to untie it. But it was no match for the all-conquering Alexander the Great, who arrived in the city in 333BC and sliced through the knot with his sword, an early example of lateral thinking. Tyson and the ATW weavers came up with a design for *Gordian Knot* of such capricious imagination that it would baffle even Alexander.

And, in keeping with Tyson's unpredictable approach, it is unusual as a tapestry and an artwork. Most notably, he made the tapestry circular. As well, in some areas different weaving techniques were incorporated, including soumak and double weave, to create the distinctly three-dimensional quality of the finished work, which oozes with strange, slippery movement, and suggests that the tubular growths are erupting from the surface. The background colour was conceived and designed so it

would recede into the display wall and the complex and colourful knot would appear to extrude extravagantly into the surrounding environment.

Tyson, a Briton, was the 18th recipient of the Turner Prize in 2002. In 2014 he was selected by the client to design a tapestry to be created with the ATW, which would investigate the potential of adding fibre to his array of materials. Batten, Cochius, Joyce and Paplinska revealed to Tyson a raft of experimental weaving techniques. 'Seeing the fantastic work that is being, and has been done there, was both inspiring and incredibly humbling,' Tyson said after that meeting.

'The labour and intricate craftsmanship is just awesome, the results vibrant and arresting. After speaking with the weavers I think there is a real opportunity to do something striking and novel with the medium.

'I do not see this as simply a diffusion of my painting but a new way of making an object in its own right,' he noted. 'The weaving together of the various strands, the strata of compressed time forming slowly into an image, all form a perfect conceptual fit with themes I have always been fascinated with.'

Tyson returned to London and began planning his design, deciding to revisit elements of his 2003 studio wall drawing, *Cutting the Gordian Knots*, in a far more complex and boisterous form.

Writing in *Frieze* magazine, critic Alex Farquharson said of Tyson's works that: 'they present the tragicomedy of trying to make sense of life, whatever interpretative system is used, including the fluid and pluralistic medium of contemporary art'.

Gordian Knot in many ways illustrates the rhizomatic notion of contemporary philosophy, which defines a form of learning based on multiple, non-hierarchical entry and exit points in the gathering of information and its interpretation (not that Tyson embraces French Theory: 'Great for thinking, very debilitating for practice,' he has said). In a biological sense a rhizome, sometimes called a creeping rootstalk, is a plant that sends out roots and shoots as it spreads, a process the tapestry visualises. But some may also read the tapestry as a mass of squirming worms. There are thousands of species of worm across the planet, all of them hermaphroditic and many of them regenerators of soil. One can only imagine trying to untie a Gordian knot of slimy worms.

Tyson seems not to take the extravagant complexities of his intellectual explorations overly seriously. For all of his encyclopedic references, which range from algebra to mathematical formulas to astronomy to psychopathology, and then some, there is more often than not a sense of humour and the absurd lurking somewhere within. In *Gordian Knot* it emerges as a funhouse roller-coaster packed with delirious children rocketing from the top of the tapestry, its participants travelling into a crazy world of wool where other oddities lay in wait.

Tyson is one of Great Britain's most acclaimed contemporary artists. His solo exhibitions include the exhibition of the major sculptural work *Large Field Array*, a multifaceted sculptural installation that toured from the Louisiana Museum for Modern Art, Denmark, to the De Pont Museum of Contemporary Art, Holland, 2006–07, and to PaceWildenstein in New York until 2008. More recently he has exhibited at David Risley Gallery in Copenhagen and Pace Gallery in London. Tyson's work is held in a number of collections, including those of the Museum of Modern Art, New York, Tate Modern, London, and the Musée National d'art Moderne, Centre Georges Pompidou, Paris.

Ashley Crawford

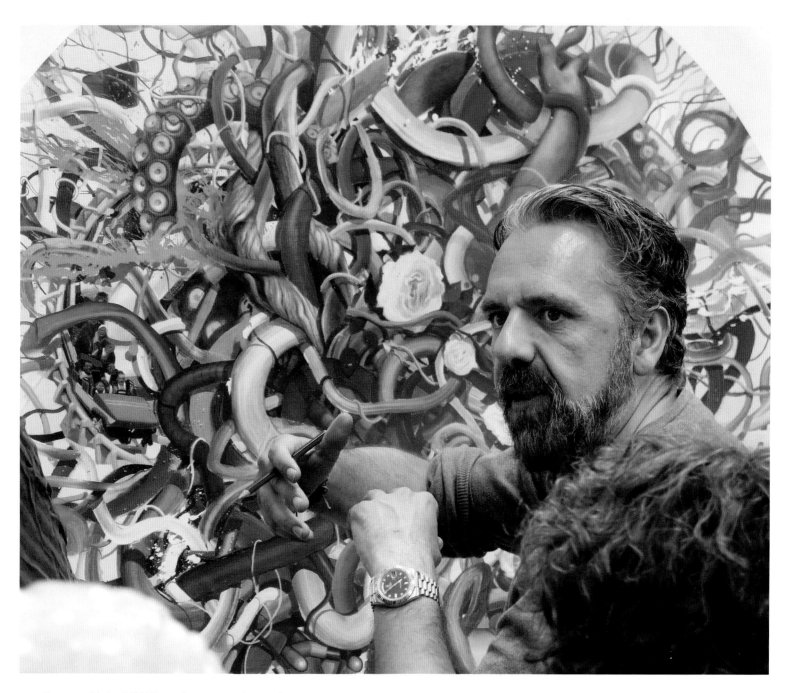

ABOVE Trusty pencil in hand, Keith Tyson discusses weaving samples during a visit to the ATW.

LEFT Preliminary samples and designs for the *Gordian Knot* tapestry.
IMAGE BY JEREMY WEIHRAUCH

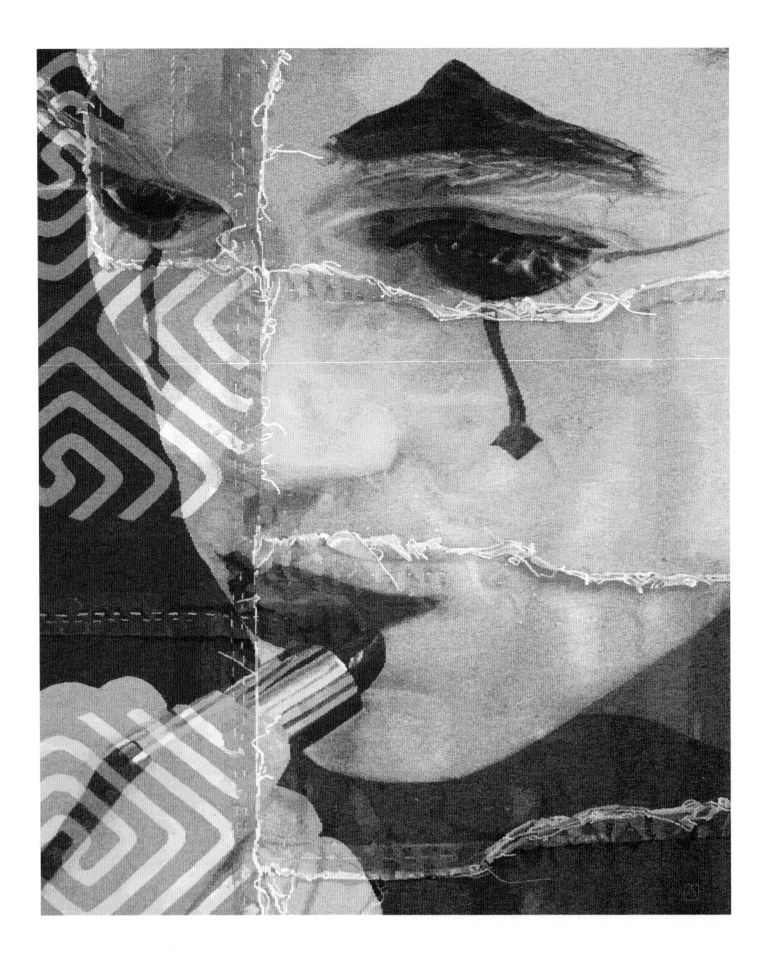

WEAVING AN
UNCERTAIN NARRATIVE

A quiet and unassuming gentleman, David Noonan most certainly knows what he wants from his art. He is also a maverick, mastering in his startling career a number of media, through drawing and painting, silk-screening, video, sculpture, photography, and installation.

His works in these media are linked by a powerful sense of nostalgia and melancholy, and he has found another outlet for it in the ancient art of tapestry, in partnership with the master weavers at the ATW.

Noonan's survey show at the Monash University Museum of Art in 2005 was an elegant compendium of his output since 2001. There were delicate paintings and textured installations, noirish videos and odd montages, all held together by an almost other-worldly sensibility imbued with wistfulness and fantasy, and rendered with a muted palette of rusty ochres and shadowy monochromes. These odd, subdued works, with their hints of secrets and the supernatural, found an avid audience through critically acclaimed exhibitions in New York, Chicago, Sydney, Melbourne and London, where he is now based.

Noonan's work is a potpourri of influences, from his childhood in semi-rural Ballarat in Victoria during the pseudo-hippy days of the 1970s, through to his explorations in science fiction, parapsychology, horror and the gothic. Literature, music, film and fashion all filter through. Past and present merge in his work; for instance, his video installation came complete with arrayed Afghan rugs, which were so in vogue in the 1970s.

He tackles whichever media is available — he's a painter, sculptor, film director and set designer and, more recently, master of the collaborative process of tapestry making. *Untitled*, 2009, his first work with the ATW, was executed in 2009. As do many artists new to the formalities and intense, co-operative aspect of tapestry, he approached the project with a mix of trepidation and enthusiasm. The tapestry was designed by Noonan and woven by the ATW's Cheryl Thornton, Sue Batten and Amy Cornall. This was a new process for him. He had collaborated before on film and silkscreen, but usually he took a far more hands-on approach to his media. Making this tapestry would be, by sheer necessity, the first time Noonan would be hands-off.

Untitled, 2009, with its mysterious figures, birds and trees, was an unrivalled success and became part of the travelling exhibition British Art Show 7, *In the Days of*

Untitled, 2012, David Noonan, woven by Emma Sulzer and Cheryl Thornton, wool, cotton, 2 x 1.63m.
IMAGE BY VIKI PETHERBRIDGE

the Comet, curated by the Hayward Gallery in London, which toured for 15 months across the UK. The tapestry is a tribute to the wonderfully garish stage make-up of Japanese Kabuki performers (indeed, the artist has long held an aesthetic affair with Japanese *Furoshiki* tapestries). Noonan also selected it as his sole work to be displayed during the 2010 Adelaide Biennial of Australian Art, held at the Art Gallery of South Australia in 2010. In April 2012 it was exhibited at the Institute of Modern Art in Brisbane and it has since been acquired by a private collector.

The ATW was naturally eager to work again with Noonan, and the feeling was clearly mutual, for in 2011 they began another collaboration. The result is a homage to one of Noonan's pet passions, the era of glamrock, especially as reflected in the work of David Bowie. Noonan's *Untitled*, 2012, carries powerful hints of the aesthetic of Bowie's Pierrot, or 'Blue Clown' costume, designed by Natasha Korniloff in 1980 for the *Ashes to Ashes* video and associated *Scary Monsters (and Super Creeps)* album cover.

The clown face, with its haunted eyes and gaudy lipstick, carries, alongside the Bowie reference, the chilling air of the Dean Stockwell character in David Lynch's film *Blue Velvet*. The clown in contemporary culture is rarely a comforting figure, from The Joker in *The Dark Knight*, sitting alongside Bruce Nauman's 1987 painting *Clown Torture*, or serial killer John Wayne Gacy's clown paintings of the 1990s or the terrifying visage of Twisty the Clown in the television series *American Horror Story: Freak Show*. As pioneering Hollywood horror star Lon Chaney suggested, there's nothing funny about a clown in the moonlight; even Bart Simpson experiences a bout of clownphobia: 'can't sleep, clown will eat me'.

Untitled, 2012, represented Noonan's second collaboration with Thornton, who wove the tapestry with Emma Sulzer. For this project, he produced a number of potential images, and the final iconographic clown was selected by the ATW in consultation with him. Unlike many of the workshop's projects, this artwork exists only as the original digital image and this remarkable tapestry.

The design relates to a body of work in which Noonan deploys a personal archive of found images to create hand-screened collages on linen depicting costumed figures set against richly patterned backgrounds, so that the subjects seem to be caught between moments of introspection and exhibitionism.

The work is composed of two layers: the face, and a superimposed layer of Japanese boro textiles fashioned from stitched-together rags of previously dyed fabric. Because of this layering the weavers used separate images of each layer to guide their interpretation.

Julian Myers, reviewing Noonan's 2006 show in Los Angeles for *frieze* magazine, noted that: 'Where some of Noonan's earlier work could be called primly gothic, these works were genuinely frightening. Unified and striking when seen from a distance, the pictures unraveled close up, the constituent dots becoming a vibrating, eye-popping optical pattern.'

The challenge faced by weavers Thornton and Sulzer was to replicate Noonan's strange optics. Their palette is almost identical to that used for the 2009 tapestry. While they initially attempted to introduce some subtle blues or purples, ultimately they felt the greyscale palette was more sophisticated and better suited to the piece. The result is a work of dramatic yet enigmatic intensity. In 2012 it was included with the earlier tapestry in the *Daydream Believers* exhibition at the Institute of Modern Art in Brisbane, and was a highlight at the ATW stall at the Melbourne Art Fair.

Noonan often looks to things such as 1970s craft books or gothic architecture to help inform his narratives. The timelessness frequently found in his work is contradicted by the hi-tech elements — or in this case by the art of tapestry — he often employs, and this adds to the tension his work generates.

Noonan obscures the absolute nature of his narrative, allowing the viewer to be drawn into his theatrical compositions. In transforming his extraordinarily complex imagery, the ATW weavers cleverly retained the most important details required to secure that uncertain narrative.

The tapestry was cut off the loom on 2 April, 2012, by special guests Penny Hutchinson, director of Arts Victoria, and Colleen Noonan, the artist's mother.

Ashley Crawford

RIGHT David Noonan inspects progress with *Untitled*, 2009.

BELOW *Untitled*, 2009, David Noonan, woven by Cheryl Thornton, Sue Batten and Amy Cornall, wool, cotton. 2.28 x 2.93m.
IMAGE BY VIKI PETHERBRIDGE

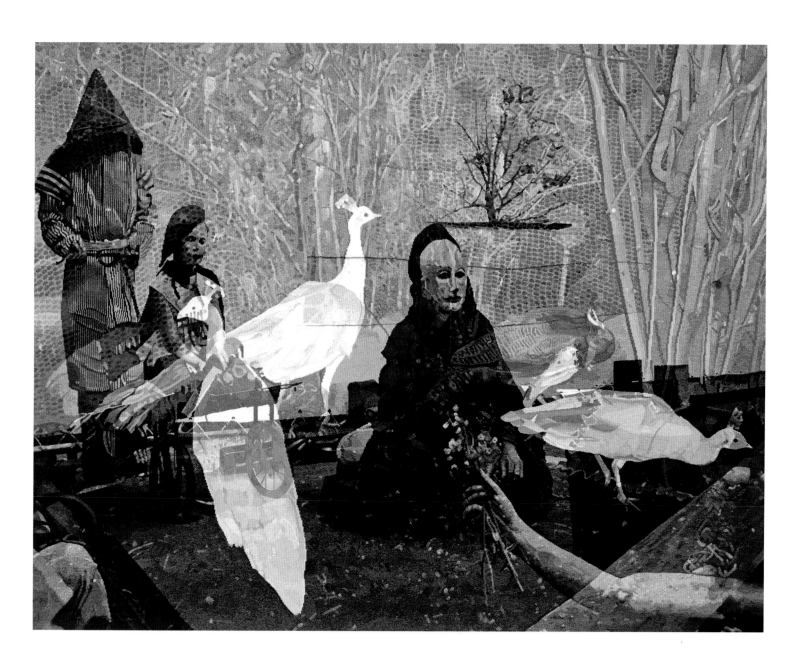

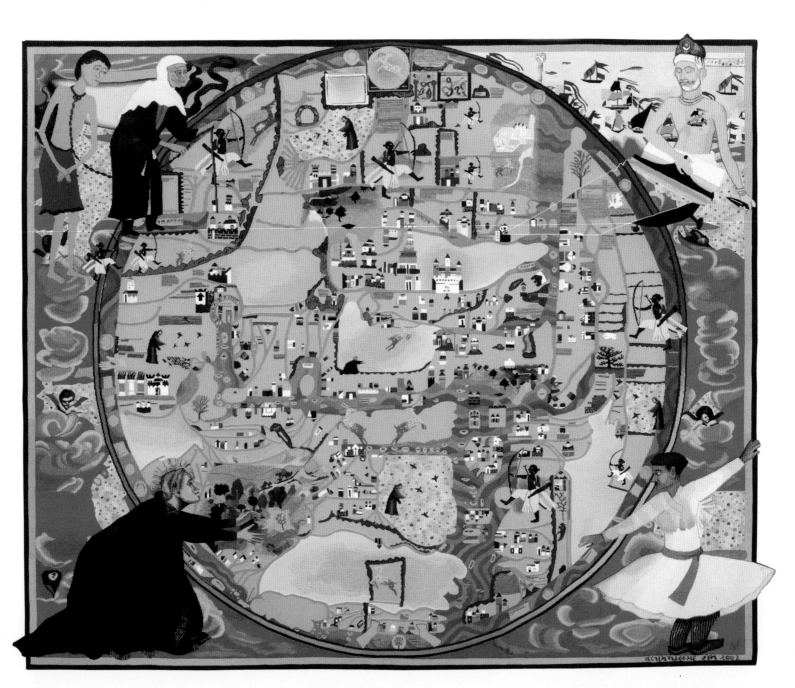

Mappamundi, 2004, Gulammohammed Sheikh, woven by Cheryl Thornton, Amy Cornall, Rachel Hine and Caroline Tully, wool, cotton, 3.02 x 3.6m. Commissioned for Asia Link, University of Melbourne.

A CARTOGRAPHY
OF LOVE

Born in Surendranagar, Gujarat, in 1937, Gulammohammed Sheikh has been a central figure in Indian art since the 1960s, when along with colleagues at the Baroda Faculty of Fine Arts he helped substantially broaden the pictorial possibilities of Indian art while insisting on its relevance to its social context.

Sheikh enrolled in the recently instituted, highly progressive fine arts faculty at the Maharaja Sayajirao University of Baroda, arriving in time to participate in the 1957 second exhibition in Bombay of the Baroda Group, whose numbers included innovative painters Jyoti Bhatt, Shanti Dave and Ghulam Rasool Santosh. He was also one of the 11 young artists who made up the Group 1890, whose 1962 and 1963 exhibition *Surrounded by Infinity* signaled a statement of intent to revitalise Indian art through the creation of an Indigenous modernism.

Completing an MA in painting in 1961, Sheikh stayed on at Baroda to teach art history, and with the exception of three years spent studying at the Royal College of Art in London in the mid-1960s, he would be a consistent presence at the school until 1993, and an influential figure in South Asian art education.

Working in the fertile milieu of Baroda (now known as Vadodara), Sheikh was integral to the development of the 'figurative-narrative' style, which rejected both the aesthetic purity of abstraction and the universalism of an earlier generation of Indian artists, introducing an expansive pictorial plane that incorporated a broad range of representational techniques while remaining firmly rooted in an immediate social reality. This new approach was asserted by Sheikh, along with Bhupen Khakhar, Jogen Chowdhury, Vivan Sundaram, Nalini Malani and Sudhir Patwardhan, in the 1981 exhibition *Place for People*.

Geeta Kapur has characterised figurative-narrative art as a localised iteration of international magical realism, a 'narrative abundance' and 'representational excess' that radically expanded the purview of postwar modernism to include popular idiom, rich art-historical references and Indigenous and vernacular styles. For Sheikh, this was a means of articulating simultaneity: the actuality, alongside one's own life, of the lives of others, and of the Indian experience of 'living simultaneously in several cultures and times', a co-existence of past and present, 'each illuminating and sustaining the other'.

Produced in collaboration with the ATW, and woven by Cheryl Thornton, Amy Cornall, Rachel Hine and Caroline Tully, *Mappamundi*, 2004, is a magnificent adaption of Sheikh's opulent visual style, incorporating historical and mythical figures in a richly coloured, dream-like tableau. He began producing these maps in 2001 after encountering a postcard of the Ebstorf Map, a celebrated 13th-century German map of the world that was destroyed during Allied bombing of Germany in 1943. The Ebstorf was a classic *mappa mundi*, the Latin term for any map of the world produced in medieval Europe, whose substantial size of 30 goatskins enabled a highly detailed elaboration of the standard tripartite division of the continents (Asia, Europe and Africa) within an encompassing orb, signifying the oceanic limits of inhabitable land, beyond which lay the cosmos.

Familiarised with digital technologies by a new media gallery in Baroda, Sheikh set about inventing his own maps composed of new sites placed within the architecture of the Ebstorf mappa mundi. The artist then overpainted the outputted inkjet prints in gouache, frustrated with 'the limitations of cloning that digital technology imposes', creating what he described as a 'jugalbandi of the hand, mind and machine' in reference to the dual solos of Indian classical music.

Mappamundi is dominated by the Ebstorf Map's *orbis terrarium*, the circle of lands that pushes against the tapestry's top and bottom limits, and by four figurative presences in each of its corners, each of which symbolically transgress the oceanic boundary between celestial and terrestrial worlds.

Edging into the map are two figures drawn from a 16th-century Mughal painting by Persian journeyman Mir Sayyid Ali: Majnun and Kabir, the jilted lover of classical Arabian verse and medieval Indo-Persian romance cycles, disguised as a beggar and led by an elderly woman in the hope of seeing his forbidden beloved Layla. In the top right of the map, the 15th-century mystic poet Kabir tends his familial loom, one of modest accoutrements with which he is typically depicted. An elderly North Indian dervish dances in the lower right, his whirling posture sourced from a Pahari miniature painting, while to his left the Mary Magdalene figure from Giotto's *Resurrection* (*Noli me tangere*) reaches out to an absent risen Christ.

Within the map is a second appropriation from Giotto, a smaller, repeated image of St Francis of Assisi preaching to birds, balanced by a similarly plural representation of the Hindu deity Rama in pursuit of the demon Marich in the form of a golden deer. As with the Ebstorf Map, Sheikh's *Mappamundi* is divided by the 11 tributaries of the Ganges, while swirling clouds and angelic Renaissance putti demarcate the unmappable heavens at the tapestry's margin.

Along with its vibrant tones and striking composition, what is most compelling about *Mappamundi* is its liberal combination of Hindu, Islamic and Judeo-Christian archetypes and the pan-Eurasian diversity of narrative and figurative traditions on which it draws. Sheikh's rendering avoids depicting the crucified Christ around which the Ebstorf Map revolves, instead opting for a play of religious references evenly distributed across the pictorial plane. This absence is of course doubled in the depiction of Mary Magdalene, whose unconsummatable longing is reflected in the figure of the lovestruck Majnun. In this sense, Kabir, 'a product of Muslim and Hindu faiths who belonged to neither' as one interpreter has rightly put it, is perhaps the closest visual register for Sheikh's own lyrical, pluralist approach to cultural inheritances.

In preceding the rational cartographies of post-15th-century European representations of the world, the fanciful form of the *mappa mundi* permits the realisation of Sheikh's visual and symbolic syncretism, which at the same time undercuts the ideological assumptions of the original map. But in doing so, the artist's critique extends to subsequent, supposedly more neutral cartographies, which simply displace the theological in favour of colonial and nationalist conventions.

Sheikh's recourse to the performatively fictive aspect of the *mappa mundi* proposes both a return and a realignment, a cartography of love, longing and encounter, through a design whose juxtapositions are not so much incongruities as intersections: pathways to possibility.

Reuben Keehan

Detail of *Mappamundi*, 2004, Gulammohammed Sheikh's very modern take on map making.
IMAGE BY JOHN GOLLINGS

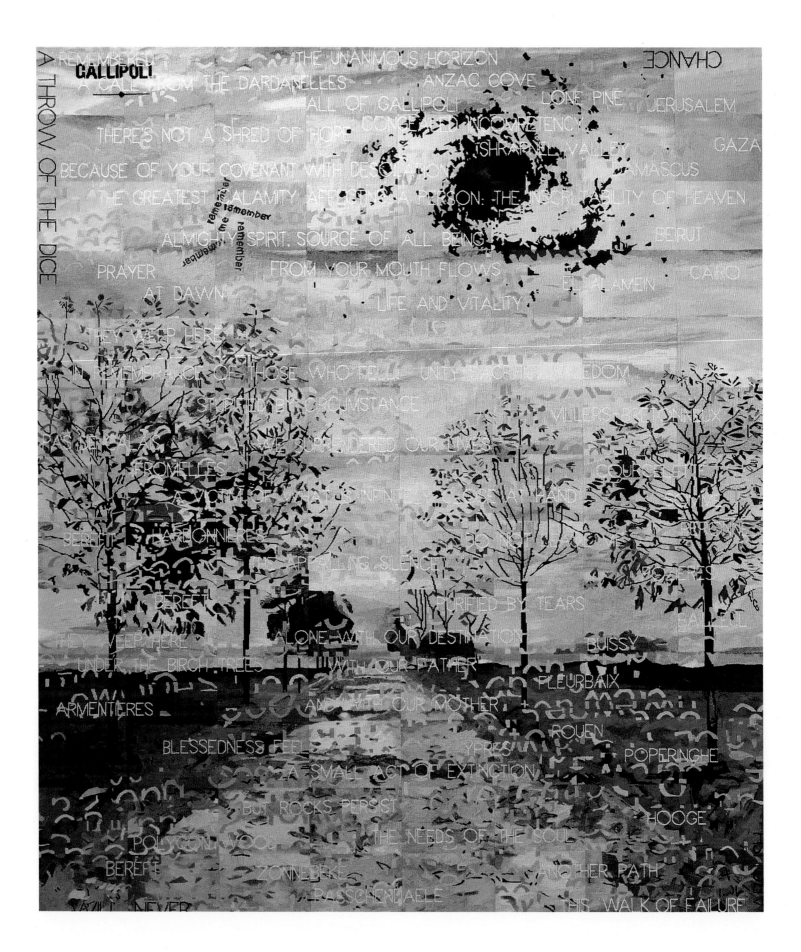

SOMBRE LAMENT FOR LOSS

Imants Tillers (born 1950, in Sydney) is one of Australia's most prominent postmodern artists. He was drawn into art when he joined a group of volunteers who assisted Bulgarian artist Christo and his partner, French artist Jeanne-Claude, on their *Wrapped Coast* project in Little Bay, Sydney, in 1969. Subsequently most of Tillers' art has been orientated to conceptual concerns and has dealt with questions of appropriation and quotation. Also early in his career he established a method of work where he would paint on small canvas panels that can be assembled, if needed, into quite large compositions.

Avenue of Remembrance, 2015, is Tillers' first excursion into tapestry and came about through the confluence of several fortuitous circumstances: the Australian War Memorial wanted to commission a tapestry to commemorate the centenary of Gallipoli, a generous donation from the Geoff and Helen Handbury Foundation financially enabled the commission, and Tillers was prepared to undertake the project at fairly short notice. He was already working on a related idea when this commission arose and quite quickly produced a painting made up of small composite boards that, coincidently, was of exactly the same dimensions as the intended tapestry. The tapestry was unveiled at the Australian War Memorial in Canberra in April 2015.

The central image in his composition is an avenue of trees, which Tillers appropriated from the painting by Swiss artist Ferdinand Hodler, *Autumn Evening*, 1892. Hodler's autumnal scene used a cool palette and its melancholy associations of the passing of seasons and the approaching bleak winter was an appropriate mood setting for the remembrance of those who died in war and those who were left behind to mourn them. Tillers had little interest in scenes of battlefield heroics or site-specific commemorative scenes of the Gallipoli peninsula and transcribed with a considerable degree of accuracy Hodler's avenue of trees, which could also have an association with the avenues of remembrance that dot many Australian rural towns. Here European deciduous trees were planted in artificial symmetry and took on their mournful, autumnal appearance during the annual Anzac Day commemorations.

For many years Tillers has employed text in his paintings, initially as quite legible inscriptions, where one could draw a parallel with the great New Zealand painter Colin McCahon, then increasingly fragmented, so one can speak of a continuous process of intertextuality, where meaning

Avenue of Remembrance, 2015, Imants Tillers, woven by Chris Cochius, Sue Batten, Leonie Bessant, Pamela Joyce, Milena Paplinska, Laura Russell and Cheryl Thornton, wool, cotton, 3.27 x 2.83m. Commissioned by the Geoff and Helen Handbury Foundation. Present location, Australian War Memorial, Canberra. IMAGE BY JEREMY WEIHRAUCH

remains fluid and difficult to pin down. Central to Tillers' thinking as an artist is the idea of layering of images, of texts and of possible meanings and interpretations. One source for some of the selected texts in this work is Sir Keith Murdoch's famous Gallipoli letter that was cabled from London to his friend, prime minister Andrew Fisher, in 1915. This 28-page letter was hastily rewritten by Murdoch in London, after the original had been confiscated by French military police in Marseilles. In it he condemned the incompetence of the British military hierarchy and praised the heroism of the Anzacs. Many historians believe it may have triggered the hasty withdrawal of the troops from Anzac Cove and the birth of the Anzac legend.

Other texts, or stray words, come from the Austrian writer Thomas Bernhard, while Stéphane Mallarmé's aphorism 'A throw of the dice will never abolish chance' also makes an appearance. The war memorial had provided Tillers with a list of names of battlefields and war cemeteries in which lie the Australians who died during World War I. Tillers selected a number of them for their significance or evocative power. While most of the texts can be deciphered, there exists no coherent narrative. The words are fragmented and suspended in paint and resonate in the imagination of the viewer.

Although Hodler's *Autumn Evening* is faithfully transcribed in the lower two-thirds of the composition, the top third points to a different source. Here, within the painted evening sky, a swirling black form appears, possibly based on an image of a nebula. It has been transformed into a vortex-shape with associations of extreme weather patterns, such as cyclones and tornadoes, but it may also be a vortex that sucks up life forces from the battlefield. Tillers had painted earlier the lower, Hodler-inspired scene

as a lament for personal loss on nine rows of his canvas tiles and, on receiving the Australian War Memorial commission, added the top four rows and amended some of the texts to make it into a general lament for loss on the battlefields.

While the painting and the tapestry have the same dimensions, they are two related but quite separate creations. For an artist such as Tillers, for whom quotation and appropriation are central to his practice, this further act of appropriation and interpretation as a tapestry provides an additional conceptual dimension. French philosopher Jacques Derrida had long argued that meaning in a text, or for that matter in a painting, is never fixed, and by translating it into a different medium it becomes an act of double translation and creates something new. The highly textured painted surface on Tillers' painting, with its use of low relief and metal paints, is reinterpreted in wool and cotton in a subtly different palette on a flat surface. The strong grid of canvas panels in the painting is less pronounced in the tapestry, so for a viewer without specific knowledge of the original painting the tapestry creates the impression of a subtle patchwork quilt-like pattern of rectangular blocks that slightly fragment the surface.

The tapestry glistens and radiates with a luminosity marking a sombre but serene lament. As Bernhard noted: 'Everyone . . . speaks a language he does not understand, but which now and then is understood by others. That is enough to permit one to exist and at least to be misunderstood.' There is a beautiful ambiguity in the tapestry through which different people will discover different meanings about loss and absence.

Avenue of Remembrance is a poignant yet subtle lament for loss on the battlefields of World War I as well as the loss felt by those at home. This tranquil European road leads into a setting sun, but above is the hint of something menacing and apocalyptic that could, in time, consume all that lies below.

Sasha Grishin AM FAHA

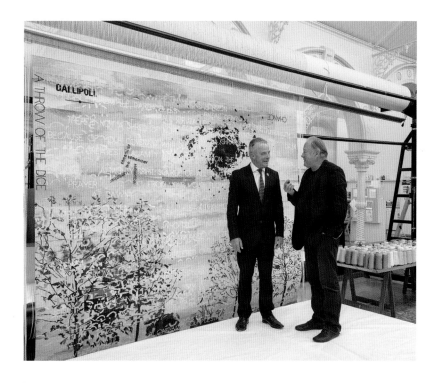

LEFT Dr Geoff Hanbury, Cheryl Thornton, Australian War Memorial Director The Hon Dr Brendan Nelson and Imants Tillers at the cutting off ceremony for the *Avenue of Remembrance* tapestry. **IMAGE BY JEREMY WEIHRAUCH**

RIGHT Australian War Memorial Director The Hon Dr Brendan Nelson and Imants Tillers at the cutting off ceremony for the *Avenue of Remembrance* tapestry. **IMAGE BY JEREMY WEIHRAUCH**

BELOW From left, Laura Russell and Leonie Bessant weaving the *Avenue of Remembrance*.

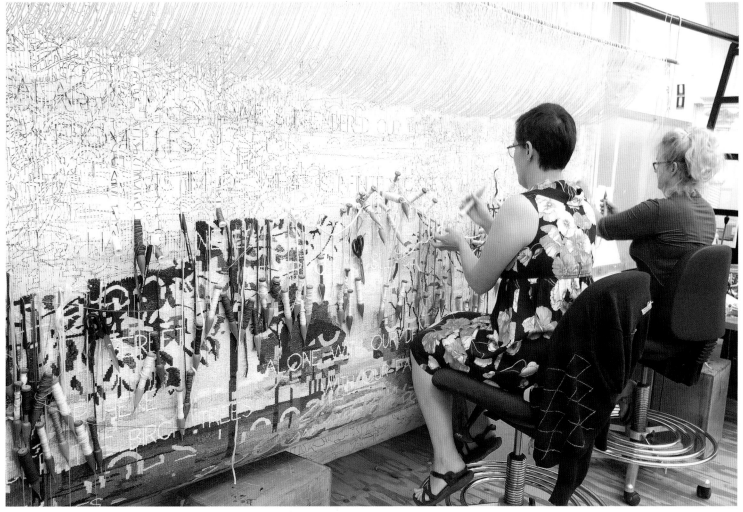

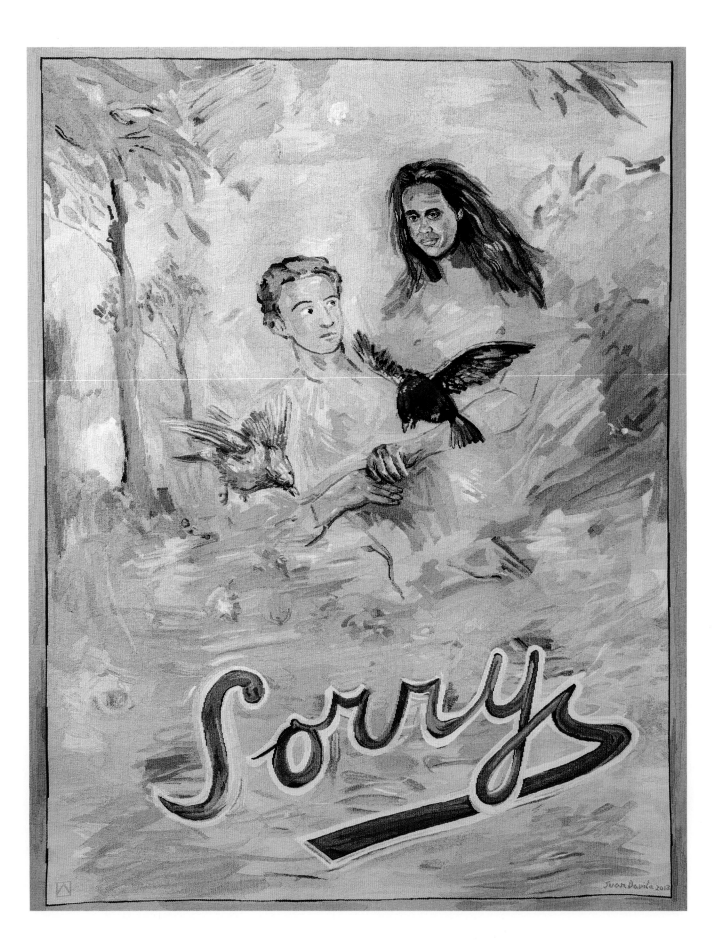

UNAPOLOGETICALLY CONFRONTING THE PAST

Sorry, 2013, Juan Davila, woven by Pamela Joyce, Sue Batten, Milena Paplinska and Cheryl Thornton, wool, cotton, 4.2 x 3.26m. Commissioned by the State Library of Victoria. IMAGE BY JEREMY WEIHRAUCH

Juan Davila's lyrical yet proclamatory tapestry invokes several relevant contexts in which we have understood the language and meaning of 'sorry' in recent Australian politics, especially in the recognition of this country's Indigenous peoples.

Pictorially, the tapestry continues Davila's long-established strategy of dismantling and reordering familiar visual languages, particularly modes of figuration, in new convergences of aesthetics with social and political content. *Sorry* exemplifies Davila's practice of making images loaded with transformative, communicative potential while retaining in them an essential quality of non-prescription and anti-didacticism, and of allusion and enigma.

On 13 February, 2008, prime minister of Australia, Kevin Rudd, commenced the sitting of the 42nd Parliament of the Commonwealth of Australia with the much-anticipated National Apology to Australia's Indigenous peoples. In his assertion that Australia must participate in a 'time in the history of nations when their peoples must become fully reconciled to their past if they are to go forward with confidence to embrace their future', Rudd focused the apology on the mistreatment and suffering of members and families of the Stolen Generations, acknowledging that the policies and laws of previous governments and parliaments pertaining to the status and welfare of Indigenous people had inflicted on them a profound loss of culture, and disconnection from their traditional lands. Above all, the apology was for the 'indignity and degradation thus inflicted on a proud people and a proud culture'.

The imperative of the Rudd government's apology had a point of origin in the *Bringing them Home* report, tabled in federal parliament on 26 May, 1997. This was the result of an inquiry, instigated through the tenacity and perseverance of Indigenous people, undertaken by the Human Rights and Equal Opportunity Commission into the forcible removal of Aboriginal and Torres Strait Islander children from their families and the devastating consequences of this practice, which was Australian government policy until 1969.

One of the report's recommendations was that there should be formal apologies from state and federal parliaments. It also called for the implementation of an annual day of remembrance to reflect on historical injustices and contemporary cultural conditions of Indigenous people. The first National Sorry Day occurred a year after the

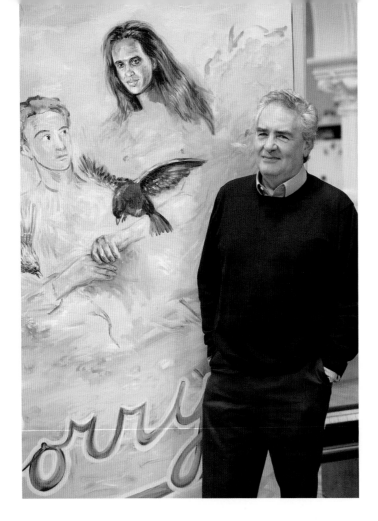

LEFT: Juan Davila with his tapestry. IMAGE BY JOHN GOLLINGS

BELOW: From left, weavers Pamela Joyce and Milena Paplinska use a bright palette for *Sorry*. IMAGE BY JEREMY WEIHRAUCH

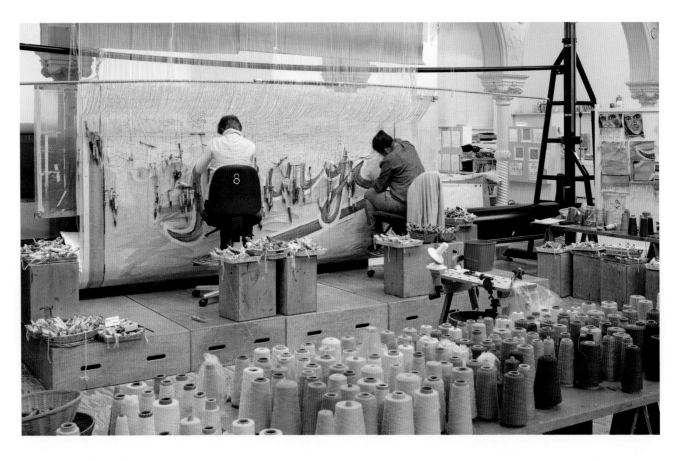

tabling of the report, and is a potent, awareness-raising commemoration of the trauma and complex residual effects of the removal of children and separation of families.

John Howard OM AC, prime minister when *Bringing them Home* was released, declared that he would not apologise on behalf of the Australian people, coupling an implicit anxiety about the scope and scale of potential claims for compensation with an explicit dismissal of what he regarded as 'black armband' politics. What followed was almost a decade of political manoeuvering towards the 2008 apology and its underscoring of the necessity for demonstrable qualitative and quantitative change in our political and cultural engagement with Indigenous peoples, their traditional practices and their prior ownership of Australian lands and waters.

The commissioning of *Sorry* to celebrate the 100th anniversary of the State Library of Victoria's domed reading room was apposite. Davila is one of Australia's most influential and learned painters, whose work during the past 40 years has tested the conceptual and semiotic potential of text as image and image as text, signaling doubt in conventional meaning and promoting in the viewer processes of rethinking and redefining of the status quo. Davila's consistent interrogation of the sociopolitical forces and mechanisms that proscribe and limit cultural and sexual identities has resulted in an often provocative oeuvre that is aesthetically and theoretically rich, and historically and politically complex. He sees the role of artist, and the work of art, as necessary agents of change through its unflinching analysis of the times.

Throughout his career Davila has drawn on a vast fund of subject matter and source imagery, and *Sorry* is part of an expansive and open-ended body of work in which he evaluates aspects of recent Australian history such as Indigenous politics, attitudes towards and the treatment of refugees and asylum-seekers, the dehumanising realities of colonisation and the rhetoric of nationalism (two enduring themes intertwined through much of his work). He also explores post-industrial society's questionable connection to nature and its consumption of landscapes, and the resilience of desire over despair.

Davila's various modes of figuration, deployment of literal signs and metaphorical symbols, his imaging of the marginalised figures of the 'other' of ambiguous gender and race, recur throughout his recent practice to delimit and liberate concepts of identity and to unsettle

authoritarianism. Davila's work opens a generative space of critical inquiry as to what we do, and what we say, to define a sense of self and belonging in time and place.

As a Chilean-born artist who arrived in Australia immediately after Augusto Pinochet's military coup and declaration of dictatorship in 1973, Davila has articulated in his work the human conditions of the oppressed and colonised, and an affinity between Davila's Chilean heritage and the Australian context has enabled him to create a form of history painting of vital contemporary relevance. At times in his career he has been an important critic of the totalising or homogenising power of institutions, and the manner in which identities are, as he told *Art & Design* in 1995, 'constructed by cultural mediators'. This critical position makes the commissioning and placement of *Sorry* in a place of learning very important.

Davila's work since 2000 has moved through a number of conceptual painterly strategies, to the point where certain works during the past five to six years — particularly the extensive *After Images* series — have been devoid of figuration and narrative content altogether, a mode that has directed the eye of the viewer from some of the strident polemics of his work to the primary (and pleasurable) act of painting and the brilliant technical dexterity of Davila's hand and fearlessly liberated imagination.

Sorry is a translation of a painting of the same title, and is characteristic of recent Davila images, in that a collage of abstract and representational forms are unified through sophisticated, indeed beautiful, painting. It depicts two central human figures, a classically drawn Caucasian and a tenderly rendered woman of Indigenous heritage, accompanied by vibrant birds, emerging from a luscious painterly field. Davila intended that the graphic and emotive word 'sorry' be contained in an image of uplifting pictorial energy, one of optimism. Its cursive script recalls the tentative marks we make when learning to write, and suggests the awareness and learning required of all of us to ensure, as he told *Art & Design*, a 'future based on mutual respect, mutual resolve and mutual responsibility'.

Jason Smith

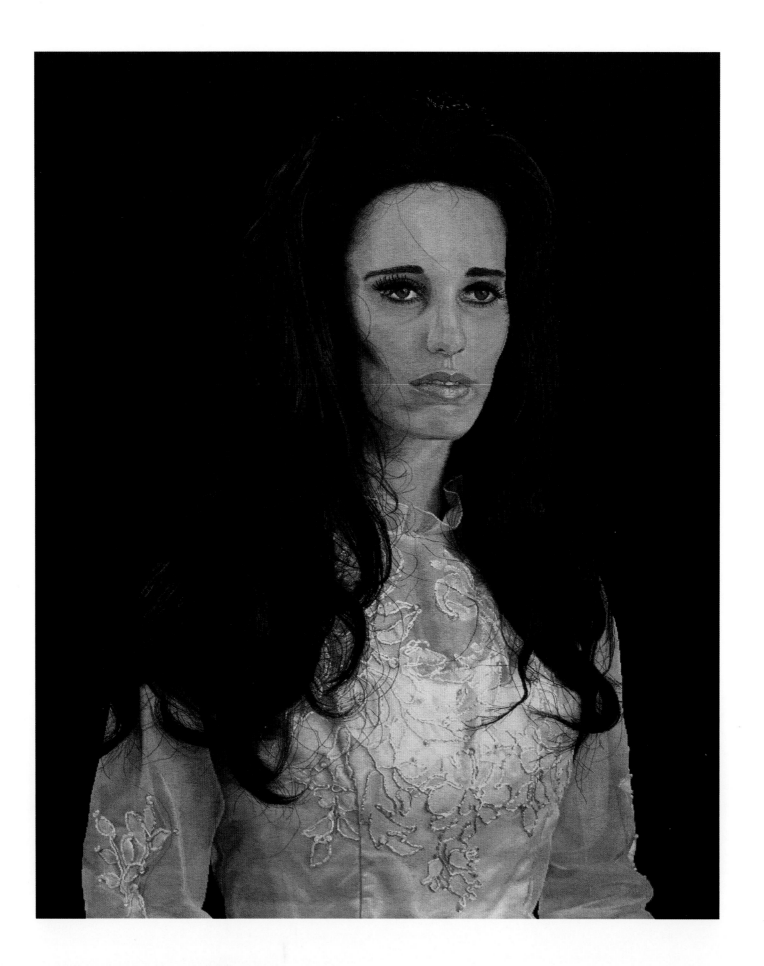

BEAUTY AND DARKNESS IN SUBURBIA

Alice Bayke, 2008, Yvonne Todd, woven by
Sue Batten and Amy Cornall, wool, cotton, 3 x 2.4m.
Commissioned in 2006 with funds from Tim Fairfax
and Gina Fairfax through the Queensland Art Gallery
Foundation. Collection: Queensland Art Gallery.
IMAGE COURTESY OF QAGOMA.

*'If I were forced to burn all my existing photos, except for
only a few, I would keep Alice Bayke.' Yvonne Todd*

Light and dark: from photography's beginnings in the
early 19th century, these have been fundamental to it
and Yvonne Todd takes these central properties seriously.
In her hands light and dark, more than simply bearing
visual information, seem to carry metaphorical freight
that suggests the emergence of being out of unformed
obscurity. What that obscurity might be, precisely, is
where Todd excels: she is a master of mystery.

Born in Aotearoa New Zealand in 1973, Todd is known
for compelling portraits of young women and has been
widely exhibited at home and internationally. In 2002 she
was awarded the Walters Prize, New Zealand's highest
recognition for contemporary art: Harald Szeemann,
celebrated Swiss curator and that year's judge, famously
declared that Todd's work had won because it irritated him
the most.

While Todd's work inhabits the world of contemporary
art, it is, importantly, informed by an apprenticeship in
commercial photography and experience as a wedding
photographer. Todd is at home in popular culture, and
sympathetic to its aspirational imagery: her signature
portraits show solitary young women, typically costumed
in elaborate but slightly hokey apparel, posed against
monochrome backdrops. Crucially, these images are not
parodies: they do not make light of their subjects, nor do
they suggest backstories. Todd's young women are always
dead straight, even sombre.

So far so conventional, one might say. That is exactly
where Todd begins to depart from the norm. Her
punctilious images, despite their solemn subject matter
and uncanny clarity and precision, are a long way from
photographic naturalism. Looking closely, one sees
slight tweaks to the make-up of Todd's sitters, the use of
artificial wigs, even altered facial profiles, assisted by false
teeth: such oddly awkward details always twist Todd's
apparently stock photograph out of true, taking it into
darker territory.

It is precisely this fine, sharp edge between surface
conventionality and subterranean peculiarity that made
Todd's 2002 photograph *Alice Bayke*, one of a series of
five titled *Sea of Tranquility*, such a remarkable choice for
a tapestry. *Alice Bayke* was always the odd one out in a
series purporting to be imaginary portraits of Mormon

pastors' daughters: New Zealand curator Robert Leonard has pointed out that the 'soap-operatic beauty' of Alice Bayke doesn't fit this lineage. Indeed, Todd has confessed that *Alice Bayke* was inspired not by Christian wives but by her fascination with Priscilla Presley, the glamorous ex-wife of the rock legend: 'I was intrigued by the heavy-handed cosmetology of her look. Wigs and false eyelashes and pale lips, her strange, doll-like appearance. I was also occupied with repressed emotions, deflation, piety and stoicism, vigilance and austerity.' Heavy baggage, and strangely compelling.

The monumental *Alice Bayke* tapestry was woven in 2008 by Sue Batten and Amy Cornall from the original large photograph. It is a transliteration into a far grander but equally disturbing work, commissioned by the Queensland Art Gallery to mark its long engagement with artists from the Pacific. (The gallery holds other works by Todd.) This institutional destination was crucial in deciding the scale of the work: at 3m high, the enormous face of Alice Bayke looms above gallery visitors, and the 2.3m width of the work encompasses their bodies. This is unsettling: the close-up of the young woman's face is depicted at a size greater than those traditionally used for heroes or gods in the European tradition. Alice Bayke is clearly a being whose like we have not met before.

This alien appearance is compounded by a number of compositional devices in Todd's original photograph. The sitter's gaze is averted: she looks steadily out of frame to the right, in the traditional pose dictated by right-handed portrait painting. Yet there is no evidence of illumination falling on her face from that direction. The light in the sitter's face seems to come from within, an effect intensified by the flat background: this bridal vision is set into an inky blackness inappropriate for a celebratory wedding portrait. This background connects physically to the sitter through her long plentiful 'big international' hair, but it is in striking contrast with the translucency of her sleeves and the delicate embroidery on her dress.

These sumptuous effects are heightened in the tapestry: Batten and Cornall used a surprisingly wide range of colours for Alice Bayke's flesh, giving it warmth and depth. They included green, for instance, and many delicate colours were especially dyed in cotton for the tapestry, while cotton threads were used for the white dress, as cotton is much more light-reflective than the black wool background. The transliteration of the original photograph required several further adaptations of the image: perhaps the most notable are several silver strands in the hair, in order to mark it out from the background.

Importantly, Batten and Cornall employed large, robust tapestry stiches to emphasise the differences between the tapestry and the original photograph, especially given the tapestry's great size. As curator Ruth McDougall has noted, the beauty and horror implicit in Todd's work is heightened in the tapestry 'through the struggle between the sense of the instantaneous photographic "real" and the laboriously constructed nature of its textile translation.' Todd understood this: 'I also knew the end result was not going to look like the photograph in the sense that it would be an exaggerated representation of the image onto the medium.'

Batten said that weaving *Alice Bayke* was 'a leap of faith'. For her part, Todd enjoyed the arduous process of the weaving: 'The fact that it was such an unusual project appealed to me. So did the slow pace and meticulousness, the obsessive nature of tapestry weaving — the fact that there are hundreds of cottons in that tapestry, which could almost be a black-and-white photograph, and that it took nine months to make.'

Alice Bayke is a favourite of Todd's, 'a spooky object'. Art and film in Aotearoa New Zealand are regularly described as 'gothic', referring to the country's postcolonial trauma as much as its dark forests and remarkable geomorphology. Yet Todd's 'suburban gothic' *Alice Bayke* is set in present-day consumer culture, and would be recognisable anywhere in the world. What is odd about *Alice Bayke*, however, is the long transit from Auckland's suburban wedding studio to a grand art museum, through Melbourne's tapestry workshop: that is truly uncanny.

Julie Ewington

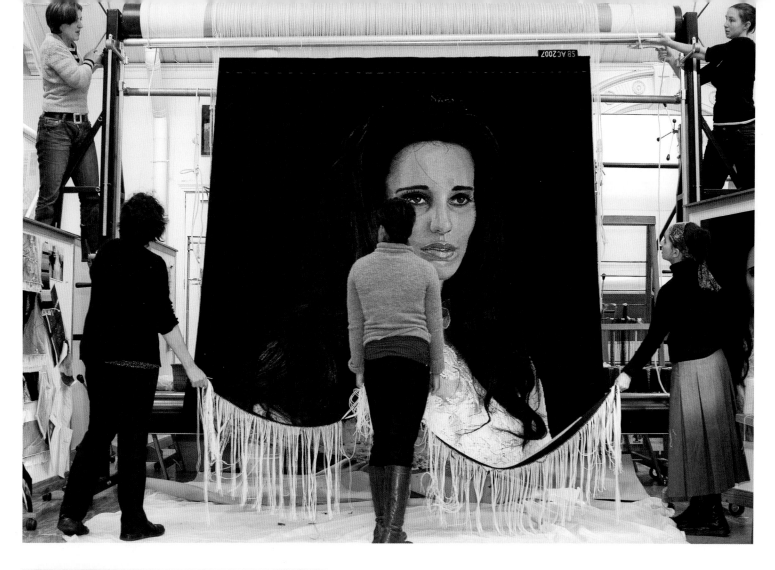

ABOVE From left, weavers Pamela Joyce, Sue Batten, Mala Anthony, Louise King and Amy Cornall at the cutting off ceremony for *Alice Bayke*. IMAGE BY VIKI PETHERBRIDGE

LEFT *Alice Bayke* partially revealed. IMAGE BY VIKI PETHERBRIDGE

BELOW The tapestry on show during *Unnerved: The New Zealand Project*, at the Queensland Art Gallery and Gallery of Modern Art, 2008. IMAGE BY NATASHA HARTH, COURTESY OF QAGOMA

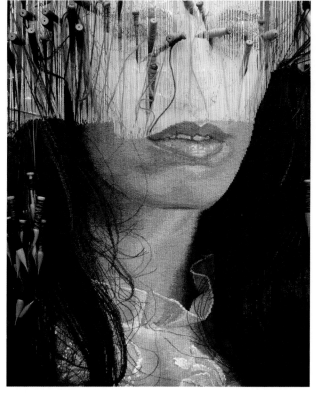

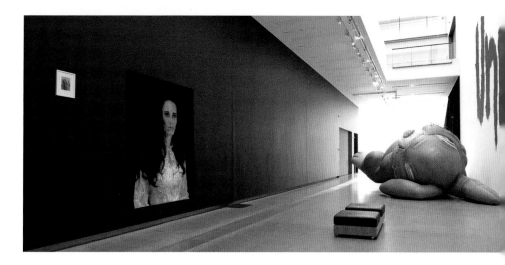

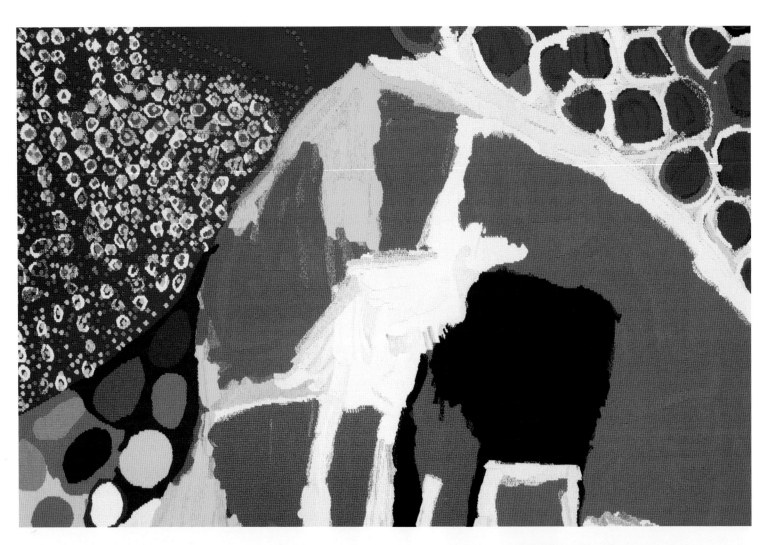

Detail of *Dulka Warngiid (Land of All)*, 2007,
Mirdidingkingathi Juwarnda Sally Gabori,
Rayarriwarrtharrbayingathi Mingungurra Amy Loogatha,
Birmuyingathi Maali Netta Loogatha, Thunduyingathi
Bijarrb May Moodoonuthi, Wirrngajingathi Bijarrb
Kurdalalngk Dawn Narranatjil, Kuruwarriyingathi Bijarrb
Paula Paul and Warthadangathi Bijarrba Ethel Thomas,
woven by Cheryl Thornton, Amy Cornall and Rebecca
Moulton, wool, cotton, 1.99 x 6.1m. Commissioned by
the Hugh Williamson Foundation and Dame Elizabeth
Murdoch. **IMAGE BY JOHN GOLLINGS**

NEW ART FROM AN ANCIENT CULTURE

Dulka Warngiid is a cultural tour de force, a defining work for the Kaiadilt senior female artists from Bentinck Island in the Gulf of Carpentaria. The seven women who collaborated on the original painting were among the last Aboriginal people from coastal Australia born beyond the settler-colonial frontier. Some had no real contact with Europeans until their 20s and all spent their early years living traditionally on their island, working with and depending on the sea for sustenance.

In 1960, ethnographer Norman Tindale AO led an expedition to Bentinck Island, taking many senior Kaiadilt people back to the islands for the first time since they had been persuaded to move to the mission on nearby Mornington Island in 1948. He recorded many place names and produced an intricately detailed map. Looking to title his work, Tindale asked the Kaiadilt men the island's name, to which they replied, 'Dulka warngiid', which Kaiadilt linguist Nicholas Evans explains as follows:

> Dulka warngiid *allows many translations into English.* Dulka *can mean place, earth, ground, country and land;* warngiid *can mean one, but also 'the same', 'common', 'in common' and 'only'. Because Bentinck Island and its small surrounding islands were the whole world for the Kaiadilt people, they did not need a word for Bentinck Island itself, since in actual conversation what was always more important were the specific places whose names rub shoulders every few hundred metres. So when ethnographer Norman Tindale sought a translation for the European name Bentinck Island, to place on his epic 1962 map, he was given the name* dulka warngiid*, which he translated as 'land of all', and it stuck. But it can equally well be translated as 'the one place', or 'the whole world'.*

In 2005, at the age of about 81, Mirdidingkingathi Juwarnda Sally Gabori was invited to attend a painting workshop at the art centre on Mornington Island. A shy senior Kaiadilt woman, Gabori had never attempted to paint before, but was a well-known weaver and maker of very fine traditional string. In fact, the sole recorded occasion of Kaiadilt people engaging with art-like materials was through a group of pencil and crayon drawings made by senior men, including her brothers and brothers-in-law, at the request of Tindale in 1960.

Without an art history or tradition to adhere to, Gabori found an entirely new way to express the things she had seen and learnt over a remarkable life. Her tentative early

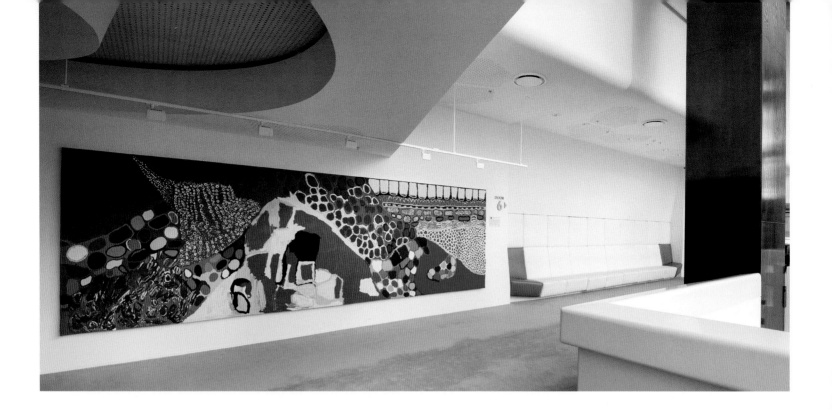

ABOVE *Dulka Warngiid (Land of All)* at home in the Melbourne Recital Centre. **IMAGE BY JOHN GOLLINGS**

BELOW LEFT Weaver Rebecca Moulton and artists Warthadangathi Bijarrba Ethel Thomas and Birmuyingathi Maali Netta Loogatha discuss yarn colours for *Dulka Warngiid (Land of All)*.

BELOW Samples for *Dulka Warngiid (Land of All)*. **IMAGE BY VIKI PETHERBRIDGE**

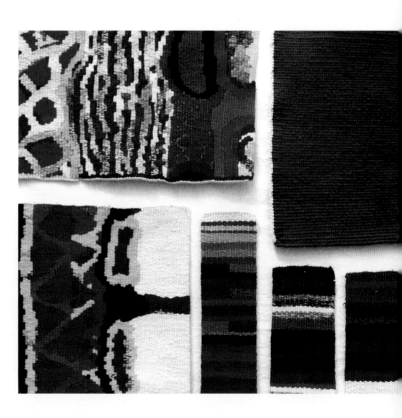

works quickly gave way to free, expressive and gestural paintings that radiated with a confidence borne of the fearlessness of an extraordinary existence and absolute authority. Her family, who had been on Bentinck Island during the dry season, were shown an early work of hers upon their pre-wet season return to Gununa, their settlement on Mornington Island. The women were surprised and proud of the work of their matriarch and they rallied behind Gabori, creating a space within the art centre — formerly the domain of local Lardil artists — for a new expression of Kaiadilt culture, Kaiadilt art, to flourish.

The fact that no prior tradition existed allowed each Kaiadilt artist to invent their own style of painting, and the women developed different styles and modes: Paula Paul's delicate rows of circular forms reflected *dirrbanda*, the arrangements of shells made in the sand before cooking, May Modoonuthi's coarse, textural representations of *burrkunda*, women's ceremonial body scars, Dawn Naranatjil's raw compositions of eruptions of schools of fish feeding at the water's surface, Ethel Thomas's depictions of rocks, both rocky sites around the island and objects used in love ritual, Amy Loogatha's focus on the expanses of red, yellow and white mottled laterite landscapes around the island, and Netta Loogatha's vibrant bristle-dotted landscapes and reefscapes, joined Gabori's intense focus on sites of personal and familial significance.

Working every day at the Mornington Island Arts & Craft Centre, this group of incredible women soon built up a strong body of work and an exhibition dubbed *The Bentinck Project* was held at Brisbane's Woolloongabba Art Gallery in 2006. Three monumental 6m paintings were created collaboratively by the seven women, each focusing on important places in their Kaiadilt country: *Dulka Warngiid*, mapping Bentinck Island; *Sweers Island*, the second largest of the islands of their Kaiadilt country; and *Makarrki, King Alfred's Country*, mapping the place and memorialising the life of King Alfred, a key figure in all of the artists' lives.

With so many idiosyncratic styles and individual modes of mark-making, in unerringly bold and vibrant palettes, there was the potential for their collaborative paintings to become an unruly visual clash. Yet the women approached the works with the same sense of community that has seen them live, grow, speak, sing and perform ceremony together throughout their lives. Through constant conversation, every aspect of the work was negotiated, executed and celebrated as part of a collaborative Kaiadilt community.

Dulka Warngiid maps Bentinck Island, through the artists' *dulkiiwatha*, the places they were born at and have birthrights over and responsibilities for. In Kaiadilt society every person born on their country had a place-based name, the suffix *-ngathi* combined with the name of one's birthplace gives a Kaiadilt person their first name. For Gabori, for instance, her name Mirdidingkingathi Juwarnda evidences that she was born at Mirdidingki, by a small creek on the southeast coast of the island and her totem is the dolphin. Birmuyingathi Maali Netta Loogatha was born at the tallest sandhill in the northeast of the island and her totem is the freshwater turtle. Warthadangathi Bijarrba Ethel Thomas was born at the northeast tip of the island and her totem is the dugong. Thunduyingathi Bijarrb May Moodoonuthi was born on the area flanking the Thundi (Thunduyi) River in the northeast of the island and her totem is also the dugong. Rayarriwarrtharrbayingathi Mingungurra Amy Loogatha was born at Raft Point, near Nyinyilki in the southeast of Bentinck Island and her totem is the woppa fish. Kuruwarriyingathi Bijarrb Paula Paul was born at a place along the long sandy coast in the southeast of the island and her totem is the dugong. Wirrngajingathi Bijarrb Kurdalalngk Dawn Naranatjil was born at the centre of the southern coast of the island, near the large central river, Kombali, and her totems are the long-tailed black stingray and dugong.

The translation of *Dulka Warngiid* from paint to tapestry by Rebecca Moulton, Amy Cornall and Cheryl Thornton has captured the vibrant energy that epitomises this group of extraordinary artists and continues the remarkable story of this new Kaiadilt visual language, Kaiadilt art, now spoken in many more languages and media than was dreamt possible just a decade ago.

Bruce McLean

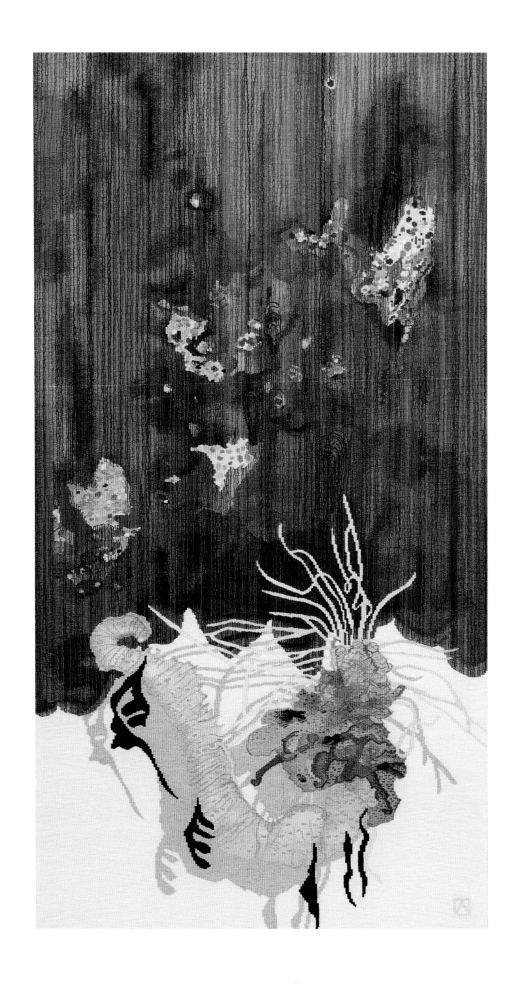

BALANCED DUALITIES

Textiles travel. Of all of the many products of the British empire, textiles were perhaps the most portable, and certainly among the most contested during the centuries: I am thinking here of Indian cottons and then English Manchester and finally Ghandi's homespun cotton, as these fabrics traced the rise and fall of great commercial and colonial enterprises across centuries. Tapestry sits aside from these histories of textile mass production, but tapestry weavers in today's Commonwealth of Nations continue to share many interests that have sprung from this long history and its complex cultural inheritances.

In 2014, Melbourne-based artist Sangeeta Sandrasegar designed *Everything has Two Witnesses, One on Earth and One in the Sky* for the ATW; it was destined for an exhibition that year in Scotland, part of an exchange between the workshop in Melbourne and Edinburgh's celebrated Dovecot Tapestry Studio, originally established in 1912 and recently revived in new premises. The two workshops, at either end of the old empire and with very different histories, nevertheless share a strong commitment to collaborating with contemporary artists and to pushing across disciplinary boundaries.

Sandrasegar was a fine choice for the project: trained in Melbourne and London, she has long been immersed in the politics and imagery of cultural exchange, and she wholeheartedly embraces new materials and methods as an intrinsic part of her process. A scissor-wielding shape-shifter who originally worked with paper cut-outs, Sandrasegar has worked with forms as various as soft fabric sculptures (2007), films (2012 and 2014), and bronze sculpture cast from eucalypt trees found everywhere in India (2012). She turned to tapestry with her customary energy.

For the Edinburgh project, Sandrasegar focused on the devastating environmental pollution seen everywhere today in the world's seas, as a pressing issue shared by these distant cities — Melbourne and Edinburgh — that speaks to their long history of interaction through maritime transport. The ocean was the original medium of connectivity in the time of empire, and now, in the period of the postwar Commonwealth, it signals the importance of sharing responsibility for a global sustainable future. As the artist noted, 'So when I begin to think about our common wealth into the future — I think about the seas and oceans that bind us — that bring us to each other.' This 'common wealth', in two words as Sandrasegar has it, is shared, and thus must be protected by concerted collective action.

Everything has Two Witnesses, One on Earth and One in the Sky, 2014, Sangeeta Sandrasegar, woven by Sue Batten, wool, cotton, 1.64m x 0.89m. IMAGE BY JEREMY WEIHRAUCH

In this mix of commonwealth locations and histories, a third intermediary postcolonial site informed Sandrasegar's design: her original home in Malaysia and its tropical fruit plantations. The watercolour series *Fruits of Her Labour*, 2013, was inspired by returning to Malaysia 25 years after she had left, and wandering through fruit plantations said to be haunted by the Pontianak, the ghost woman of her childhood. In these delicate watercolours, a rich variety of coloured fruits sit over a fine field of black lines, and this sense of differently vibrant life, seen against a ghostly background, was borrowed for the tapestry. It made sense: as Sandrasegar remarked of the tapestry, 'The design was created upon the concepts of multiple identities emerging out of a colonial and Indigenous past and what a future commonwealth should examine for these countries.'

The finished tapestry is extraordinary, giving full rein to Sandrasegar's lyrical sensibility. In a vertical slice down through the ocean, the long black upper section depicts oil on the ocean's surface, punctuated by scatterings of colourful but deadly microplastics, which are so dispersed across the tapestry as to evoke the map of the Commonwealth nations. But oil and plastics threaten to overcome marine life, and the black shifting sea is textured, like Sandrasegar's watercolours, to evoke the effect of oil on water.

This was achieved through the use of soumak weaving, a weft-hitching technique originally from the Caucasus region — from the Turkish Anatolian coast, Iran, and as far east as Afghanistan — that brings additional strength but also a complex embroidery-like surface to the tapestry.

For weaver Sue Batten, the soumak technique was perfect for rendering the fine lines in Sandrasegar's original watercolour, and she spoke of 'capturing the spirit of the artist's work'. Sandrasegar was equally enthusiastic: as Batten was weaving, the artist wrote on her blog, 'I am so excited about the soumak weave across the tapestry to capture the line-work in the painted section, plus the evocative translation of the watercolour process itself — the sense of bleeding and spread intrinsic to watercolour interpreted into the material of tapestry . . .'

Remarkably enough, *Everything has Two Witnesses, One on Earth and One in the Sky*, which is woven in wools, nevertheless brilliantly suggests the translucency of water. The distinction between the threatening black oily spills above, and the vivid flourishing sea-life below the surface of the ocean, could not be starker, however. At first glance, the polluting oil threatens to overwhelm the gorgeous warm palette seen in the submarine environment. Yet below, in the depths of the ocean, hope is at hand: the exquisite pale oranges, yellows and pinks reveal thriving life forms, and most importantly the presence of sea worms, seen here in the form of the extraordinary large orange worm casting its own haunting shadow. As recent important research conducted across the Commonwealth indicates, these worms are important indicators of the health of a marine environment: rather like earthworms in the soil, some marine worms can act to help manage oil spills naturally.

Finally, the title of this tapestry speaks to the complex of dualities embodied in the work: darkness and vivid colour; ecological threat and natural vigour; potential disaster and hope for the future. Sandrasegar found the idea in statements made by Australian Aboriginal people in 1993, but in fact it has a long history in the political philosophies of the world's Indigenous people. Here, this beautiful phrase summons everyone, whether they come from an Indigenous or settler heritage, to the urgent cause of the collective care of the universe.

Julie Ewington

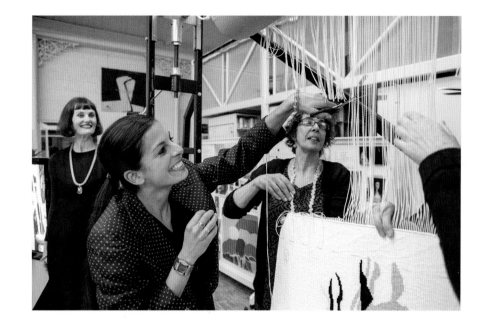

RIGHT From left, ATW director Antonia Syme, Sangeeta Sandrasegar and head weaver Sue Batten at the cutting off ceremony.
IMAGE BY JEREMY WEIHRAUCH

BELOW The tapestry in progress, festooned with bobbins. The tapestry was woven upside-down to allow a more refined application of soumak.

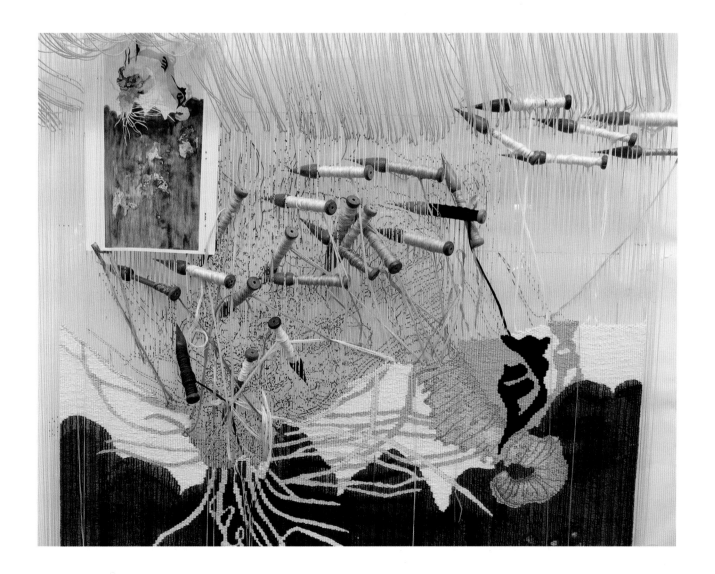

Finding Kenneth Myer, 2011, John Young,
woven by Cheryl Thornton, John Dicks and
Milena Paplinska, wool, cotton, 2.3 x 3.02m.
Commissioned by the Myer family for the
National Library of Australia, Canberra.
IMAGE BY VIKI PETHERBRIDGE

VISIONARY PHILANTHROPIST

In 1995 John Young commenced an ongoing project creating a successive series of paintings known collectively as *Double Ground Paintings*. In them, a general pictorial structure for individual works incorporates a digital scan of an historical or culturally specific image, or abstract field, over which are painted a number of dispersed or abutting photographically sourced images and vignettes.

The works are also collaboratively produced by the artist working in close dialogue with technicians and studio assistants who themselves are artists. The final painting is a cohesive, balanced whole in which the disparate images propose speculative, open-ended narratives, and certain integral relations between seemingly incongruous significations — landscapes, bodies, still-life subjects — drawn from the vast reserves of art history and the everyday. Carolyn Barnes, in 'Towards a layered imaginary', in *John Young*, by Barnes, William Wright and Young (Craftsman House Thames & Hudson, 2005), notes that 'despite their heterogeneous sources, the *Double Ground Paintings* are not empty arrangements of things. Their complex constellations of cultural materials challenge the viewer to recognise different narratives of culture and history.'

In a statement on his website Young describes that the process in the *Double Ground Paintings* is to work them 'from all four sides. The structure aims to make you feel as if the images in the foreground and the background have belonged together all the while — a sort of necessary dependency.' It is this format in which Young designed *Finding Kenneth Myer* as a way of encapsulating in one tapestry the many intertwining threads of Myer's personal and public passions, and his exceptional lifelong commitment to Australian society and culture.

The art of Young and the life — the 'many lives' — of Myer could each be described as a meandering line exercising the mind. Meandering, however, is not to imply a lack of focus, but rather two distinctly inquisitive and scholarly minds aware of the profound value of knowledge, and by extension the intellectual and spiritual role, and the social responsibility, of the arts and sciences. Young is, and Myer was, polymathic, and it is the character of the polymath to not only be learned in numerous diverse subject areas, but to be highly attuned and sensitive to the world they inhabit.

ABOVE The tapestry on the loom.

LEFT John Young, second from left, considers progress on the tapestry with Antonia Syme and weavers Cheryl Thornton and John Dicks.

As he told *Art & Australia* in 2011, Young sees a role for art in linking the present to 'a world of forgotten stories, discarded objects, and memories. Making art not only means to recollect stories, but to reawaken an intrinsic ethical impulse in the present.'

John Young Zerunge was born in Hong Kong in 1956 to a politically and culturally progressive family, and emigrated to Australia in 1967. Prior to commencing studies in painting and sculpture at the Sydney College of the Arts in 1978 (where an early influence was Imants Tillers), he read the philosophy of science and aesthetics in the department of general philosophy at the University of Sydney in 1977.

As much as philosophy, aesthetics and the theoretical underpinning of an 'active' art have underpinned Young's art since he began exhibiting in 1979, his practice has also mined the biographical, sociopolitical and artistic conditions of his biculturalism: his Chinese heritage, his Australian context. He has been central to our understanding of transcultural art, and his work conspicuously activates the productive concepts and realities of an unfixed, multi-perspectival identity.

What made Young so appropriate a choice to design *Finding Kenneth Myer* is the humanist impulse that asserts the ethical and elucidating foundation of his art. Myer, too, was driven by a humanist spirit focused on the value of a progressive culture through material and moral support for education, innovation and leadership. It is apt that this tapestry is displayed in the National Library of Australia, for Myer was appointed in 1960 by prime minister Sir Robert Menzies to the library's interim council. He was also a founding member of the library's statutory council from 1961, and was chairman of the council from 1974 to1982.

This tapestry was commissioned in 2010 through the agency of siblings Neilma Gantner, Baillieu Myer AC and Lady Southey AC and other members of the Myer family, to commemorate the life and achievements of their brother Kenneth Myer AC DSC, most particularly his work and contribution as a philanthropist for the arts, science and humanities. Kenneth Myer, along with his siblings, established the Sidney Myer Music Bowl in 1959, in honour of their father Sidney Myer OBE, who together with his wife Dame Merlyn Myer DBE, instilled in all of their children the value and necessity of dedicated philanthropy and commitment to social change.

In addition to his founding work with the National Library of Australia, Kenneth Myer also made significant financial and time-based contributions to institutions including the Victorian Arts Centre, the Howard Florey Laboratories of Experimental Physiology and Medicine, the School of Oriental Studies at the University of Melbourne, and the Division of Plant Industry of the CSIRO. He assisted in the development of the Asian art collection of the Art Gallery of New South Wales, and had a long-term engagement with Japan, especially through his second marriage to Yasuko, with whom he died in an accident in 1992.

The tapestry comprises 11 distinct parts and numerous pertinent words and phrases that reflect aspects of Myer's life. The central composite portrait depicts Myer at three crucial ages: the 13-year-old schoolboy at the time of his father's death and his elevation to the head of the family; the naval officer whose love of adventure and the aesthetics of other cultures shaped an inquisitive mind; and the elder philanthropist and statesman. Various leitmotifs make up the whole: images of eucalypts, cotton flowers and camellias, reflecting Myer's love of nature, gardens, and his work with the CSIRO, an 18th-century Japanese scroll and a lyrical Japanese landscape.

When asked by Yasmin Nguyen of *Vault* in 2013 to summarise one priority of his work as an artist, Young has asserted that it is 'the condition of our vision, in relation with our consciousness and time, which has always been foremost . . . maybe it's also good to constantly reinvent your expectations, and ask, as an artist, "What social condition am I in, and what then is my position and capability of helping or clarifying?"'

Myer asked himself similar questions, and in this tapestry we are able to find those passions and the projects that defined so visionary a man.

Jason Smith

LOVE AND HARMONY

Black, ironically, is the key to Nell's two vibrant works made with the ATW. The flat black background of the tapestries is much more than a straightforward graphic field highlighting simple forms and radiant colours: Nell's black is the primal empty field out of which the glory of creation in all its forms emerges, and against which this exuberant life must be understood.

Just 30 when the first piece, *Let Me Put My Love into You*, 2006, was commissioned, Nell is an energetic artist who explores a wide range of materials and processes. Yet her adventures across media always pursue core interests: as she remarked in 2010, 'Some artists ask different questions using one media; I ask the same question using different materials.'

Playful and passionate, Nell addresses large questions of existence through contemporary vernaculars, which are nevertheless surprisingly attentive to historical archetypes and references. Let's take Nell's black, with its popular, high cultural and spiritual connotations. Her blacks are delightfully demonic, the badge of rocker pride: the title of the 2006 tapestry comes from the AC/DC song 'Let Me Put My Love into You', from the *Back in Black* album released in 1980 — a great enthusiast of rock, including heavy metal, Nell takes many of her titles from rock songs.

Set against that tough, perfect black is Nell's trademark smiley face. Interviewed by her friend and fellow artist Lionel Bawden in *Yoke* magazine in 2014, she said, 'Everything has a face and everything is happy! There is a part of my practice devoted to keeping things preposterously simple and almost childlike.'

The smiley face, recalling cartoon characters and more recently emojis, is a constant in Nell's work. It's a down-to-earth cipher for the principle of constant joy that informs her life and art, but it's also deadly serious. Like a comedy mask in classical Greek theatre, this eternally cheerful front suggests purposeful commitment to joyfulness that recognises, nevertheless, the pain underlying daily existence. The smiley face appeared on a granite tombstone for the 2006 sculpture *Happy Ending*, was a happy cloud in a 2012 neon and, in its most recent outing in *The Wake 2014–16*, at the Adelaide Biennial of Australian Art at the Art Gallery of South Australia in early 2016, was a magnificent constellation of three-dimensional characters in materials ranging from clay to glass to papier-mâché to a traditional Vietnamese conical straw hat.

TOP *Let Me Put My Love into You,* 2006, Nell, woven by Sue Batten, John Dicks and Pamela Joyce, wool, cotton, 1.61 x 3m. Commissioned by Deutsche Bank, Sydney. **IMAGE BY VIKI PETHERBRIDGE**

BOTTOM *Birds and Leaves and We Ourselves Come Forth in Perfect Harmony,* 2010, Nell, woven by John Dicks and Sue Batten, wool, cotton, 1 x 2m. Private Collection. **IMAGE BY VIKI PETHERBRIDGE**

In the two tapestries the smiley face shows its versatility again. In *Let Me Put My Love into You,* all the protagonists smile: the serpent pregnant with eggs and the promise of new life, the red apple of the knowledge of good and evil, the tiny worm that the serpent spits into the unsuspecting fruit. The trinity of grins adds up to an ouroboros, the ancient motif of the serpent eating its own tail in perpetual life, or eternal return, a fine, self-reflexive image for a bank office, evidently one with a robust sense of humour. This is a deliciously provocative set of themes for its eventual home, a financial institution: temptation, eggs (the nest eggs of providential savers, even of those who put 'all one's eggs into one basket'); and what about insemination as a form of investment? It's cheeky, amusing.

Both Nell's ATW tapestries are attentive to their architectural and social settings. *Let Me Put My Love into You* was commissioned by Deutsche Bank for its award-winning new offices in central Sydney designed by architects Bligh Voller Nield and completed in 2006. The citation for the Australian Institute of Architects' Award for Interior Architecture that year notes how lively colours in the artwork commissions, such as Nell's tapestry, contributed to the overall impact of the premises.

Seen close up, the colours are glorious, sumptuous, modulated: the delicious red of the apple was developed by Sue Batten and the workshop's yarn dyer for the project, although Nell used the same rich red for the innocent birds in the second tapestry. Moreover, while she was designing the Deutsche Bank tapestry, Nell visited tapestry workshops and collections in Paris, and the powerful modeling of form achieved by great European weavers inspired the dazzling figures appearing out of the black background in her works. Back in Australia, she visited weavers Batten, John Dicks and Pamela Joyce in Melbourne to work up the crucial colour palette with them.

Nell's second, slightly smaller tapestry, *Birds and Leaves and We Ourselves Come Forth in Perfect Harmony*, 2010, was woven for a particular location in the home of a private client who had seen the Deutsche Bank work. After visiting the house, and seeing trees in the garden overlooked by the dining room, Nell designed the tapestry for a wall near doors to the garden; in situ, the birds in the tapestry appear to fly out into the world. This setting of image into architecture is a charming artistic conceit, but more than that, it marks a commitment to a sense of domestic peace and love.

Nell's Zen Buddhist practice of daily meditation is the key here: she first took Chan (Zen) Buddhist vows in China in 2005, again in Sydney in 2006. The title *Birds and Leaves and We Ourselves Come Forth in Perfect Harmony* is adapted from a longer form of the Zen evening dedication: 'Infinite realms of light and dark convey the Buddha mind; birds and trees and stars and we ourselves come forth in perfect harmony.' That helps account for the lovely nurturing darkness in Nell's design, out of which light, and rebirth, and life, will come: 'The flat black gives depth to the background' says Dicks, 'creating an infinity in which the image floats, vibrant and life enhancing . . . in keeping with Nell's conception'. (Remarkably, the Buddhist name that Nell was given is One Colour, which may perhaps be black, defined as the combination of all other colours.)

At the same time, as in the previous tapestry, Batten and Dicks used metallic threads and cottons to give sparkling life and light to the birds and the smiley maple leaf character, who bears witness to the cyclical passing of the seasons with her glorious changing colours.

Nell's deceptively simple tapestry designs point to another core Buddhist principle, which has also been applied in economics and technology: the spirit of appropriateness. I am struck by the perfect fit between the subjects of the tapestries and their very different corporate and private settings, and how Nell has taken only several pertinent images, in each case, from her rich lexicon of eggs, serpents, meditating women, texts, pearls and insects. When it comes right down to it, birth and death and continuity are simple, irrefutable and to be treasured.

Julie Ewington

RIGHT Samples for *Birds and Leaves and We Ourselves Come Forth in Perfect Harmony*. **IMAGE BY VIKI PETHERBRIDGE**

BELOW From left, Sue Batten, Nell and John Dicks at the cutting off ceremony for *Birds and Leaves and We Ourselves Come Forth in Perfect Harmony*. **IMAGE BY VIKI PETHERBRIDGE**

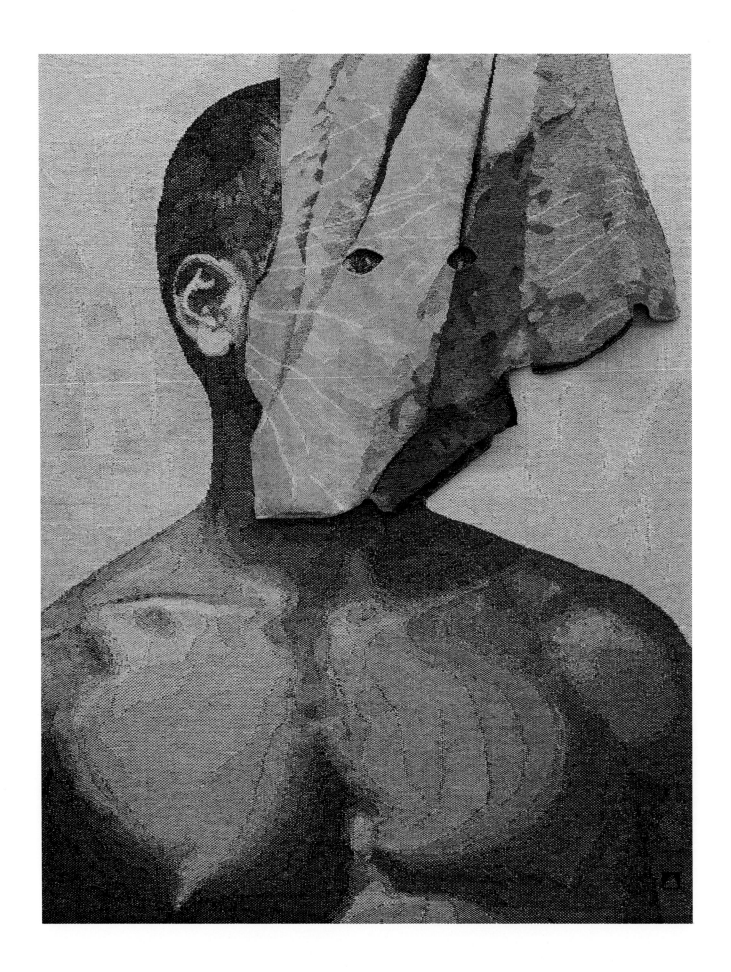

A SCRUPULOUS WEAVE

Among the many uncertainties of European contact with the Indigenous other was the aesthetic appeal of the muscular male body. There is much archival material that shows Aboriginal men were in exceedingly good shape. Their lithe and athletic physiques were most likely the outcome of good diet and vigorous exercise.

Brook Andrew keeps a collection of archival material, a beautiful example of which he used as the visual source for this monumental tapestry. The unknown model in the original photograph is heavily muscled, possibly developed through European weight-training as much as bush practice. He sports a Victorian moustache and may have taken his shirt off for the photograph, revealing himself to the lens as 'an admirable specimen'. His powerful pectorals and deltoids suggest white muscle (increased by the ripping action of heavy strain) rather than red muscle (the dense and stringy kind that you might see on the riders in the Tour de France), which was more aligned with the traditional Australian bush physique.

Archival material is often hard to interpret; but I fancy that the image — right from its gestation in the physical training of the model — was produced as spectacle. In many photographic studios it was not uncommon to stage a simulacrum of Aboriginal existence using Aboriginal models, props and scenic backdrops. Andrew's tapestry extrapolates every aspect of this complicated relationship that the viewer has with the impressive indigenous model.

In being the voyeur of the handsome gentleman, we might experience a scruple. Whatever this man's condition, should we derive visual pleasure from the spectacle of his nudity? Are we still exploiting an uncomfortable power relation from the 19th century and taking advantage of his status of subjection for aesthetic relish? It could be that the thought of extending this undignified destiny of the image gave the artist a scruple. Perhaps it is the reason for the unusual second skin in the tapestry. Falling over the model's head is a veil, which will remain to be explained long after we have advanced our theories. This tapestry upon a tapestry would continue to be enigmatic even if the artist told us why he wanted it there.

Within muscle, there is already a kind of inbuilt scruple, which takes us deeply into European attitudes to the corporeal. Muscles are seldom discussed in canonical poetic literature. In art, however, muscles are of maximum interest, not just as a metaphor for strength but at the core of the science of drawing. But it is left to lyric

Catching Breath, 2014, Brook Andrew, woven by Chris Cochius, Pamela Joyce and Milena Paplinska, wool, cotton, Lurex, 1.9 x 1.5m. Commissioned by the Tapestry Foundation of Australia and the Department of Foreign Affairs and Trade. Present location the Australian high commission Singapore.
IMAGE BY JEREMY WEIHRAUCH

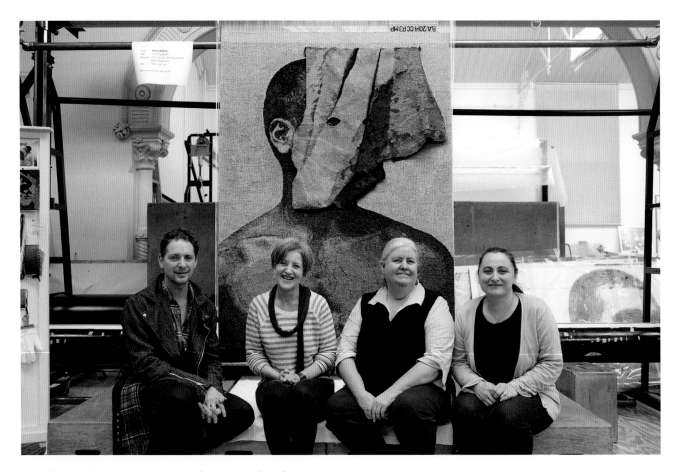

ABOVE From left, Brook Andrew and weavers Pamela Joyce, Chris Cochius and Milena Paplinska. **IMAGE BY JEREMY WEIHRAUCH**

BELOW Brook Andrew lifts the veil on *Catching Breath*. **IMAGE BY JEREMY WEIHRAUCH**

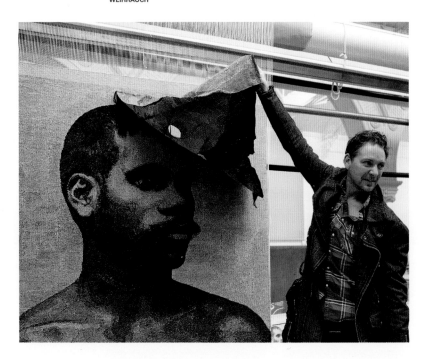

and epic poetry to identify the literal and metaphorical scruple in muscle, as when the 17th-century Italian poet Giambattista Marino speaks apologetically through the figure of Pan, the randy goat-like god who is both abject and divine. He would woo the gorgeous nymph Syrinx and addresses himself to his own sun-roasted and arid flesh, his chest full of pebbles or 'scruples' (*scropoli*), his twisted legs, his big rough arms that are knotted with muscle as signs of strength.

The muscles are studded or lumpy, where the plates run over one another and ripple. To call these extrusions scruples is poetic archaism; but the hyperbole is also telling, because muscles, though of noble appearance, belong equally to the galley slave, the miner, the builder's laborer or a horse.

Andrew does not use the second tapestry to conceal the muscle but the face, the identity-bearing physiognomy

rather than the physique that is common to buff men. Whether scrupulous or capricious, the artistic intruder — the second tapestry — is also constructed as a woven artefact and is therefore too heavy to resemble a veil in its three-dimensional bulk. In a final paradox, the illusionism of the veil rescues the incongruity and resolves the ensemble as a muscular man evocatively hidden by a veil.

The concept of adding anything to a tapestry is sacrilege to the medium, even if conventional taste has been transgressed many times in the past as an artistically disruptive gesture. The thought of it arouses further scruples. The medium of tapestry is unique in not being layered. In tapestry, there is no support that is not also the skin. The structure of a drawing or digital print or painting presupposes a base upon which another substance is applied. The carbon or paint is attached to the paper or canvas. Essentially, everything that you see is stuck on. In tapestry, however, everything is built into the fabric: surface and substance are one. So, to use this medium of exceptional integrity and then violate the surface by attaching an alien layer is heresy.

The tapestry purist can be assured: aesthetically, the incongruity resolves itself, because the veil is, after all, tapestry; and the two tapestries come together, like rival ethnicities with their incommensurable dispositions but same substance.

Beyond the formal audacity of the two tapestries in collision, there are questions that arise in relation to the subject matter. There is a sense of narrative, as the veil has eye-holes. So is the man hiding and, if so, why? Is the veil a kind of ceremonial hood, with its cut-out eyes? Does the peeping reflect some personal coyness or does it suggest some sinister institutional ritual? What personal or social perversion could be at play?

Judging by the bulky musculature and the Victorian moustache, the figure is not a 'noble savage'. He must be a go-between, a translator, a man who can travel between cultures, who can patronise the European appetite for the exotic.

Beneath the veil, the hero may not enjoy the glory that we would impute to his triumphant frame. He lives under a veil. We refer to that dangling visual interloper as a veil; but it is not really a veil, if you think that the essence of a veil is transparency. Rather, it is a kind of shroud with a weight equivalent to the calibre of what it conceals.

A key item of scrupulosity in *Catching Breath* is the weaving itself. The muscles are hard to draw but a lot harder to weave, because they require the gentlest tonal gradations to represent the transitions from light to dark. But if they never exactly match the organic smoothness of the source photograph, it is no scandal: if contours are visible, they map out the 'staggering' quality of the physique, supplementing the rough flesh that our poets have so long scrupled about.

The final scrupulosity of *Catching Breath* relates to the process by which Andrew arrives at his image. He does not simply enlarge a photograph from his archive. Rather, working at Spacecraft with the master printer Stewart Russell, he runs the image through a rich printing operation, where the image already makes contact with textile. Responding to the massive pressure of the printing press, the weave is somewhat corrupted: the friction forces the weave out of true and little ridges and gullies are formed where the ink either gathers emphasis or fades. In this preliminary work with the archival picture, the image is proved, as it were, emerging alongside certain fault-lines. These flaws and scars are deployed almost as a signature aesthetic in Russell's Spacecraft studio, where textiles are celebrated as inherently floppy and crushable, rather than as a flat canvas, like paper, that accommodates perfectly to the flatbed of the press.

At the ATW, the artist and weavers then faced the scruple: shall we include the distortions of the printing process that were integral to establishing the image in the artist's estimation? The answer, as we see, was yes: the weave should acknowledge the imperfections of contour, the corrugations produced by the lighter textile tripping up under the weight of the press. The original textile itself had a kind of pebbliness, a knotted set of grooves that run against the pressure; and this scruple in the Latin sense is honoured by a scruple in the artistic sense: it is a gesture of one fibre studio paying tribute to another fibre studio, with an artist of archival sensibility relating them both to major shifts in the way we see our own corporal fabric across ethnicities, cultures and epochs.

Robert Nelson

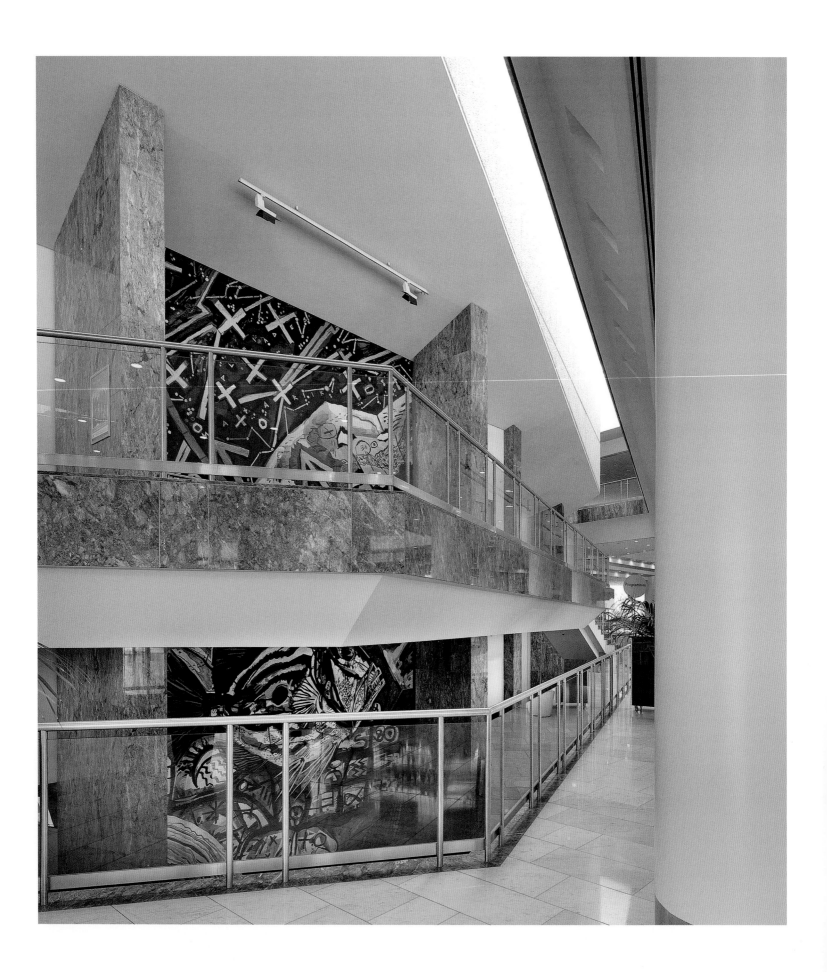

TAPESTRY'S GLOBAL REACH

The ATW is an international leader in contemporary tapestry — one of only a handful in the world for the production of contemporary, handwoven tapestries. During four decades the workshop has focused on establishing and building an international reputation through commissions, exhibitions, residencies and exchanges and, since the early 2000s, via its Australian Embassy Tapestry Collection.

Since its inception the ATW has been a national and an international organisation, encouraging interaction between Australian and foreign artists. More than 500 tapestries have been woven and displayed in Australia, New Zealand, Singapore, Canada, the United Kingdom, India, Canada, the USA, France, China, Japan, Switzerland, Germany, Mexico and Brunei, and these extraordinary accomplishments across 40 years represent many compelling stories.

The workshop's founding vision was informed by Scotland's Dovecot Tapestry Studio (established in Edinburgh in 1912) through its then director and master weaver, Archie Brennan, who had been asked to advise on the structure and feasibility of the new enterprise. Not surprisingly, regular exchanges of weavers and ideas have continued between the two organisations ever since.

Fortuitous timing and determination combined to secure the workshop's first major commission. In April 1976, as weavers were being sought and trained, an inquiry came through Craft Australia: Canadian artist Alan Weinstein, who had won a public art award, was searching worldwide for workshops and master weavers capable of creating a suite of four large tapestries to hang on a vast wall in the Saskatchewan Centre for the Arts in Regina, Saskatchewan's capital.

Not yet having woven a tapestry, the ATW grasped the opportunity and advised Weinstein of its existence and ambitions. Keen to demonstrate the workshop's collaborative approach, weavers selected a section from a photograph of Weinstein's design and sent two woven samples showing different ways in which his work might be interpreted. Weinstein was impressed, and the new Australian workshop was suddenly in the running for an international commission and, by late 1976, negotiations had confirmed it.

One of the first ATW tapestries destined for an international home. It hangs in the Aotea Centre, Auckand. *Aotea Tapestry*, 1991, Robert Ellis, woven by Irene Creedon, Chris Cochius, Anne Kemp, Marete Tingstad, Irja West and Iain Young, wool, cotton, 11.5 x 6.4m, in situ at the Aotea Centre, Auckland.
IMAGE BY JOHN GOLLINGS

Weinstein, who had collected samples and quotations from long-established workshops around the world, said: 'It was self-evident when we compared the quality and interpretation of the Australian work with other samples. The Australian sample was unique in that the weavers managed somehow to capture both the spirit and intent of my work.'

This interpretive mastering of an artist's painting, print, photograph or design in imaginative and innovative ways has been happening ever since in scores of commissions for a wide range of tapestries. A recent example is the 2015 commission for British artist Keith Tyson's *Gordian Knot*, a circular tapestry with experimental 3D forms woven in cotton and wool.

Wide visions

By the end of the 1980s the workshop could claim to be a unique national organisation and was recognised as a world leader in contemporary tapestry, with its work being exhibited in several overseas centres and acquired by international clients. This was due in large part to inaugural director Sue Walker's vision and research. She had travelled throughout the 1980s, showing tapestries and forming significant connections with artists and galleries in world centres. By the 1990s she was achieving particularly positive results in New Zealand, London and Singapore.

New Zealand artist Robert Ellis's monumental *Aotea* tapestry, commissioned for the new performing arts centre in Auckland, was on the loom throughout 1990. The largest single tapestry the workshop had produced to date, it was woven on a new 8m loom custom-made by American John Shannock. Ellis made several trips to the workshop, interacting with the weavers and encouraging them to reinvent his design, a gouache on a half-metre piece of board.

Further New Zealand projects followed, notably *Festival*, designed by Gordon Crook, and a group of 18 small maritime tapestries woven for the Dowse Art Museum.

The workshop's links with the UK were strengthened through the 1980s by John Lewis, then its London representative, and Rebecca Hossack, cultural development officer with the high commission at Australia House in London, who were enthusiastic supporters. In 1995 Hossack promoted *The Stuff of Dreams*, an ATW exhibition at Australia House that had been shown at Heide Museum of Art in Melbourne and then toured to Denmark. The scale and ambition of the works attracted large crowds and resulted in the acquisition of Martin Sharp's *Terra Australis* for permanent display in Australia House.

The scene had been set for this success by an exhibition at the Victoria and Albert Museum in 1993, which had been extended for four months and had culminated in the acquisition by the V&A of five small tapestries from the show.

Walker often visited Singapore and, assisted by Brett Martin from the Australian high commission there, met key figures in Singapore's art world, including artists, collectors, architects, benefactors, political figures and arts bureaucrats. As a result, the ATW gradually became well known in Singapore, and secured its first commission in 1993, the spectacular *Celebrating the City*, designed by local artist Simon Wong. Subsequent tapestries included *Shall We Say Three Trees*, 1997, based on a painting by Jeremy Ramsay and, in 2001, Eng Tow's *The Big Picture — A Convivial Gathering of Elements*, which was hung in the foyer of Singapore's Ministry for Foreign Affairs.

In 1999, two significant projects were undertake which were facilitated by LaSalle College of the Arts in Singapore and supported by the National Arts Council of Singapore and Arts Victoria. The first was a monumental tapestry by Australian artist David Larwill, *Celebration*, 1999, his first, which attracted particular interest at home and in Singapore. It was commissioned by the Victorian government as a gift to Singapore's new Esplanade — Theatres on the Bay arts centre.

FAR LEFT HRH Prince of Wales, a fervent supporter of traditional crafts, gives the royal seal of approval to the ATW during his visit in 2012.

LEFT *Celebration*, 1999, David Larwill, woven by Georgina Baker, Sue Batten, Merrill Dumbrell and Irja West, wool, cotton, 2.85 x 4m, in situ at Theatres on the Bay, Singapore. IMAGE BY JOHN GOLLINGS

BELOW *The Big Picture – A Convivial Gathering of Elements*, 2001, Eng Tow, woven by Sue Batten, Merrill Dumbrell, Miranda Legge, Laura Mar, Gerda van Hammond and Irja West, wool, cotton, 1.88 x 6m, in situ at the Ministry of Foreign Affairs, Singapore. IMAGE BY JOHN GOLLINGS

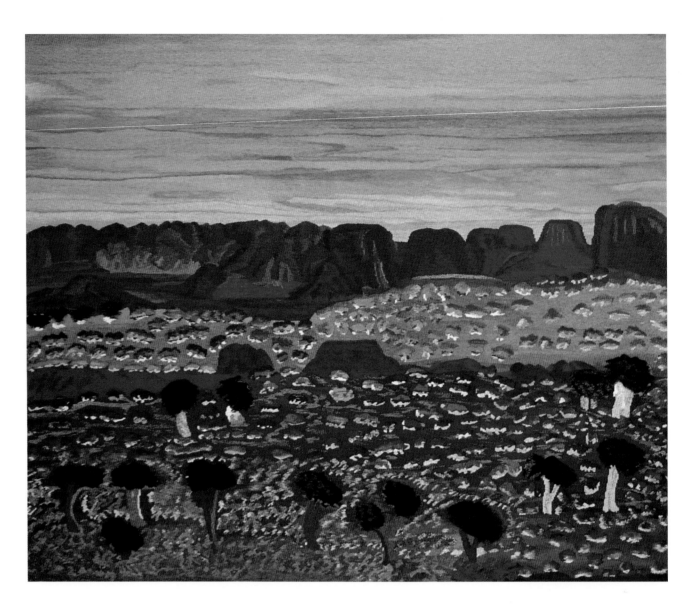

This project also supported a ten-day artist exchange which saw three young artists from Singapore – Ian Woo, Salleh Japar and Chng Chin Kang – join Melbourne artists Geoffrey Ricardo, Peter Walsh and Merrin Eirth. Included also were Kate Derum with some of her students from Monash University, and weavers Sue Batten, Grazyna Bleja and Katia Takla from the workshop.

In 2005 an ATW exhibition, *The Art of Collaboration*, was mounted in the spacious new galleries of the Singapore Tyler Print Institute. It included *Celebration* and all the other ATW tapestries in Singapore collections.

Although Singapore was the main centre of the workshop's activity in Asia through the 1990s, it also explored other Asian markets. In Japan, Malaysia, India and China, ATW staff gave lectures and held workshops,

contacted artists and galleries, and established networks. However, some of the most important connections in Asia resulted from two large projects.

Mappamundi, designed by Indian artist Gulammohammed Sheikh, was commissioned in 2004 by the Tapestry Foundation of Australia to be part of its Asian Artists' Collection. Destined to hang in the Asialink building at the University of Melbourne, Sheikh's large tapestry attracted great interest during its many months on the loom. The artist visited the workshop, bringing to the weavers a deeper understanding of the culture that inspired his work.

The other large commission, *Open World,* designed by Hong Kong-born John Young, was woven as a gift from the Victorian government and the State Library of Victoria to Nanjing Library in the Chinese province of Jiangsu.

The embassy collection

In the early 2000s an opportunity arose to commission a tapestry for the Australian embassy in Tokyo. This was the first tapestry to be placed at an Australian overseas mission, and was the beginning of a significant and continuing program.

The Australian Embassy Tapestry Collection, funded through an initiative of the Tapestry Foundation and with the support of the Department of Foreign Affairs and Trade, places large-scale Australian-designed and made tapestries in selected embassies. Under the program tapestries are lent from the foundation's permanent collection to an embassy and may on occasion be exchanged between embassies. Each tapestry is based on a design by an Indigenous Australian artist, with the intention of selecting unique images that are distinctly Australian but accessible to international audiences. The foundation was acknowledged in 2008 for this key project, winning the AbaF Giving Awards, Victorian section, in conjunction with the ATW.

Daisy Andrews' *Lumpu Lumpu Country*, 2004, was the first tapestry in this program and it hangs at the embassy in Tokyo. *Lumpu Lumpu Country* captures the drama of a landscape with its cliffs and valleys, wildflowers and blazing red earth carpeted by purple flowers. Andrews,

LEFT *Creek Bed*, 2009, Elizabeth Marks Nakamarra, woven by Pamela Joyce, Chris Cochius and Louise King, wool, cotton, 1.82 x 2.72m. Australian Embassy Tapestry Collection. Currently on loan to the Australian embassy, Paris. **IMAGE BY VIKI PETHERBRIDGE**

BELOW *Kimberley Under the Stars*, 2008, Trevor Nickolls, woven by John Dicks, Milly Formby and Louise King, wool, cotton, 1.34 x 2.9m. Australian Embassy Tapestry Collection. Currently on loan to the Australian embassy, Washington DC. **IMAGE BY VIKI PETHERBRIDGE**

RIGHT *Ngayuku Ngura (This is My Country)* 2010, Nyankulya Watson, woven by Louise King, Amy Cornall, Emma Sulzer and Caroline Tully, wool, cotton, 1.81 x 2.73m. Australian Embassy Tapestry Collection. Currently on loan to the Australian embassy, Rome. **IMAGE BY VIKI PETHERBRIDGE**

whose paintings, drawings and prints are memorials to her homeland — comes from the remote Aboriginal community at Fitzroy Crossing in the Kimberley region of Western Australia and belongs to the Walmajarri people.

In 2005 the project's second tapestry was commissioned and now hangs in the dining room of the embassy in Beijing. The workshop sent work by three artists for consideration by the ambassador, who selected *Pwoja Pukumani (Body Paint Design)* by Pedro Wonaeamirri. The geometry of the design and the limited colour palette — ochres, in particular — made this work very suitable for translation into tapestry. Wonaeamirri, whose paintings are based on traditional body painting motifs, was born on Melville Island, the larger of the Tiwi Islands off the coast of Darwin.

Untitled (Detail from Kiwirrkurra Women's Painting), 2007, the third tapestry to be funded, hangs in the foyer of the Australian chancellery in New Delhi. The final artwork was selected from a shortlist by then high commissioner to India, John McCarthy. As the workshop was unable to borrow the

large original painting, project leader Cheryl Thornton viewed the painting in Sydney and made colour matches with samples and Pantone cards. The design is a detail from the original, which was painted in 1999 by a group of 17 women from the Kiwirrkurra community on the border between the Northern Territory and Western Australia.

The fourth tapestry, Trevor Nickolls' *Kimberley Under the Stars*, 2008, was based on a painting of an expedition to Warmun in Western Australia in 2002. It hangs in the embassy in Washington, DC. While the painted surface has a definite texture, the weavers incorporated exaggerated stepped lines and raised forms to capture the vigorous, structural feel. Nickolls' art is autobiographical and universal, drawing freely from European and Aboriginal art traditions.

The fifth tapestry, Elizabeth Marks Nakamarra's *Creek Bed*, 2009, is on loan to the embassy in Paris. The delicate and complex painting on which the tapestry is based is reminiscent of the vast landscapes of the Western Desert and the stories of its creation.

The sixth work, Nyankulya Watson's *Ngayuku Ngura (This is My Country)*, 2010, is on loan to the Rome embassy. Based on a painting of the same title, the tapestry's strong reds and magentas contrast with the dark background. A senior Pitjantjatjara woman, Watson lives in the Nyapari and Kalka communities in South Australia, where she paints for Tjunga Palya and Ninuku Artists.

Patrick Mung Mung's *Ngarrgooroon*, 2010 was the seventh in the series and hangs in the Dublin embassy. The simplicity of the design belies its complex mark-making. Mung, a senior artist at Warmun Art Centre and an elder in the Warmun community in the East Kimberley, discussed the interpretation with the weaving team, emphasising the importance of the white dots and the directional marks in each area.

The eighth tapestry, *Kunawarritji to Wajaparni*, 2011, is on loan to the embassy to the Holy See in the Vatican. The weaving is based on a collaborative painting by eight Indigenous men — Peter Tinker, Jeffrey James, Charlie Wallabi Tjungurrayi, Patrick Tjungurrayi, Richard Yukenbarri Tjakamarra, Helicopter Tjungurrayi, Putuparri Tom Lawford and Clifford Brooks — from regions around the Canning Stock Route in Western Australia.

The ninth and most recent tapestry is Brook Andrews' enigmatic *Catching Breath*, 2014, and is on loan to the high commission to Singapore. In *Catching Breath* the presence of the veil conceals or represents faith, culture and social values — the subject peers through the veil with eyes clearly focused on the outside. The original portrait is from Andrew's archive of rare books, postcards and paraphernalia.

LEFT *Ngarrgooroon*, 2010, Patrick Mung Mung, woven by Cheryl Thornton, John Dicks and Milly Formby, wool, cotton, 1.8m x 2.16m. Australian Embassy Tapestry Collection. On loan to the Australian embassy, Dublin. **IMAGE BY VIKI PETHERBRIDGE**

ABOVE *Kunawarritji to Wajaparni*, 2011, Clifford Brooks, Jeffrey James, Putuparri Tom Lawford, Peter Tinker, Richard Yukenbarri Tjakamarra, Charlie Wallabi Tjungurrayi, Helicopter Tjungurrayi and Patrick Tjungurrayi, woven by Pamela Joyce, Sue Batten, Chris Cochius, Milly Formby and Emma Sulzer, wool, cotton, 1.67 x 4m. Australian Embassy Tapestry Collection. Currently on loan to the Australian embassy to the Holy See. **IMAGE BY VIKI PETHERBRIDGE**

RIGHT *Untitled (Detail from Kiwirrkurra Women's Painting)*, 2007, Nanyuma Napangati assisted by Polly Brown Nangala, woven by Cheryl Thornton, Mala Anthony and Milena Paplinska, wool, cotton, 3.05 x 1.98m. Australian Embassy Tapestry Collection. Currently on loan to the Australian high commission, New Delhi. **IMAGE BY VIKI PETHERBRIDGE**

Diamond Jubilee project

The *Diamond Jubilee Tapestry Project* began in 2012 in celebration of the Queen's 60 years on the throne and the visit to Australia of HRH The Prince of Wales and the Duchess of Cornwall.

It has its roots in a collaboration with the Prince's School of Traditional Arts in London, which he founded. The first stage was an intensive four-day workshop in Melbourne for students at Coolaroo Primary School together with educators from the Prince's School, the Royal Botanic Gardens and artist Nusra Latif Qureshi. Trained in Lahore in the Mughal miniature painting tradition, Nusra has developed a rich contemporary practice that links the visual histories of South Asia with her experience as an immigrant woman in Australia.

Nusra was inspired by her participation in the student workshops as well as by extensive conversations with senior weavers, and her vibrant design incorporates aspects of the students' artwork. The ochre of the background refers to the vast red earth of Australia and the spikes of the callistemon filled with specks of bright colour are symbolic of the diversity of the country's people.

On 6 November, HRH The Prince of Wales visited the ATW, chatted with the students and viewed their artwork. The completed tapestry travelled to the UK in early 2013, where it was exhibited as part of the Wool House show at Somerset House and then in the Dovecot Tapestry Studio exhibition in Edinburgh in 2014.

In the days of the comet

In 2011 the workshop completed a work by Australian artist David Noonan that was exhibited in the UK as part of the influential British Art Show 7: *In the Days of the Comet*, curated every five years by London's Hayward Gallery. British Art Show 7 paid particular attention to the ways that artists use history to illuminate the present and 39 artists were invited, based on their significant contribution to British and international art.

Noonan's *Untitled*, 2009, toured with the exhibition for 15 months to several cities in the UK. 'To have one of our works exhibited in such an influential contemporary art show . . . is a wonderful opportunity for the workshop to showcase the extraordinary skills of our weavers and highlights the breadth of possibilities in contemporary tapestry', ATW director Antonia Syme said at the time. In transforming the work's complex imagery, the workshop's weavers retained key details needed to maintain the sense of an uncertain narrative as well as capture the textures and mood.

FAR LEFT *Wamungu – My Mother's Country*, 1996, by Ginger Riley and John Olsen's *Rising Suns over Australia Felix*, 1997, take pride of place at headquarters of the Department of Foreign Affairs and Trade, Canberra. **IMAGE BY JOHN GOLLINGS**

LEFT Weavers Chris Cochius, left, and Sue Batten, right, discuss samples with Nusra Latif Qureshi for her tapestry.

BOTTOM LEFT HRH The Prince of Wales and artist Nusra Latif Qureshi meet school children during his visit to the ATW. **IMAGE BY GREGORY ERDSTEIN**

BELOW Nusra Latif Qureshi's the *Diamond Jubilee Tapestry* in progress.

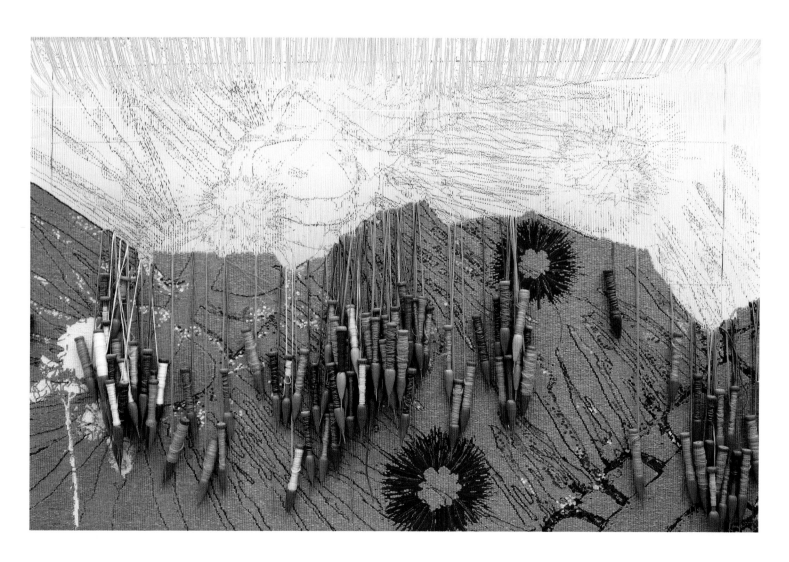

2015 Hancock Fellow Reiko Sudo at the ATW studio during her *Do You NUNO?* exhibition. IMAGE BY JOHN GOLLINGS

Hancock Fellowship

Supported by the Tapestry Foundation, the Hancock Fellowship was established in 1998 to bring international experts in tapestry, textile and design to the ATW and share their expertise through workshops, lectures and exhibitions while experiencing contemporary art and creative industries in Australia. The fellowship, named in honour of former ATW chairman Arnold Hancock OBE, demonstrates the workshop's commitment to strengthening engagement with the international arts community and promoting Australia's creative talent to audiences worldwide.

In 2010 the Hancock Fellow was Dr Elisabeth Taburet-Delahaye, director of the Cluny Museum: The National Museum of the Middles Ages, in Paris, who visited Australia in November of that year and delivered three lectures sponsored by the ATW, the National Gallery of Victoria and the academic centre at Newman and St Mary's colleges at the University of Melbourne.

Taburet-Delahaye has published widely on medieval art, especially on gold and silver metal work and enamels. She was principal curator of the exhibitions *Paris 1400*, held at the Louvre in 2004, which celebrated the arts under Charles VI, and *France 1500: the Pictorial Arts at the Dawn of the Renaissance* at the Grand Palais in Paris in 2010.

The 2015 Hancock fellow was Reiko Sudo, artistic director of renowned Japanese textile producer NUNO Corporation. NUNO has created fabrics for the fashion and interiors industries such as designer Issey Miyake and Yohji Yamamoto, and Sudo has created designs for MUJI, Tsuruoka Textile Industry and steteco.com. Her work has been shown in the USA, India and Israel, and is also represented in collections of the Museum of Fine Arts in Boston, the V&A, the Philadelphia Museum of Art, and the Cooper-Hewitt National Design Museum in New York.

At the workshop Sudo delivered a lecture exploring NUNO's constantly changing approach to textiles, and the gallery displayed NUNO designers' sketches and test samples, highlighting their interaction with local Japanese artisans and demonstrating the processes that go into creating every textile. In the gallery, the centrepiece of the exhibition, called *Do You NUNO?*, and launched by long-time friend of Sudo and director of Sherman Contemporary Art Foundation, Dr Gene Sherman AM, was a walk-in space encircled by two large suspended compilations created from 360 swatches selected from among NUNO's 2500 designs.

Dovecot and the International Weaver Exchange

Since 1976 exchanges of weavers and ideas between Dovecot Tapestry Studio and the workshop have continued and 2014 marked the beginning of another cycle of such interchanges between Melbourne and Edinburgh, through an exchange of weavers jointly funded by Creative Scotland's Creative Futures Program and the Tapestry Foundation of Australia.

This more formal arrangement is designed to raise the profile of contemporary tapestry weaving by building relationships and sharing knowledge. By spending an extended period in the host country, weavers have engaged with familiar and new working practices and immersed themselves in the local arts and cultural community.

Celebrating the continuing connections between ATW and Dovecot Tapestry Studio, an exhibition in 2014 at the studios brought together recent work from both institutions. Although geographically separate, they share a similar philosophy of working closely with contemporary artists to produce tapestries at the cutting edge of artistic practice.

Ian Were

LEFT Dovecot Tapestry Studio weaver Rudi Richardson and ATW exchange weaver Sue Batten warp up a tapestry at Dovecot Tapestry Studio, Edinburgh. **IMAGE BY BILL BATTEN**

RIGHT TOP ATW exchange weaver Sue Batten discusses the tapestry she wove *Everything has Two Witnesses, One on Earth and One in the Sky* with members of the Dovecot Tapestry Studio. The tapestry was on display as part of the exhibition *Current Exchanges: Dovecot and the Australian Tapestry Workshop*, Dovecot Tapestry Studio, Edinburgh, 2014. **IMAGE BY BILL BATTEN**

RIGHT BOTTOM Dovecot Tapestry Studio exchange weaver Johnathan Cleaver and ATW weaver Cheryl Thornton working on *Bush Foods*.

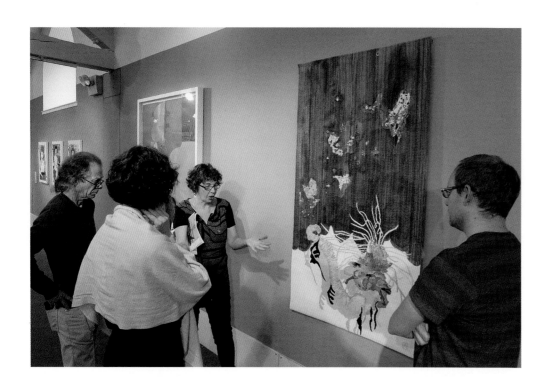

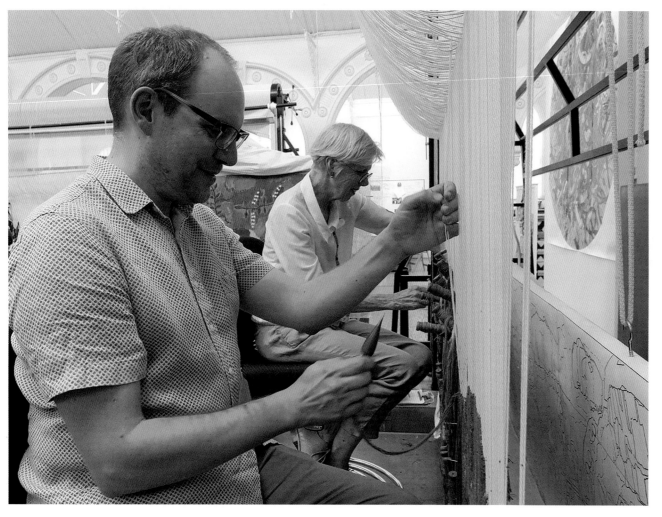

The Roger Kemp tapestry suite reflects the Leonard French stained-glass ceiling at the Great Hall of the National Gallery of Victoria.
IMAGE BY JOHN GOLLINGS

ART IN SPACE

The historical connection between architectural space and textile art, particularly tapestry, is long-standing. Rare tapestry remnants have been found in Greece dating from the third century BC and the tapestry-laden walls with woven cloths dating from the mid-15th century and onwards in many European museums and palaces are very familiar to us. The longevity of this art form during many centuries makes my 17-year connection with it, via the Australian Tapestry Workshop, seem insignificant. Time, however, is not the relevant metric when measuring the alchemy that occurs in the creation of tapestry — this is timeless.

Significant wall hangings have been created within many cultures and have been used in many configurations for functional, decorative, celebratory and didactic purposes, and some with a clear knowledge of their 'other' underlying capacity to modify thermal and acoustic conditions within interior built space. Tapestries have ranged from monumental formats in great public and private buildings to small-scale intimate works for personal enjoyment. Often underpinned by great wealth, they have been traded and presented as gifts to leaders for hundreds of years across countries and societies. From the Middle Ages in Europe these textiles have been used as vehicles to expound traditional designs employing historical and mythical themes, and became a preferred medium for avant-garde architects and artists at the beginnings of the Modernist movement in Europe.

Textiles, from their earliest history to the full integration of the form into the comprehensive design program of the Bauhaus in Germany under Walter Gropius and later under Mies van der Rohe, tapestries have been linked intimately with built space and its creation. One only has to think of the great French architect Le Corbusier and his integration of textiles with architecture, including his masterfully designed tapestries from the 1950s and 1960s, to understand the significance of their placement in architectural space.

William Morris in the 19th century and his contemporary, French artist Jean Lurçat, paved a way for others to follow, including influential artists such as Pablo Picasso, Alexander Calder, Fernand Leger and Joan Miró, who used the mediums of tapestry and textile as key platforms for their work.

LEFT Local Aboriginal artists at the Papunya settlement, 240 kilometres northwest of Alice Springs, viewing the finished *The Winparrku Serpents* tapestry. **IMAGE BY MURRAY WALKER**

FAR RIGHT *Wattle,* 1979, Marie Cook, woven by Marie Cook, Gordon Cameron, Ilona Fornalski, Kathy Hope, Jan Nelson, Cheryl Thornton, Wendy Webb and Irja West, wool, cotton, 3.65 x 6.09m, brings native flora into the lobby at the Sofitel, Melbourne. **IMAGE BY JEREMY WEIHRAUCH**

BELOW *The Winparrku Serpents*, 1978, Kaapa Djambidjimba, woven by Sue Carstairs, Alan Holland, Kathy Hope, Andrea May, Cheryl Thornton and Irja West, wool, cotton, 2.52 x 3.96m, in situ in the Playhouse Foyer, Arts Centre, Melbourne. **IMAGE BY JOHN GOLLINGS**

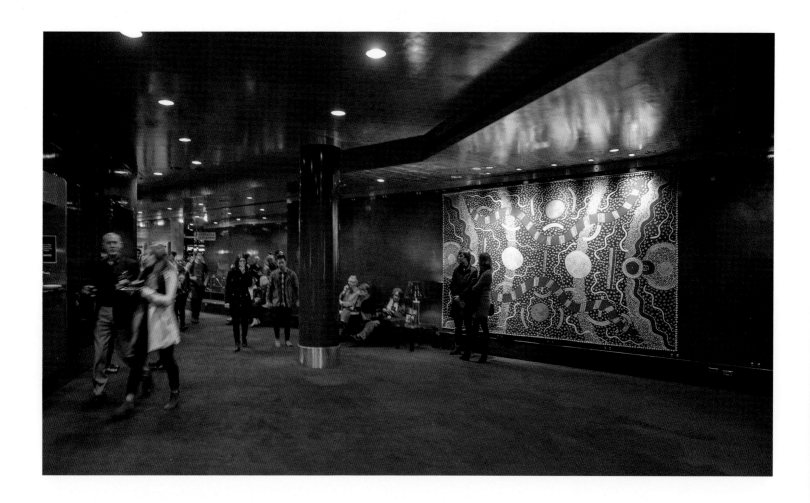

With such recorded provenance, the inclusion of
textiles within contemporary architectural design and
spatial configuration is more than justified. The siting
and placement of a tapestry, its scale, dimension and
proportion can be as significant as every other aspect of
spatial creation orchestrated by the architect. Whether
included for the meaning inherent in its design or for
its ability to accent, focus or soften a space, a tapestry
provides an engaging dimension to any interior volume.

In Australia our somewhat shorter but no less significant
engagement with tapestry production continues, and
has extended the centuries-old European art form into
the 'remote new world'. Prior to the establishment of
the ATW's forerunner, the Victorian Tapestry Workshop,

ABOVE *Home of Snake in Waterhole*, 1979, Yala Yala Gibbs, woven by Sue Carstairs, Mary Coughlan, Christine Harris, Valerie Kirk, Jan Nelson and Irja West, wool, cotton, 3.48m x 3.97m, at the *Singing the World* exhibition, Arts Centre, Melbourne, 2012. **IMAGE BY MARK ASHKANASY, COURTESY OF THE ARTS CENTRE MELBOURNE**

RIGHT Richard Johnson opens the 2015 Tapestry Design Prize for Architects at the Sydney Opera House, recalling his walk through the room with its architect Jørn Utzon: 'He began by talking, not about his design, but how people would experience it, and of the music and art that had inspired his thinking.' **IMAGE BY NIC LONG**

in 1976, Australian artists were well aware of the great tapestry art tradition of Europe and sought participation in the form by weaving their work in the workshops of France and Portugal. One only has to think of the superb suite of large-scale tapestries designed by Arthur Boyd AC OBE and woven at Portalegre in the 1970s and the many John Coburn works woven on European looms prior to the existence of an Australian workshop.

In site-specific architectural terms, realisation of the Great Hall tapestry for the new Parliament House in Canberra, later followed by the impressively long and lyrical work in the Sydney Opera House, represent respectively the compelling and noteworthy starting point and continuation of 'architectural' tapestry in this country. These works came into being via collaboration with the VTW, establishing to an Australian audience the importance of such textile work in architectural space. These monumental works were designed for a specific location, and with an architectural intent.

In the case of Parliament House, its architect and enthusiastic champion of integrated art within architecture, Aldo Giurgola of Mitchell Giurgola Thorpe, advocated the commissioning and incorporation of the Boyd tapestry *Untitled (Shoalhaven Landscape)* into the Great Hall. This new, democratic building for the Australian people was the result of an international competition and was briefed to be built with a minimum lifespan of 100 years. The inclusion of this epic Boyd tapestry, the second largest in the world, not only enriched the chosen space but added a cultural asset that would 'go the distance' with the building.

It is noteworthy that the French government provided a gift to the Parliament of Australia to celebrate the opening of the new building in 1988, in the form of a tapestry designed by Le Corbusier. The original of *The Woman and the Blacksmith* tapestry was woven in Beauvais in 1967 and is owned by the French government. The gift to Australia was made from the cartoon of the work, one

of the 27 (at least) cartoons Le Corbusier designed for tapestries. It was hidden within Parliament House until it went on show in 2016.

Major tapestries in Australia generally have an interesting backstory. Jørn Utzon, having won the international competition to design the Sydney Opera House, commissioned a tapestry to be designed by Le Corbusier for inclusion in the interior of the building. This 1960 tapestry, *The Dice Are Cast*, was woven at the Aubusson workshop and had resided in Denmark until its acquisition and return to its intended destination within the sails of the Opera House at Bennelong Point in 2016. It is an inspiring textile work added to the space as conceived by the architect to imbue and enrich the experience within his visionary and poetic architecture.

Utzon designed the tapestry *Homage to CPE Bach* for the interior of the reception hall. This interior space was conceived as a location for chamber music, lectures and functions. The room sits within the concrete vaults of the Opera House's podium, oriented to the waters of Farm Cove. The space, now called the Utzon Room, is a harmony of natural materials and details dominated by a singular work of art, the tapestry, which adjusts the acoustics of the space and adds colour, texture, human scale and symbolic meaning.

In the Utzon Room in 2014 at the launch of the inaugural ATW Tapestry Design Prize for Architects, Richard Johnson AO MBE, the architect responsible for the creation of that room, captivatingly recalled a conversation with Utzon in his home in Mallorca, where he had excitedly explained his idea for the space.

'He began by talking, not about his design, but how people would experience it, and of the music and art that had inspired his thinking,' Johnson said. 'He wanted a seating arrangement for chamber music with Sydney Harbour as a backdrop, and he needed the wall opposite to be sound-absorbing. He understood that in this long room, with a window on the east side and his 14m-long tapestry on the west, people would first encounter the work on entry from the south, by promenading down the space.'

This was a very clear intention from a towering architectural mind for an artwork to be purposefully integrated into a space. Following a strong collaborative

process between Utzon and the VTW, the epic work was woven in the workshop in Melbourne and installed in 2003.

Harry Seidler AC OBE, European emigre and pioneer Australian modernist architect, included tapestry works in his local buildings in Sydney and Melbourne. His Australia Square Tower project in Sydney included the grand Le Corbusier tapestry *UNESCO* from 1960, woven at the Aubusson studio, and a smaller tapestry by Calder in the Plaza Building coupled with the prominent massive steel sculpture on George Street by the same artist .

The Tapestry Design Prize for Architects aimed to promote and reinvigorate the connection between architectural built-form and textile art. By building an awareness of tapestry as a relevant medium that sits comfortably within the materiality of contemporary architectural thinking, it provides another tool that architects can draw on to craft spaces to inhabit and uplift the soul in this increasingly complex and challenging world.

TOP LEFT 2015 Tapestry Design Prize for Architects joint winners Alex Peck and John Wardle (John Wardle Architects) with their design *Perspectives on a Flat Surface*. IMAGE BY JEREMY WEIHRAUCH

TOP RIGHT The other joint winners of the 2015 Tapestry Design Prize for Architects, from left, Michelle Hamer and Kristin Green (KGA Architecture) with their design *Long Term Parking*. IMAGE BY JEREMY WEIHRAUCH

RIGHT Former ATW Chairman Peter Williams, Victorian Minister for the Creative Industries Martin Foley and ATW Director Antonia Syme at the exhibition opening of finalist entries for the 2015 Tapestry Design Prize for Architects. IMAGE BY JEREMY WEIHRAUCH

Architect John Wardle and head weaver Sue Batten assess the samples for *Perspectives on a Flat Surface*.

RIGHT Samples for *Perspectives on a Flat Surface*. IMAGE BY JEREMY WEIHRAUCH

In one of two proposals jointly selected for the inaugural prize, reference is made by its author John Wardle Architects to Italian Vicenzo Scamozzi's exaggerated perspective *trompe l'oeil* designs based around Palladian villa architecture. These served as inspiration for the Wardle studio's exploration of contemporary tapestry surface for its competition entry: 'A series of imagined sets have been created that reverse Scamozzi's inverted perspectives, forming a series of picture planes drawn toward the audience. Each multiplies shifting perspectives across one wall whilst allowing another to exaggerate the proportions of the space. The partial views and variant transmissions of light within each inverted chamber suggest a place that is 'elsewhere''.

The Wardle work offers a compelling and unquestionably current vision for tapestry and is on the loom at the ATW, commencing the process that will see the realisation of this unique spatial vision. A second design competition for architects in 2016 will continue to encourage and establish further and deeper connection with architects and the inclusion of tapestry in their spatial interpretation. An increasing interest in the handmade in all fields of contemporary design and making has been evident in recent years. A re-emergence of traditional skills in woodworking, metalworking, glass, ceramics, textile-making and weaving, combined with incorporation of a wide range of new materials, is manifest in jewellery, furniture, utility items and architecture. Input from makers and those possessed of specific areas of knowledge in the making of things are sought out and are part of collaborative teams focused on design progression and realisation. Coupled with ever-increasing digital visualisation techniques and the enhanced ability to represent object and surface, the settings for advancement of tapestry are palpable.

This potential for technical and artistic advance is bolstered by the increasing adoption of tapestry as an artistic medium in its own right by influential artists, Australian and international, who understand the potential of the collaborative process that prevails at the ATW. Perhaps a final word on the modification of architectural space can be left to Ainsley Murray, who was a participant in a collaborative team submission for the 2015 Tapestry Design Prize. In her marvellous review in *Artlink* magazine of an installation by Sandra Selig at the Museum of Contemporary Art Australia in 2004, she wrote perceptively and provocatively about architecture and intervention:

Architecture has long since surrendered the tactile in favour of grander visions. Processes of digitisation, prefabrication and mechanisation have led to the widespread abandonment of the human hand in architectural practice, and private eccentricities are now buried, smoothed over with flatter, more uniform design solutions. Recalcitrant fingerprints and other imperfections have dissolved from all but the vernacular and Indigenous architecture of Australasia. The question is, how might we reconsider our relationship with built matter to restore a direct connection with human experience? I suspect the clues lie not in architecture, but in contemporary installation.

As she concluded: 'Perhaps the handmade in architecture is nothing to do with the physical character of buildings, but entirely to do with how we engage with them in our enlivened and repetitious gestures. Not only is architecture rethought, but the relationship between being and building reconsidered.'

Peter Williams

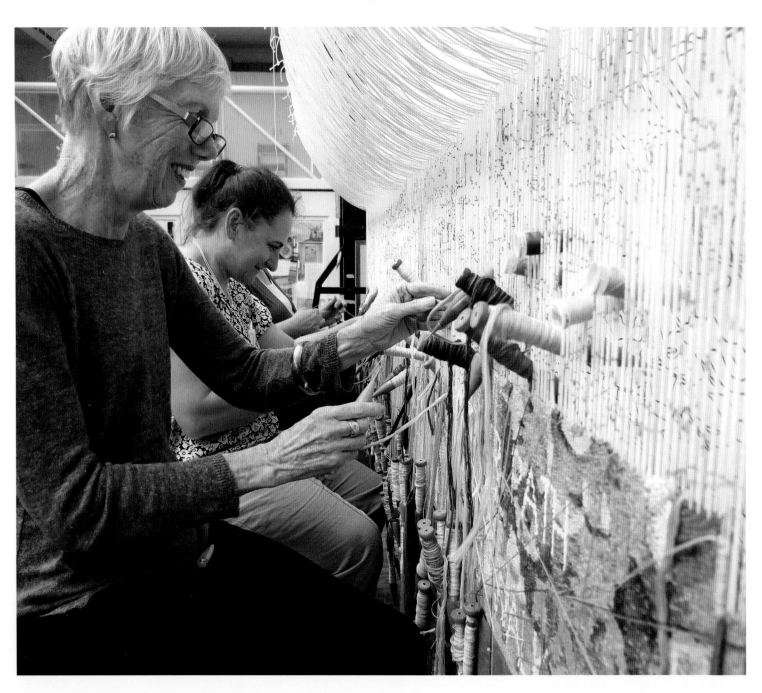

From left, Cheryl Thornton and Milena Paplinska focused on weaving *Avenue of Remembrance* by Imants Tillers.

ADVENTURE AND AMBITION: THE WEAVING PROCESS

Dr Sue Walker AM, founding director of the Victorian Tapestry Workshop, now the ATW, recalled the goals that shaped the organisation in its early days as, 'adventure and ambition . . . while maintaining truth to the inherent qualities of tapestry and truth to the intention of the artists whose work was being interpreted'.

These objectives, developed in consultation with Archie Brennan, at the time director of the Edinburgh Tapestry Company in Scotland, which ran the famed Dovecot Tapestry Studio, were grounded in an approach to weaving tapestries that Brennan had developed in the 1960s. This method involved working with interesting and challenging contemporary artists and taking a collaborative approach to interpretation and weaving. When translating artworks into tapestry, weavers and artists would work together to develop an interpretation that best expressed the artist's intention, while taking advantage of the unique qualities of the medium. As equal partners in this process, weavers would ideally be art or design school graduates and creative practitioners in their own right, and artists excited by the transformative potential of the interpretive process.

In his advice to the Victorian government in 1975 Brennan recommended taking an evolutionary approach to the workshop's development. By beginning with a small team of locally trained artist-weavers and adopting an attitude of adventure and experimentation, the organisation could forge its own direction and explore its creative potential in response to the Australian context. Given time to explore the tapestry process, weavers would be able to develop their own weaving language before attempting their first commission. Such an approach, as Walker noted, would allow the workshop to 'take on its own identity, rather than becoming a replica of overseas workshops'.

Forty years later, the ATW has indeed developed a distinctive Australian idiom that is immediately recognisable in the quality and diversity of the tapestries produced, the superb interpretative skill of the weavers, the precision of their weaving and their mastery of colour and tone.

Those ideally positioned to identify and explain the genesis of these qualities are the weavers themselves, so this essay draws on conversations in late February 2016 with a small group of ATW weavers who have a longstanding relationship with the organisation: Sue Batten, Chris Cochius, Cresside Collette, Pamela Joyce, Sara Lindsay and Cheryl Thornton.

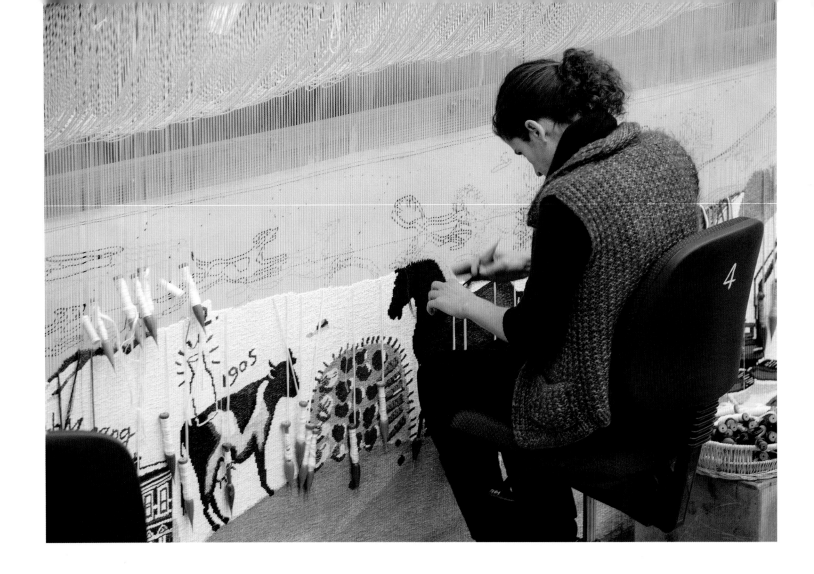

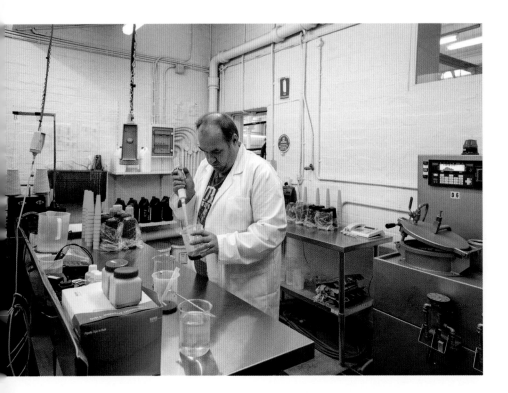

ABOVE Emma Sulzer weaving *North Facing* by Bern Emmerichs.
IMAGE BY VIKI PETHERBRIDGE

LEFT ATW dyer Tony Stefanovski in the colour laboratory, where he creates colours to match the needs of individual tapestries.
IMAGE BY JEREMY WEIHRAUCH

TOP RIGHT A selection in the yarn shop of the ATW weavers' palette of 370 carefully chosen colours. IMAGE BY JEREMY WEIHRAUCH

BOTTOM RIGHT In progress: John Dicks renders *Kimberley Under the Stars* by Trevor Nickolls in 2008.

Superlatively woven, ATW tapestries have a powerful presence; their dense structure and straight edges mean they hang flat and, usually, square, physical characteristics that are often taken for granted, but as any beginner weaver knows, they require great technical control to achieve. Although the equipment necessary is relatively simple, as the process is controlled by the weaver rather than the loom, gradual improvements to the workshop's equipment during the past 40 years have enhanced the weavers' control. For instance, John Shannock looms, engineered to be easy to use and completely stable, hold the warps at an even tension and at perfect weaving height, while brass-tipped bobbins made by Michael Perry enable the weft to be firmly compacted. These refinements facilitated the development of the weavers' technical skills, practical knowledge and creative innovation.

For 40 years this knowledge has been consolidated and expanded by the more than 60 weavers who have been employed at the workshop to reach an extraordinary level of expertise. As Joyce said recently: 'All the weavers currently employed at the workshop have been there for 20 years or more, so technique is not an issue and the weavers can focus their attention on interpretation and shape. Technically the skill level is so high the weavers can do anything.'

But technical skill is only a means to an end: collaboration between weavers and artists, and among the weavers themselves, is key to the quality of ATW tapestries. The discussion and exchange of ideas that ensue from the collaborative process can be enriching for artist and weaver, as Cochius noted: 'Collaboration has the potential to enhance the experience of both weaver and artist but is dependent on the ability of both to be open to an exchange of ideas, an ability to be able to communicate and a desire to be challenged. The weavers are a cohesive team with a strong desire to produce the best possible tapestry . . . we work hard to build on an initial intuitive response by developing a strong, faithful and coherent vision, which is enhanced by a collaborative relationship with the artist.'

In order to guide the interpretation before work on a tapestry begins, the weaving team produces samples that experiment with different warp settings, colour relationships and ways of translating the image into the language of weaving. Being true to the artist's vision while keeping to a budget and timeframe is crucial.

Dyer Tony Stefanovski and head weaver Sue Batten discuss the development of new colours for the *Sun over the You Beaut Country* tapestry by John Olsen.

Having worked at the ATW since its inception, Thornton and Batten each made the point that the challenges of working to tight budgets and timeframes can lead to innovation and concision: 'These challenges can make for exciting new interpretations, a coarser warp set for instance often forces you to think more decisively or boldly, this can make for a more powerful image or even line. There can be a temptation to include too much information and detail. There is a need to find weaving solutions to achieve effects; to only weave what is relevant and the skill to decipher and weave only the significant essence of an artist's work . . . no more, no less,' said Thornton. This last point is reiterated by Batten when she notes that: 'Every tapestry needs momentum but a limitless budget and open timeframe can lead to over-complication of a tapestry. I do like the saying, and usually find, that less is more.'

As well as creating new samples for each commissioned work, weavers are able to draw on knowledge embedded in samples made for previous commissions, for as Joyce comments: 'The 40-year archive of past tapestry samples provides an extraordinary resource that can be drawn on when deciding on the interpretation of current tapestries.' This archive could be thought of as the memory of the organisation; a tangible record of diverse approaches to the interpretation of artworks held in physical form.

Unlike the practice in many European workshops, tapestries at the ATW are woven from the front of the loom. Being able to see the image as it is woven gives weavers better control of the interpretative process: they are able to make subtle modifications to the woven image which is impossible when working from the back. Being able to see their work close up and at a distance is essential for weavers to monitor the development of the woven image and to visualise how the tapestry will appear when installed.

Because tapestries woven at the ATW are made collaboratively and by hand, the success of each work is not foretold but is revealed over time as the result of thousands of decisions made jointly by the weaving team in consultation with the artist. Furniture designer David Pye OBE called this kind of process the 'workmanship of risk' as opposed to the workmanship of certainty, where the result is predetermined even before work begins. It is this capacity to embrace risk rather than certainty that underpins the culture of the workshop and the quality of the tapestries produced.

As the ATW rarely weaves editions the process of making each tapestry is a new experience, throwing up different challenges for the weavers. Each tapestry records the many decisions made by the weaving team, becoming a record of their thinking, for as anthropologist Tim Ingold explained, 'This thinking, this imagining, goes on as much in the hands and the fingers as in the head.' This aspect of the process makes each tapestry a fresh and stimulating experience for the weaving team.

During the past 40 years an impressive range of contemporary artists have provided designs for tapestries that have challenged the weavers' creative and technical skills. Batten noted that 'the decision to not weave editions, and to only work with living artists, has meant we have a constantly changing list of artists to work with. In recent years the calibre of our artists has been impressive. We have been able to confidently take on challenging projects like the Yvonne Todd, Keith Tyson, David Noonan, Brooke Andrew etc. These challenges keep weaving at the ATW exciting, which I think is reflected in our tapestries.'

Noonan's enigmatic and haunting artworks took on another life when woven at the ATW. The ambiguity of his images, found photographs sometimes printed on cloth or superimposed one over another in digital form, was heightened by their skilled interpretation into tapestry; their mysterious transparency and subtle tonal gradations were seamlessly translated into the materiality of woven cloth. In a different way, the strangely constrained and deadpan qualities of the portrait, *Alice Bayke*, by Todd, were amplified and intensified by the scale of the resulting tapestry, with its compelling woven interpretation of impassive expression and wayward hair.

Collette commented that collaborating with such artists has extended the weavers' interpretive capacities and skills while demonstrating the expressive capacity of the medium. She said: 'When possible, the choice of artists' work to be interpreted has been of a very challenging or subtle nature, designed to stretch the idea of tapestry as an imaginative medium and the technical skills of the weavers.' When asked what she thought was most distinctive about ATW tapestries Collette (as did the other weavers) immediately nominated colour and speculated that this might stem from 'the light conditions we have in Australia, where we are really able to see and interpret colour in clear, hard light. Also the fact that a lot of the painters whose work we have interpreted produce very colourful work compared to those practising in Britain and Europe.'

Whether it is the clear, vibrant colour of a tapestry by John Olsen AO OBE or the startlingly complex colour relationships in the ATW's most recent commission, Keith Tyson's *Gordian Knot*, the tapestry weaving process intensifies and heightens colour relationships. Unlike painting, where the pigments are blended to create hue and tone, tapestry is woven from strands of yarn used singly or mixed together to become one weft. Mixing yarns of different colour and texture gives weavers the capacity to combine the light-absorbent density of woollen threads with the shimmering, reflective qualities of cotton. This adds another dimension to colour.

By employing specialist dyer Tony Stefanovski, the ATW ensured it could rely on a large and consistent colour range in wool, and a smaller complementary range of cotton, each colour expertly dyed in tones ranging from dark to light. This palette has enabled weavers to develop very sophisticated methods of mixing coloured yarn, where up to 12 threads of varying hue, tone and lustre are mixed on the bobbin to enrich and enliven the colour of the weft.

When considering how the weavers' use of colour has developed over the years, Joyce commented: 'Through the build-up of experience this capacity has become more sophisticated. In the early days of the workshop colour mixes often had higher tonal contrast, leading to a more speckled effect. Now colour is mixed by adding a couple of lighter threads to mixes of different hues but of the same tone, which gives a vibrancy to the colour without a speckle . . . in relation to the latest Olsen tapestry, the weavers decided to add more DMC cotton to the colour mix to ensure a vibrant, clear and luminous orange, qualities that cannot always be obtained by using woollen yarn (which can impart a yellowish cast to lighter hues).'

Woven tapestry is a textile as well as an image, a dense and heavy cloth with an intense materiality. While tapestries can evoke the everyday associations that adhere to cloth, this familiarity is made strange by the fact that tapestry is simultaneously image and cloth. Close up, you're aware of the woven structure, a grid of densely compacted coloured wefts that from a distance suddenly transform into an image. This double life gives the medium its enticing power; an authority demonstrated through the unparalleled skill of the weavers at the ATW.

Kay Lawrence AM

ABOVE Left to right Cheryl Thornton and Sue Batten work on sample cartoons for the *Avenue of Remembrance* tapestry.

RIGHT Left to right Cheryl Thornton, Jennifer Sharpe, Pamela Joyce, Chris Cochius and Sue Batten weave the *Life Burst* tapestry.
IMAGE BY JEREMY WEIHRAUCH

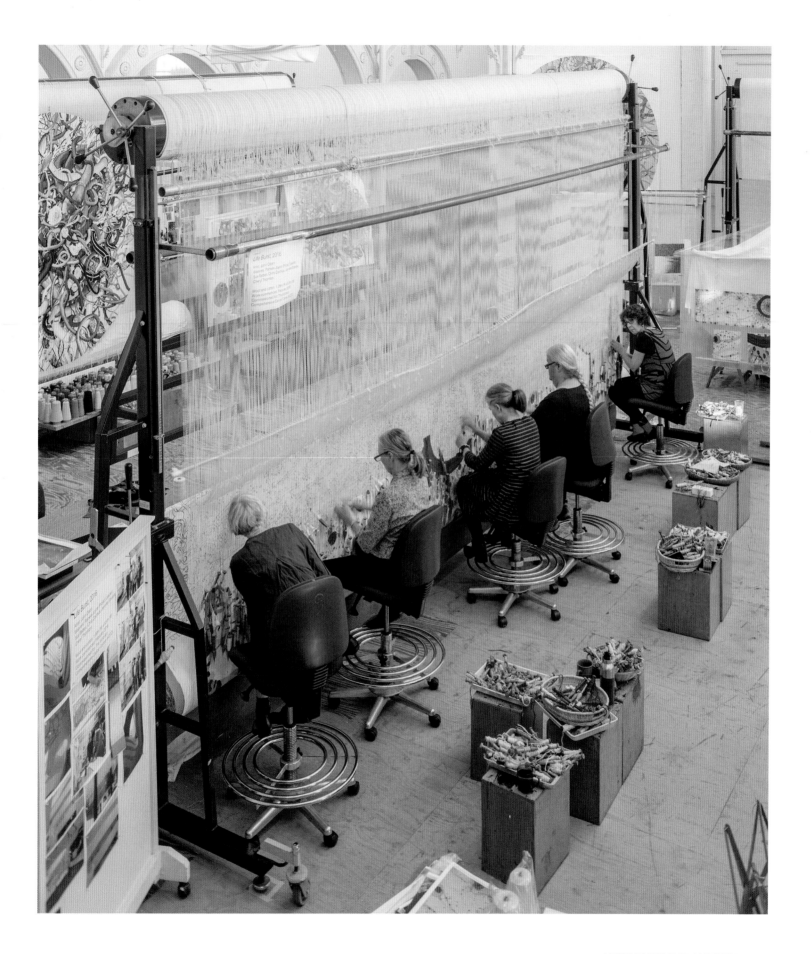

THE WEAVERS

1976 – 2016

Mala Anthony
Georgina Barker
Sue Batten, née Hick
Joan Baxter
Leonie Bessant
Grazyna Bleja
Paula Bowen
Dot Callender
Gordon Cameron
Sue Carstairs
Paul Churcher
Peter Churcher
Chris Cochius
Cresside Collette
Marie Cook
Amy Cornall
Mary Coughlan
Irene Creedon
Robyn Daw
John Dicks
Merrill Dumbrell
Carol Dunbar
Merrin Eirth
Kath Farmer
Joanne Feder
Peta Fleming, née Meredith
Milly Formby
Ilona Fornalski
Helen Gibbs
Hilary Green
Tim Gresham
Heather Griffiths
Gerda van Hamond
Owen Hammond
Sonja Hansen
Christine Harris
Rachel Hine
Alan Holland
Kathy Hope
Abigail Howells
Kate Hutchinson
Pam Ingram
Nicole Johnson
Meryn Jones

Pamela Joyce
Margaret Kelly
Anne Kemp
Louise King
Valerie Kirk
Miranda Legge
Sara Lindsay
Elizabeth Lipscombe
Claudia Lo Priore
Amanda Markey
Barbara Mauro
Tass Mavrogordato
Andrea May
Joanne Mills
Bhanu Mistry
Rebecca Moulton
Robyn Mountcastle
Susan Mowatt
Jan Nelson
Liz Nettleton
Wendy Owen
Milena Paplinska
Lindsay Pells
Belinda Ramson
Jan Rizzo
Hannah Rother
Laura Russell, née Mar
Dorota Skoneczna
Jennifer Sharpe
Alexis Simmons
Joy Smith
Lisa Stebbing
Emma Sulzer
Anne Sutton
Katia Takla
Cheryl Thornton
Mark Thrush
Marete Tingstad
Caroline Tully
Wendy Webb
Andrew Weekes
Irja West
Jos Windle
Iain Young

ABOVE Foundation Director and weavers, left to right: Marie Cook, Cresside Collette, Sue Walker, Sara Lindsay and Liz Nettleton.

LEFT The first full-time weaver Merrill Dumbrell works on a sample for the *Emerald Hill Yellow* tapestry.

TOP LEFT 2014 artist in residence, sculptor Troy Emery.
IMAGE BY JEREMY WEIHRAUCH

BOTTOM LEFT 2014 artist in residence, jeweller Vicki Mason.

TOP RIGHT 2015 artist in residence, performance and multimedia
artist Gabrielle Leah New.

BOTTOM RIGHT 2013 artist in residence, multimedia artist Paul Yore.
IMAGE BY JEREMY WEIHRAUCH

THREADS OF COMMUNITY

As with a rock band or dance troupe, tapestry is a collaborative art. It may have a visionary at the helm — in this case the originating artist — but it cannot be completed without the rhythmic pulse and poetic coordination of the weavers literally weaving their spell.

But there is a further component essential to making this magic: the audience. The ATW prides itself on bringing together original images from leading artists and the precise skills of its weavers. However, a further priority is communicating the results to the public at large and engaging young and old alike through education in the evolution and innovation of this ancient art. This priority is realised through the ATW's Outreach and Wellbeing programs.

Artists in Residence

While the ATW is arguably best known for its work with well-known artists such as John Wolseley, David Noonan and Sally Smart, its renowned Artists in Residence program (AIR) allows artists space and interaction to enable them to expand their practice.

AIR invites artists to immerse themselves in the unique studio environment of the ATW for between two and eight weeks, full- or part-time. Artists working in any medium, not just the visual arts or textile-based practice, and at any stage of their career, can undertake the residency. This ensures a constant flow of creativity undulates through the space, creating a high-energy environment as practitioners of differing generations and media intermingle.

In 2016 alone AIR hosted such diverse artists as Aliça Bryson-Haynes, Lizzy Sampson, Andrei Davidoff, Anna Dunnill, Cat Poljski, Claire McArdle, Clementine Barnes, Debris Facility, Eva Heiky Olga Abbinga, HANDMADELIFE, Jennifer Goodman, John Brooks, Kirsty Mcafee, Louise Meuwissen, Martha Poggioli, Penelope Hunt and Sera Waters. Their media ranged across almost every form conceivable: collaboration, architecture, text and drawing, printmaking, embroidery, photography, blogging, sculpture and painting. Such diverse materials as metal, textiles, stone and wood, and many others, were used.

Interests explored in 2016 ranged across such heady subjects as national identity, religious ceremony and ritual in relation to the body, parasitic methodology, ecology and regimes of value within contemporary consumerist society.

The AIR program has, over the years, featured a dazzling, disparate array of artists. Lucas Grogan's work creates a unique autobiographical world that incorporates embroidery, drawing, painting and installation. During his residency in 2012 Grogan fashioned a remarkable patchwork quilt to add to his storehouse of aesthetics.

That same year Kate Just, who is best known for her large-scale knitted sculptural works, took inspiration from Diego Velazquez's 1656 painting *Las Meninas* to create a work weaving the activity of female artists into the very narratives of the works that they create.

In 2013 the ATW went psychedelic via the eccentric vision of Paul Yore. With strong hints of *Arte Povera*, Yore essentially ritualised practices of installation and textiles to evoke do-it-yourself craft activities.

Artists who have undertaken the residency have taken their practices well beyond the ATW's walls and into the world at large, including regional galleries and fringe festivals. The AIR program has even hosted butoh dances via the works of Lauren Cruickshank and Helen Smith, who are practising butoh dancers. During their residency Cruickshank and Smith constructed a 'movement vocabulary', creating dance-based narratives inspired by the activity of making tapestries and the process of weaving itself.

Artists who have enjoyed the hospitality of the AIR program hail from far reaching cultural and geographic backgrounds. Some are well established in their careers and share their diverse experiences with younger and emerging artists, which opens up a broad range of educational opportunities for participants. In many ways AIR contributes to the many cultural and creative freedoms the ATW represents.

Weaving into Wellbeing

In 2013 the ATW piloted a series of Weaving into Wellbeing (WiW), workshops, through the generous support of the Teresa Wardell Trust, which were held at the Royal Melbourne Women's Hospital, the Royal Children's Hospital and the Northern Hospital Bundoora Extended Care Centre. The workshops were developed in collaboration with art therapists, art educators and recreational officers.

In 2014 the ATW continued the program at these hospitals and implemented it at Warrnambool Base Hospital through donations. In 2015 the ATW continued these as

In 2013 two groups of women from refugee communities, artists from the Karen people of Burma, who work primarily in paper collage, and textile artists from Afghanistan, took part in a six-week program at the workshop, during which they were taught tapestry weaving by Sara Lindsay.

well as preparing a pilot program for future projects at the Women's & Children's Hospital Foundation in South Australia and at the Gold Coast University Hospital in Queensland. This program involves a series of weekly sessions comprising a total of 30 teaching hours. In these sessions people of all ages and abilities recovering from illness will have the opportunity to participate in therapeutic weaving activity.

WiW is a unique program that involves skilled weaver-teachers becoming hands-on participants, working with maternity patients as well as the elderly and children, all of whom seize the opportunity with great enthusiasm. But it is not just for fun and games. The ATW has worked with medical specialists to achieve practical as well as aesthetic results. The teachers become weaver-therapists, who aim to help patients with self-awareness, stress relief, dexterity and concentration.

WiW brings light and colour, contemplation and creativity into the often melancholy experience of being hospitalised.

One patient at the Royal Women's Hospital noted that during her six-week stay in Ward 5 South she had the opportunity to attend weekly classes. 'I was excited to meet new people and learn a new skill. This was vital for my mental wellbeing,' she said.

A patient at Bundoora Extended Care Centre said she 'thoroughly enjoyed reconnecting with an activity I used to do as a child'.

Tapestries in Hospitals

Public tapestries commissioned from the ATW hang in a range of institutions, including the Great Hall of the National Gallery of Victoria, Parliament House, Canberra, the Sydney Opera House, the Melbourne Museum, the foyers of Sofitel Hotel Melbourne and the Melbourne Cricket Ground.

And through the remarkable Tapestries in Hospitals program, the ATW aims to lift the spirits of the suffering via extraordinarily colourful and creative works, taking as its premise that almost every human in the western world has visited a hospital at least once, either as patient or visitor, or both. The white walls, the antiseptic smells, the often stern-looking staff, the stifled sounds, can induce anxiety in many. Tapestries in Hospitals bring colour and life into that environment, and alleviate the austere harshness of hospital interiors.

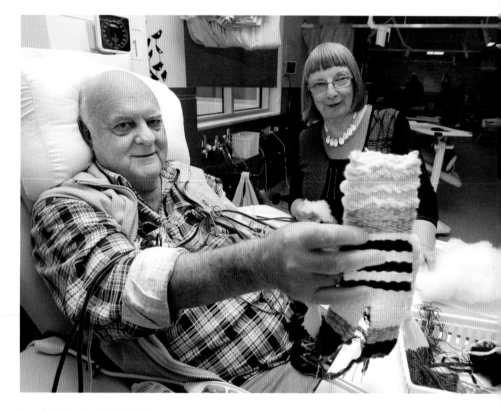

Weaving into Wellbeing Marie Cook, teacher with a patient at the Warrnambool Base Hospital.
IMAGE BY ANGELA MILNE, COURTESY OF *THE WARRNAMBOOL STANDARD*

The Royal Women's Hospital hosts one such work: *Eye Desire*, 2011, by Melbourne artist Sally Smart, who has held many exhibitions in Australia and internationally. The work was unveiled in 2011, and Smart's playful, theatrical images belie a thoughtful, considered approach to the world around her.

Smart's work often incorporates gender issues and one may think of the term 'femmage', coined by Miriam Schapiro and Melissa Meyer in the 1970s to refer to artworks created by women that incorporate assemblages of objects, as in collage. Smart wittily and creatively applied such techniques to the weaving process.

The Northern Hospital in Epping, Melbourne, proudly hosts *North Facing*, 2012, by Bern Emmerichs, a commission with the support of Hotel Care (the charitable arm of the Australian Hotels Association) and Anne and Mark Robertson. Emmerichs often works in ceramics, and for this tapestry she painted the original artwork on tile, which underwent several firings as colours were layered on. (There are two versions of the original, and the artist left it up to the weavers to compare the elements in each version and choose the one they thought most suitable.)

The artist grew up in the area where Northern Hospital is located, and created a design that whimsically incorporates the nature and history of the area. Elements of the local landscape include river red gums, volcanic rocks, the Plenty Ranges and the Plenty River, while

historical references stretch from the early Indigenous inhabitants and European settlers through to modern urbanisation. There are also allusions to commercial and leisure pursuits, including the dairy industry, market gardens and horseracing.

Emmerichs has exhibited widely throughout Australia as well as in the US and Europe. Her work has been collected by the National Gallery of Australia, the National Gallery of Victoria, the Queensland Art Gallery, the Art Gallery of Western Australia and Sydney's Powerhouse Museum, among others.

One of Dame Elisabeth Murdoch's great passions was caring for children, and one of the recipients of her generosity was the Royal Children's Hospital. As a tribute to this 75-year relationship with the hospital, its foundation commissioned Robert Ingpen AM to create the 2009 tapestry, *The Games Children Play*.

Ingpen was born in 1936, and his career has encompassed book illustration, stamp design, public mural commissions and sculptural design as well as an active fine art practice. He has illustrated and/or written more than 100 published books, both fiction and nonfiction, including illustrating Colin Thiele's classic *Storm Boy* in 1975, and illustrating a 1982 edition of *Clancy of the Overflow* by Banjo Paterson.

Ingpen has a long-standing relationship with the ATW, being the designing artist for the Melbourne Cricket

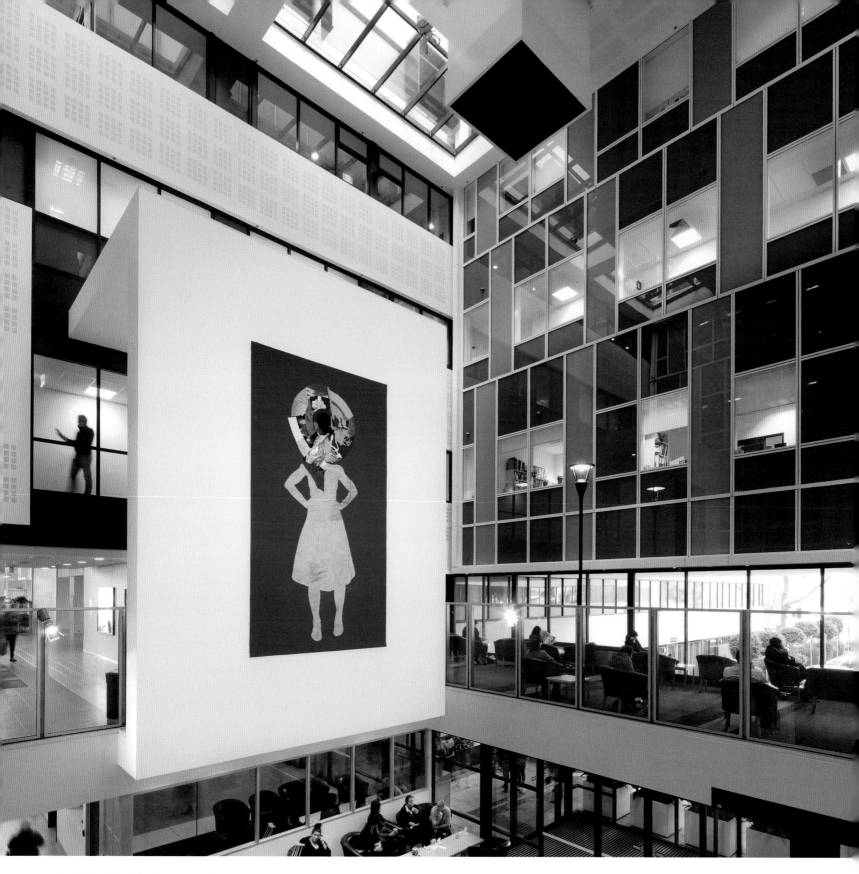

ABOVE *Eye Desire,* 2011, Sally Smart, woven by Sue Batten and Chris
Cochius, wool, cotton, 4.84 x 2.75m, in situ at the Royal Women's Hospital,
Melbourne. IMAGE BY JOHN GOLLINGS

LEFT *North Facing,* 2012, Bern Emmerichs, woven by Emma Sulzer and
Sue Batten, wool, cotton, 1.5 x 4m. Commissioned for Northern Hospital,
Melbourne. IMAGE BY VIKI PETHERBRIDGE

ABOVE *The Games Children Play*, 2009, Robert Ingpen, woven by Sue Batten, John Dicks and Emma Sulzer, wool, cotton, 1.5 x 4.2m. Commissioned for the Royal Children's Hospital, Melbourne. IMAGE BY VIKI PETHERBRIDGE

LEFT *The Games Children Play*, 2009, by Robert Ingpen enlivens the space at the Royal Children's Hospital, Melbourne. IMAGE BY JOHN GOLLINGS

TOP RIGHT Performers and visitors savour the creative space at the ATW studio during the 2015 Emerald Hill Festival. IMAGE BY JOHN GOLLINGS

RIGHT During Open House Melbourne, 2015, *Theremin Tapestry* by Chicks on Speed watches over the popular children's weaving activity. IMAGE BY JOHN GOLLINGS

Ground tapestry launched in 2004. The inspiration for this design comes from the painting *Games Children Play* by Pieter Brueghel the Elder, painted in 1590. Ingpen, using the format and flat picture plane of this work as a starting point, has re-set and re-cast Brueghel's work in the 21st century.

Other community-based collaborative projects include the *Theremin Tapestry*, which is a musical instrument designed by the artist collective Chicks On Speed in collaboration with Craft Victoria. This was a community project involving many hands and used weaving materials made from recycled fabrics and yarn.

The instrument is a tapestry with the particularity that some fragments are woven with copper wire. These filaments behave as theremin antennas connected to four sensors that can detect the presence of the human body within a metre.

Chicks on Speed is a music and fine art ensemble formed in Munich in 1997, when members Australian Alex Murray-Leslie and New Yorker Melissa Logan met at the Munich Academy of Fine Arts.

The Wolseley touch

The remarkable and eccentric John Wolseley was born in Somerset, England, in 1938. Since moving to Australia in 1978, he has deeply immersed himself in the landscape, which has given rise to a variety of different ways of collaborating with the land. His large-scale works on paper, watercolours and installations are often based around scientific themes such as the movement of tides or sand dunes, or even the forces of continental drift and evolution.

His epic tapestry *Concerning Wading Birds of the Warrnambool Wetlands*, 2012, was commissioned privately for the Warrnambool Base Hospital. This masterful work is based on a section of a comparatively humble watercolour by Wolseley. The artist had previously worked with the ATW on two tapestries, most recently with the extraordinarily complex *Fire and Water — Moths, Swamps and Lava Flows of the Hamilton Region*, commissioned by the Hamilton Art Gallery in celebration of its 50th birthday in 2011.

Wolseley's sensitivity to regional natural environments, which is so evident in *Fire and Water*, is also readily apparent in the new work. *Concerning Wading Birds* was inspired by his explorations of the wetlands and lakes of southwest Victoria. The original watercolour features evocative and beautifully rendered details of native flora and fauna, focusing on representative birds from the region, particularly the shore birds of the Warrnambool coast. It also references American abstract artist Helen Frankenthaler, who died in 2011, in its gentle tonality.

While benefiting from the established relationship between the designing artist and weavers Chris Cochius, Pamela Joyce and Milena Paplinska, which grew out of their past collaborations, this project presented its own challenges. There was the difficulty of capturing the delicate watercolour marks without making the tapestry overly complicated. The artist and weavers also had to make crucial decisions about the palette, deciding to use colours that were slightly stronger and more intense than in the watercolour.

The mysterious and inviting realm that Wolseley created serves as a site for contemplation and escape for those who may be dealing with difficult health issues, while the sheer beauty and life energy of the work will engage the broad cross-section of the community who pass through the hospital's doors.

Wolseley's work can be found in all state galleries in Australia and in many public and private collections. In 2005 he was awarded an honorary doctorate of science by Macquarie University in Sydney and the emeritus medal from the Visual Arts Board of the Australia Council. With poet Barry Hill, Wolseley published *Lines for Birds — Poems and Paintings* (UWA Publishing) in 2010.

Ashley Crawford

Concerning the Wading Birds of the Warrnambool Wetlands, 2012, John Wolseley, woven by Chris Cochius, Pamela Joyce and Milena Paplinska, wool, cotton, 1.8 x 1.9m. Commissioned for the Warrnambool Base Hospital, Warrnambool.
IMAGE BY JEREMY WEIHRAUCH

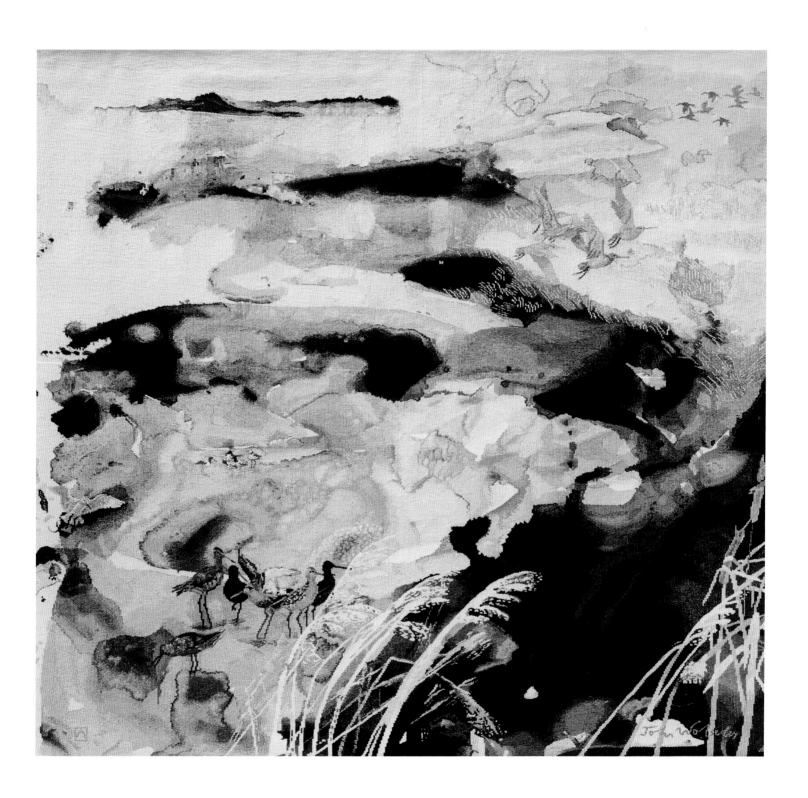

DONORS AND SUPPORTERS

The ingredients that constitute a civil and civic society are often to do with things of the spirit, for things that nourish the soul also help us reflect on what it is to be human. These are the symbols and elements of true civilisation.

In a western democracy such as ours, government income is used for a variety of purposes in the realm of the public good. For many years federal and state governments have nurtured the development of a distinctive and authentic Australian cultural life. Whilst initially drawing on the inherited traditions of Europe, focus included also Indigenous cultures and the emerging contemporary context that reflects the stories of all Australians.

Wise and mature politicians during these decades have responded to initiatives that may come from the ground up rather than from the top down. For example, in Melbourne such initiatives came from the University of Melbourne in the growth of the Melbourne Theatre Company, whereas theatre practitioners themselves were supported in the growth of La Mama, the Pram Factory, Circus Oz and the Playbox Theatre.

Notably, along this spectrum of support it was people associated with the National Gallery of Victoria Art School plus a group of enlightened Melbourne benefactors who spearheaded the growth of the Victorian College of the Arts. And it was the enthusiasm with which some of these benefactors backed Australian artists' fascination and experience with tapestry that led to the establishment of the Victorian Tapestry Workshop.

In the late 1950s John Olsen AO OBE and John Coburn discovered the deep possibilities of tapestry, one of Western civilisation's oldest and richest art forms. Financially backed in this by philanthropist art dealers, they researched the great tapestry workshops of Europe and began designing work to be woven in them. Other eminent Australian artists, such as Arthur Boyd AC OBE, Sidney Nolan OM AC and Leonard French, were also captivated by the rich potential of the medium and they also had their designs woven in Europe.

From left, core ATW supporters Baillieu Myer, Sue Walker, Janet Calvert-Jones, Dame Elisabeth Murdoch, Arnold Hancock and Carrillo Gantner at the launch of Walker's monumental survey, *Artists' Tapestries from Australia 1976–2005*.

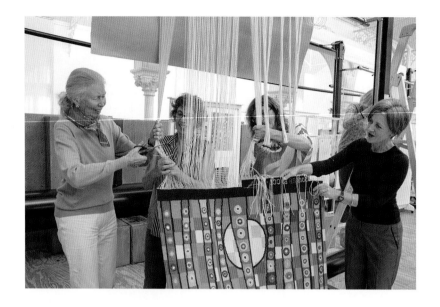

TOP From left, Sarah Myer, Sue Batten, Bronwyn Bancroft and Pamela Joyce at the cutting off ceremony for Bancroft's *Sunrise on the Washpool*, 2013.
IMAGE BY JEREMY WEIHRAUCH

BOTTOM From left, Eva Besen, artist Angela Brennan, Alan Schwartz, Marc Besen and Carol Schwartz celebrate the cutting off for *Point Addis*, 2013.
IMAGE BY JEREMY WEIHRAUCH

RIGHT From left, Pamela Joyce, Antonia Syme, Sue Batten, Keith Tyson, Chris Cochius, Elisabeth Murdoch and Milena Paplinska with the beginnings of Tyson's *Gordian Knot*, 2016, rising on the loom behind them.

In Victoria a well-supported arts scene was emerging by the early 1970s with premier Sir Rupert Hamer as minister for the arts and Eric Westbrook as his inaugural director of the ministry.

In a letter to premier Hamer, Dame Elisabeth AC DBE wrote in 1974 that 'funding by the state government is the critical factor . . . we cannot foresee the tapestry workshop as a profitable undertaking . . . its role should be seen in the community as a culturally enriching one inspired by cultural standards rather than profit, and thus should be the venture of a benevolent and sensitive government.'

Dame Elisabeth also championed a distinctive 'Australian attitude', which has become the hallmark of the tapestries produced over the past four decades, with Australian artists and weavers using Australian wool and dyes.

From its formal inception in early 1976 the VTW, rebadged as the Australian Tapestry Workshop in 2010, has relied on public and private commissions and the generosity of patrons. Two Melbourne families have been particularly involved with the workshop since its inception, as significant and generous donors, commissioners and board and committee members. Inspired by Dame Elisabeth's fervour and active engagement, her extended family have maintained their close involvement with the workshop, and similarly Myer's early engagement has been maintained and extended through his family's similar activities.

During the ensuing decades important contributions have been made by other families, including the Besen, Darling, Handbury and Robertson families by individuals such as Peter Walsh, by foundations including the Helen McPherson Smith Trust, the Buckland Foundation, the Hugh DT Williamson Fund, the Ian Potter Foundation and the Brenda Shanahan Charitable Foundation and more than 150 other donors and sponsors.

The 500-plus tapestries woven in the Australian Tapestry Workshop hang in Australian embassies, parliament houses, the Sydney Opera House, the National Library of Australia, the Great Hall of the NGV, the Arts Centre, and many other public buildings, churches, hospitals, hotels and universities throughout Australia, Canada and the UK, as well as in private and public collections and homes. It has been estimated that millions of people see the workshop's tapestries every year.

Architectural, government and individual commissions represent the earned income of the ATW, but government and donor support is important. It is a unique Australian cultural organisation, marrying as it does the artistic vision of outstanding Australian and some international artists with the skills and interpretative strengths of Australian weavers to create outstanding contemporary tapestries. As with all Australian artistic endeavours, fundamental to the sustainability of the ATW are patrons as clients and donors.

The competition for donors across the not-for-profit sector increases each year and regular donors are swamped with requests in the months leading up to the end of the financial year. Supporting the arts enables us to express our values, our stories, our diversity and importantly our rich Indigenous and settler history and our relationship with the land. Supporting the ATW enables the ongoing growth of a unique Australian cultural gem that demonstrates outstanding creativity and skill.

At an immediate level and in the tradition of Dame Elisabeth, for whom personal engagement was as important as cheque writing, such involvement in creation can also enable the visual treat of seeing the workshop in action, of watching tapestries unfolding and the sharing of celebrations in the 'cutting off', when a finished tapestry is taken off the loom and yet another glorious work of art is dispatched into the world.

Andrea Hull AO

TOP John Olsen, left, and Marc Besen cheer the final cut for Olsen's *Sun over the You Beaut Country*, 2014. **IMAGE BY JEREMY WEIHRAUCH**

BOTTOM From left, Antonia Syme, Peter Walsh, honourary life member of the Friends of the ATW, The Hon Frances Fitzgerald, Ireland's minister for children and youth affairs, and Australian ambassador to Ireland The Hon Bruce Davis at the unveiling of Patrick Mung Mung's *Ngarrgooroon*, 2010, at the Dublin embassy.

PROFILE: DAME ELISABETH MURDOCH

Dame Elisabeth Murdoch AC DBE was a remarkable and much-loved woman, a passionate advocate, an enthusiastic supporter and an inspired patron of a multiplicity of important and varied causes. She was an exceptional Australian who touched the lives of many through her warm encouragement and philanthropic support. Her love of life was infectious, as was her enthusiasm for the arts.

For those who knew her at the ATW she is remembered with great warmth and affection. As a key figure and indeed the driving force behind the workshop's establishment in 1976, Dame Elisabeth continued to be one of its most enthusiastic supporters until her death in 2012, aged 103. The ATW owes its very existence and much of its extraordinary success to the vision, drive, and astute dealings of this remarkable woman.

The idea of establishing in Victoria a workshop where Australian artists could have tapestries woven as an exciting new form of contemporary art was initially conceived by Lady Delacombe, wife of the state governor. But it was Dame Elisabeth who carried the concept forward when Lady Delacombe returned to England, chairing a small but influential committee of Melbourne's art lovers. During several years of research and lengthy negotiation with the Victorian government of the day led by premier Sir Rupert Hamer, Dame Elisabeth's tenacity and diplomacy ensured that the committee's far-sighted vision became a reality. In May 1976, with a sound philosophy and a clearly articulated business plan in place, the workshop finally opened for business.

Excited by the potential of the new workshop and the opportunities it gave to artists Dame Elisabeth threw herself with great enthusiasm into every facet of the workshop's activities. Arriving in her car from Cruden Farm she would call in on a regular basis offering encouragement and sharing in the excitement of tapestry production. She followed the progress of many tapestries on the looms from beginning to end. Inquiring into the lives and welfare of each of the weavers on her visits, and always interested in the artists, she shared the creative journey with the weaving teams and exhibited her famous exuberance at the completion of weaving.

She took on several official roles, including a long term role as a board member from 1976 to 1995. During 1988, when the workshop hosted an International Tapestry Symposium, as chairman of the board she was a gracious hostess to the 220 representatives from 43 countries who participated in the symposium, including directors from overseas workshops and celebrated artists who were keynote lecturers.

Through her board membership, which coincided with her trusteeship of the National Gallery of Victoria, her thoughtful advice, clear thinking and wise counsel were instrumental in many of the steps taken by the workshop to advance its aims and ensure its future. But she was also very practical, and readily took up a broom and bucket on one famous occasion when the studio roof flooded during a board meeting.

Dame Elisabeth readily offered her personal support to any ATW activity where she felt she could make a contribution. She was a founding member and trustee of the Tapestry Foundation of Australia, a founding member of the Friends of the Workshop, and a patron of the ATW until her death. She contributed financial support to many specific projects where the ATW needed funds to promote its cause, but her most substantial and far-reaching donation was in the mid-1990s when she contributed funds that together with a contribution from the government enabled the TFA to secure a 70 per cent freehold in the building at Park Street that had been the workshop's home since 1976.

Her great passion for tapestry and her enthusiasm to share this with others saw a level of patronage on a grand scale that ensured the people of Victoria, and visitors from interstate and overseas, could enjoy the work of Australian artists in tapestry. She funded the creation of several monumental tapestries based on the work of Roger Kemp that hang in the Great Hall of the National Gallery of Victoria, a suite of tapestries translated from delicate

watercolours by Mary Macqueen that hang in an upstairs foyer at the Arts Centre, Melbourne, and a monumental Kemp tapestry that hangs in Blackwood Hall at Monash University. With all such gestures Dame Elisabeth never sought acclaim for her generosity but offered it with grace, modesty and dignity so others could share in the pleasure she so greatly enjoyed.

Her own portrait in tapestry woven by the workshop in 2000, in which she is shown in her beloved garden at Cruden Farm, hangs in the National Portrait Gallery in Canberra as a tangible reminder of her bright mind, her generosity of spirit and her boundless enthusiasm: a fitting tribute to the workshop's beloved founding figure and staunch patron.

Dr Sue Walker AM

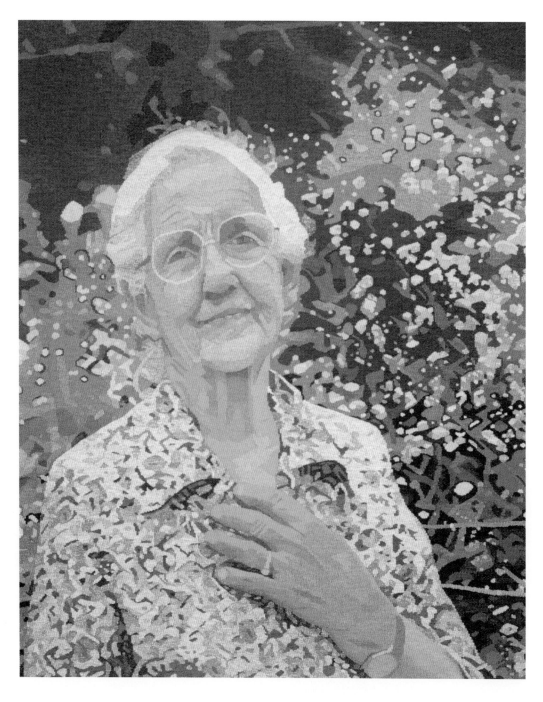

Portrait of Dame Elisabeth Murdoch, 2000, Christopher Pyett and Normana Wight, woven by Merill Dumbrell, wool, cotton, 1.47 x 1.2m. Commissioned by the National Portrait Gallery, Canberra with funds provided by Marilyn Darling, 2000. IMAGE COURTESY OF NATIONAL PORTRAIT GALLERY, CANBERRA.

PROFILE: BAILLIEU MYER

Baillieu Myer AC was an important figure in the small committee of influential Melbourne citizens who founded the Victorian Tapestry Workshop, which became the Australian Tapestry Workshop. Invited in 1973 by his close friend and admirer Dame Elisabeth Murdoch AC DBE to join the committee, his experience in large-scale retailing and his personal attributes were of enormous value in researching the feasibility of establishing a tapestry workshop in Victoria. His interest in the arts, his business acumen, a mind that was open to new initiatives and fresh opportunities, and an active belief in philanthropy were all of great benefit to the committee.

While welcoming the initiative of the committee, Myer was cautious and reminded members that traditionally the tapestry industry had only flourished in low-cost countries such as Portugal. He foresaw considerable difficulties in establishing such an industry in Australia. Forty-three years later and very proud of the workshop's extraordinary success, he is the first one to laughingly remind people of his initial scepticism. Indeed, ever since the launch of the workshop in 1976 he has been a consistent, generous and farsighted supporter of it.

As regular visitors to the workshop and familiar faces at its functions Myer and his wife Sarah have been key figures in the supportive circle that surrounds the ATW. When his friend Arnold Hancock OBE envisaged the need for a foundation to support the workshop Myer readily agreed to become a founding trustee of the Tapestry Foundation of Australia, a position he held from 1996 until 2009. In 2009 Myer was appointed Emeritus Trustee. In that role his guidance in matters relating to philanthropy and his own generous contributions brought enormous strength to the foundation and enabled it to flourish. His interest in the wider world and his lateral thinking brought imaginative concepts to the meetings of the foundation and resulted in some initiatives not previously considered.

His particular interest in Asia and its rising place in the world prompted his suggestion that a group of tapestries designed by Asian artists should be woven at the workshop. Through the auspices of the foundation and with generous donations from Myer this initiative brought a richness of experience to the weavers and forged international links of importance. With his interests in research, ideas and education, he supported any initiative of the foundation that enhanced the workshop's development.

As an ambassador for the workshop he introduced many influential friends and collectors to the world of tapestry, and through commissioning tapestries for their own home and farm he and Sarah ensured that their own lives were enhanced by the medium. An engaging painting by James Fadoulys that depicts them on their farm, with Myer riding a white horse in the foreground, was the subject for their first commission, and this was followed by several more commissions.

In 2013 he accepted the position of patron of the workshop, a fitting testament to his longstanding, generous and far-sighted contribution to it.

Dr Sue Walker AM

Baillieu Myer at the cutting off ceremony for the *Sunrise on the Washpool* tapestry designed by Bronwyn Bancroft. IMAGE BY JEREMY WEIHRAUCH

PROFILE: JANET AND JOHN CALVERT-JONES

Janet Calvert-Jones AO and John Calvert-Jones AM have been outstanding supporters of the ATW in every possible way. As imaginative patrons, as influential ambassadors and as generous philanthropists during many years, they have enthusiastically encouraged the art of tapestry and helped to ensure the success and longevity of the ATW.

Just as nobles in past centuries presented tapestries as gifts to celebrate important occasions, Janet and John commissioned personal tapestries full of individual significance for family members to mark important milestones. Indeed, they have shown a rare level of patronage through these commissions, each one of which has drawn their family circle closer to the workshop whose principal founder, Dame Elisabeth Murdoch AC DBE, was Janet's mother.

One of the most fascinating commissions was secretly negotiated by John to mark a significant moment in Janet's life. He wanted to surprise her with a tapestry depicting the scene near their beach house, which could hang in their house in town and so remind her of the beach. The

tapestry was a great success and broke new ground with senior weaver Merrill Dumbrell going to the beach location, photographing the surrounds and then weaving a scintillating tapestry with rippling water and a little boathouse.

But they have been much more than patrons: Janet and John have excelled as ambassadors and used their many influential connections to introduce new visitors to the ATW and the delights of tapestry, often dropping in to visit with a dear friend or an overseas colleague. They influenced many outcomes from these visits and encouraged the commissioning of numerous new tapestries, including important ones for public buildings.

In 2004 Janet took over the role as chairman of the Tapestry Foundation of Australia on the retirement of Arnold Hancock, a position in which she has supported significant initiatives such as the embassy tapestries and tapestries in hospitals. Janet and John have generously contributed to both these causes, thus enabling the wider community here and overseas to enjoy the work of contemporary artists in tapestry.

Of great advantage to the ATW has been the experience and wisdom Janet and John have brought from their involvement in the wider world, and particularly from their other activities in business and philanthropy. The great range of their interests and professional dealings and their extensive overseas travels have brought them in contact with a broad range of prominent people to whom they could enthuse about their shared interest in the ATW.

Janet's gracious presence on her regular visits to the workshop, where her interest in the weavers and their welfare has shown a high level of personal concern, and her thoughtful and well-prepared handling of meetings as chairman of the foundation, together with John's supportive role on official occasions, have contributed a warmth and certainty of utmost value to the heart of the ATW.

Dr Sue Walker AM

Janet Calvert-Jones speaking at the launch of Sue Walker's book.

PROFILE: ARNOLD HANCOCK

Arnold Hancock OBE has been a towering figure in the history of the ATW. His first formal contact with the workshop was in 1984 when, as the newly appointed chairman of the State Bank of Victoria, he became involved in commissioning a large tapestry for the bank.

Following on from that commission he encouraged the initiation of many further commissions and attracted generous support for the ATW through his enthusiastic advocacy.

Serving as a board member from 1987 to 2001, his great strength lay in his understanding of the workshop's position as a business in the arts and the critical need to sensitively balance commercial reality with artistic excellence. He understood absolutely the threats to the workshop's existence in a world where labour-intensive industries struggle to break even and survive.

His enthusiasm for the workshop's activities, and his sympathetic and skilled leadership, quickly made him an ideal candidate for chairman of the board, a position he held from 1989 to 1993.

Hancock's visionary thinking resulted in some far-reaching initiatives. He recognised the need for a foundation that could act as a tax-deductible conduit for donations. He set about establishing the TFA. From June 1995 until June 2003 he chaired the foundation and he remained a trustee until 2007. He instituted the Hancock Fellowship with a donation he received when he retired from his official duties with the Myer family companies. Every two years this enables the workshop to enrich its activities by bringing an international artist or scholar to lecture or participate with the weavers.

In 1988 while chairman of Commercial Union he presided over the commissioning of two remarkable tapestries designed by Michael Johnson.

In 1995, he raised the money from several corporate sources for the weaving of a tapestry depicting the raising of the flag at Botany Bay by Captain Arthur Phillip, based on the painting *The Founding of Australia* by Algernon Talmadge. The tapestry was donated to the Royal Marines Museum at Portsmouth.

While on the Monash University Council Hancock became an admirer of Celia Rosser's fine botanical illustrations of banksias. In 1993 he and his wife Pat encouraged and then purchased the first tapestry the workshop wove based on one of Rosser's banksia drawings.

Together with Gordon Darling, Hancock initiated a scheme to place ATW tapestries in Australian diplomatic posts overseas. Unable at that time to win support from Australian government sources, he raised money from private donors, including Darling and others, for the weaving of the first embassy tapestry based on a colourful painting by Indigenous artist Daisy Andrews. The tapestry hangs in the foyer of the Australian embassy in Tokyo, the first of nine tapestries from the work of Indigenous artists that are hanging in our posts overseas.

Further new ground was broken when Hancock took up the idea initiated by Baillieu Myer for the creation of an Asian Artists Collection of tapestries.

Through these initiatives and many more Hancock has added richly to the success and longevity of the ATW and helped to take it down unexpected paths. His personal interest in art, his extensive management experience, his visionary mind, his sensitive diplomacy and exceptional generosity of spirit and excitement have all contributed profoundly to Australian tapestry.

Dr Sue Walker AM

Arnold Hancock with 2015 Hancock Fellow Reiko Sudo.
IMAGE BY HEATHER LIGHTON

PROFILE: CARRILLO GANTNER

One of the distinguishing features of the founding philanthropists of the ATW is their family's continuing loyalty and support. The Myer family support began initially with Baillieu Myer AC, then extended to his siblings Ken Myer AC DSC, Lady Southey AC and Neilma Gantner, and now includes their offspring.

Carrillo Gantner AO is the son of Neilma Gantner, and the grandson of Dame Merlyn Myer OBE and Sidney Myer, of the Myer retail chain. He has had a long and distinguished career in the arts, initially as an actor, director and arts administrator then in leadership roles.

As cultural counselor at the Australian embassy in Beijing he strengthened his long-standing commitment to fostering cultural exchanges between Australia and Asia, including his founding involvement as donor to and chairman of Asialink at the University of Melbourne. He has been a member of the Australia Council and chairman of its performing arts board, a member of the Australian International Cultural Council and a Melbourne city councilor.

When it came to tapestries, he had the example of his aunt, Lady Southey (nee Marigold Myer), a long-time supporter of and donor to the ATW. Following her lead, Gantner has been a commissioner of tapestries for the ATW, as well as a co-initiating supporter of the Embassy Tapestry Program and, since 2007, a trustee of the Tapestry Foundation of Australia.

In 2004 he contributed to the completion of *Mappamundi* by Gulammohammed Sheikh. The finished tapestry is now in the collection of Asialink. Fittingly, *Mappamundi* represents a melting pot of eastern and western culture, history and contemporary events. Sheikh was born in India and has exhibited extensively in India and internationally for more than 50 years.

On behalf of his mother Neilma, Gantner commissioned *Bush Foods*, 2015, by Indigenous artist Sheena Wilfred. *Bush Foods* depicts native flora and fauna in a bright field of colour, vibrancy and spontaneity.

The Tapestry Foundation Embassy Collection places tapestries in Australian embassies and high commissions around the world. These tapestries are designed by Indigenous artists and woven by the artist weavers at the ATW. The collection commenced in 2004 with the initial support of Gantner and Arnold Hancock OBE. Nine tapestries have been completed. These hang in our embassies in Dublin, Rome, the Holy See, Beijing, Tokyo, Paris, Washington, DC and high commissions in Delhi and Singapore.

The TFA attracts donations, bequests and gifts and thus enables the ATW to initiate and support tapestry commissions. Gantner, as a previous chairman of his family foundations, the Myer Foundation and the Sidney Myer Fund, brings experience and wisdom to its deliberations.

Gantner has a lightness of touch, combined with a deep commitment to fostering a distinctive and authentic Australian cultural life.

That he has been such a patron of the ATW is no accident – family engagement may well have introduced him to it – but its values and intent are synchronistic with so much of what he has championed.

Grace Cochrane AM

Carrillo Gantner speaks at the cutting off ceremony for Sheena Wilfred's *Bush Foods*, 2015, which he had commissioned. IMAGE BY JEREMY WEIHRAUCH.

PROFILE:
SUE WALKER

Dr Sue Walker AM was the founding director of the Victorian Tapestry Workshop (VTW), and ran it for 28 years from 1976 until late 2004. After receiving a Diploma of Education and a Bachelor of Arts in Music and Political Science in 1958, she was introduced to weaving while teaching in London in the early 1960s. She continued her practice as a professional interest after her return to Melbourne, while teaching at Melbourne State College in the early 1970s. During this time she became involved in the developing crafts movement and was president of the Craft Association of Victoria in 1975–76 and president of the national body, the Crafts Council of Australia, in 1978–79.

As the proposal to establish a tapestry workshop in Melbourne developed between 1971 and 1975, Walker was invited to join its interim committee and the Victorian Council for the Arts. In February 1976 she was appointed director of the VTW and embarked on an innovative and continuing program of commissioning tapestries, training weavers, fundraising, exhibiting and publishing. Vitally important were the relationships established with government and sponsors, through the VTW board, the Tapestry Foundation of Victoria and the Friends of the VTW.

As well as managing the production of more than 350 tapestries as collaborative projects between artists and weavers during this time, Walker established a high profile for the VTW in Australia and overseas through the presence of commissioned tapestries in significant locations, as well as touring exhibitions to key venues and events. These projects provided many professional opportunities for artists and weavers, as well as architects, and Walker was regularly asked to speak, often as an official delegate, at national and international events.

During this period she was also invited to be a member of a range of boards and committees, including the Australia Council for the Arts in 1981–84, and Artbank as a founding member in 1980 and later chairwoman, from 1984–88. With weaver Kate Derum she convened an International Tapestry Symposium in Melbourne in 1988 that brought delegates from 23 countries, reinforcing the profile of the VTW as a leader in the international tapestry network. From the VTW's beginning, Walker was conscious of the need to record projects and events, and developed an important archive of documents and tapestry samples. As well as producing catalogues for exhibitions such as *Tapestry and the Australian Painter*, for the National Gallery of Victoria as early as 1978, and writing consistently for a range of journals, she carried out study for a Master of Arts Prelim in Art History at the University of Melbourne in 1995. Following her editorship of *Modern Australian Tapestries* in 2000, she drew on the detailed ATW archive in 2007 to write the milestone survey *Artists' Tapestries from Australia 1976–2005*, published by The Beagle Press. In 2009 she was awarded a Doctor of Letters by the University of Melbourne for her analysis of this history.

The significance of Walker's role in the development of the VTW, and in her related service to the arts, has been further acknowledged through being made a Member of the Order of Australia (AM) in 1983, and being awarded life membership of the NGV in 1989, an Advance Australia Award in 1994 and an Emeritus Medal by the visual arts board of the Australia Council in 2002.

Andrea Hull AO

Sue Walker, ever the passionate advocate for weaving, makes a presentation to members of the federal Parliament House Construction Authority in the 1980s.

Geoff Handbury speaks at the cutting off ceremony for *Avenue of Remembrance* tapestry.
IMAGE BY JEREMY WEIHRAUCH

HONOUR ROLL

PATRONS
Lady Delacombe CStJ
Dame Elisabeth Murdoch AC DBE
The Hon. Sir Rupert Hamer AC KCMG
Mrs Jan de Kretser
Baillieu Myer AC

ATW BOARD OF MANAGEMENT MEMBERS 1976–2016
Lenton Parr AM 1976–97
Doug Alexander 1976–77
Marion Fletcher 1976–80
Daryl Jackson AO 1976–85
Dame Elisabeth Murdoch AC DBE 1976–95
Jeffrey Newman 1976–80
John Paterson 1976–83
Brian Seidel 1976–78
Eric Westbrook 1976–85
Victor Greenaway 1978–80
Betty Churcher AO 1980–84
Lady Grimwade 1980–87
Jack Kennedy 1980–99
John Serpell 1981–86
Angus Bartlett-Bragg 1983–86
Linton Lethlean 1983–88
Jenny Chapman 1984–89
Cresside Collette 1984–89
Fiona Caro 1985–2010
Alex Dix AO 1985–90
Arnold Hancock OBE 1987–2001
John M Harrison 1987–99
Robert Bruce 1988–99
Lotte Wharton 1988–98
Stuart Purves AM 1989–91
Margaret Manion AO 1990–99
Trevor Fuller 1990–98
David Pitt 1993–2005
Jack O'Connell 1994–98
Kate Derum 1995–2004
Robyn Cass 1997–2011
Ron Millar 1997–99
Rae Ganim 1996–2004
Robyn Stewart 1999–2003
Andrew Silverson 2000–05, 2006
Rhett d'Costa 2000–03
Diana Renard 2002–09
Fran Awcock AM 2003–06
Tim Bass 2003–08

Peter Williams 2003–16
Geoffrey Ricardo 2005–11
Richard Stubbs 2006–12
Paul Quinn 2006–12
John Ridley 2007–14, 2016–
Tim Shannon 2007–11
Jon Cattapan 2008–10
Antonia Syme 2009–
Guy Abrahams 2010–14
Kay Lawrence AM 2011–
Rebecca Coates 2011–15
Bronwyn Johnson 2012–14
Richard Hilton 2012–
Peter Bancroft OAM 2013–
Robyn Baillieu 2013–
Rachel Peck 2013–
Bob Nation AM 2016–
Lisa Newcombe 2016–
Lynn Rainbow-Reid AM 2016–

BOARD CHAIRMEN 1976–2016
Lenton Parr AO 1976–85
Dame Elisabeth Murdoch AC DBE 1986–88
Arnold Hancock OBE 1989–93
Jack O'Connell 1994–98
Jack Kennedy 1998–99
David Pitt 2000–05
Fran Awcock AM 2006–08
Peter Williams 2008–16
John Ridley 2016

TRUSTEES AND MEMBERS OF THE TAPESTRY FOUNDATION OF AUSTRALIA 1976–2016
Arnold Hancock OBE 1996–2007 *
Jack Kennedy 1996–99 °
Dame Elisabeth Murdoch AC DBE 1996–2003 *
Baillieu Myer AC 1996–2009 *
Janet Calvert-Jones AO 2001–16 °
Elizabeth Proust AO 2001–02 °
Ian Evans 2000– °
Carrillo Gantner AO 2007–16 °
Anne Robertson 2008–16 °
David Pitt 1993– ^
Dr Fiona Caro 1995–^
Peter Walsh 2016– ^

* Emeritus trustee ° Trustee ^ Member

ATW board member and chairman John Ridley and Tapestry Foundation of Australia trustee Anne Robertson. IMAGE BY SEAN FENNESSY

DONORS $10K AND ABOVE

Allens-Linklaters (Arthur Robinson
 & Hedderwicks)
Annamila Pty Ltd
Australian Hotels Association
Joanna Baevski
BHP Billiton
Will and Dorothy Bailey Bequest
Diana Elizabeth Browne Trust
Janet Calvert-Jones AO & John Calvert-
 Jones AM
The Calvert-Jones Foundation
Ann Cole
John & Chris Collingwood
Community Support Fund
CRA
CUA
L Gordon Darling AC CMG
The Gordon Darling Foundation
Alan Davies and Alayne Davies
Beverly Dean in memory of Ruth Warren
Deutsche Bank
Tim Fairfax Family Foundation
Paula Fox AO
Carrillo Gantner AO
Neilma Gantner
R & L Gregory
G F Hagger
J Arnold Hancock OBE & Pat Hancock
The Geoff and Helen Handbury Foundation
Isobel and David Jones Family Foundation
Marjorie M Kingston Charitable Trust
The Robert and Mem Kirby Foundation
Estate of Dr Phillip Law
Helen MacPherson Smith Trust
Helen M Schutt Trust
Herald & Weekly Times Ltd
Hotel and Leisure Management Pty Ltd
The Jack Kennedy Fund
Macquarie Bank Limited
Morandi Investments P/L
The Hon Susan Morgan
Dame Elisabeth Murdoch AC DBE
The Estate of Dame Elisabeth Murdoch
Elisabeth Murdoch Trust
Baillieu Myer AC and Sarah Myer
Martyn Myer AO and Louise Myer
The Sarah & Baillieu Myer Family
 Foundation

The Sidney Myer Fund and The Myer
 Foundation
National Australia Bank
The Orloff Family Charitable Trust
Hazel Peat Perpetual Charitable Trust
The Ian Potter Foundation
Richard and Rosemary Raw
John T Reid Charitable Trusts
Anne and Mark Robertson OAM
Jean Elisabeth Ryan Charitable Trust
The Brenda Shanahan Charitable
 Foundation
Lady Southey AC
John Kerr Tutton Charitable Trust
Estate of Miss Margaret Littledale Tutton
The University of Melbourne
Teresa Wardell Trust
Meg Warren in memory of Ruth Warren
The Norma Mavis & Graeme Waters
 Perpetual Charitable Trust
Windermere Foundation Ltd
The Yulgilbar Foundation

CORPORATE AND IN-KIND

Architecture Media
Elgee Park Wines
Gollings Photography
Shadowfax Wines
Shelmadine Wines

GOVERNMENT

City of Port Phillip
Creative Partnerships Australia
Creative Victoria
Department of Foreign Affairs and Trade

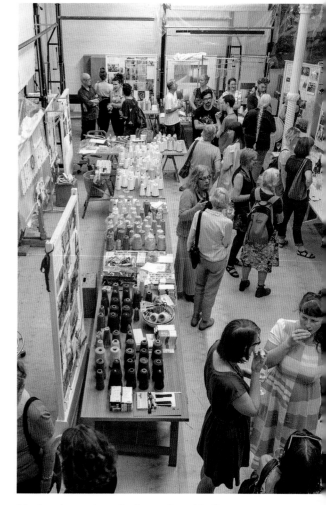

Friends and supporters enjoy the opening celebrations of *ATW AIR 2015*, an exhibition of works by ATW Artists in Residence. **IMAGE BY JEREMY WEIHRAUCH**

ABOUT THE AUTHORS

IMAGE BY JOHN LEE

Grace Cochrane AM is an independent writer and curator, and a leading expert in the field of contemporary craft. She has curated numerous exhibitions and has published many books including *The Crafts Movement in Australia: A History*, 1992.

IMAGE BY NATASHA HARTH

Julie Ewington is an independent writer, curator and broadcaster. She led the Australian art department at the Queensland Art Gallery | Gallery of Modern Art from 2001 to 2014 and has curated several Asia-Pacific Triennial exhibitions. A key figure in establishing the Women's Art Movement in the mid-1970s, she was awarded the prestigious Australia Council Visual Arts Award 2013.

IMAGE COURTESY OF THE AUTHOR

Andrea Hull AO has had a long career in the arts, cultural policy and arts education in chief executive and board roles at federal and state government levels. She was the director-chief executive of the Victorian College of the Arts for 14 years, and is now emeritus professor.

IMAGE BY SONIA PAYES

Ashley Crawford is a freelance cultural critic based in Melbourne. He writes regularly on the arts for newspapers and journals and is the author of a number of books on Australian art. He is the former editor of *World Art*, *Tension*, *21.C* and *Photofile* magazine.

IMAGE COURTESY OF THE AUTHOR

Sasha Grishin AM FAHA is an emeritus professor at the Australian National University and an art historian, curator and art critic. He has published more than 25 books and more than 2000 articles and catalogue essays dealing with various aspects of art.

IMAGE COURTESY OF THE AUTHOR

Reuben Keehan is curator, contemporary Asian art, at Queensland Art Gallery | Gallery of Modern Art. He was previously curator at Artspace, Sydney and a curator for the Asia-Pacific Triennial of Contemporary Art (2012 and 2015).

IMAGE BY NIC LONG

Kay Lawrence AM is emeritus professor at the University of South Australia and lives in Adelaide. She has an international profile as a tapestry weaver and writes on contemporary textile practice. Kay is a board member of the ATW.

IMAGE COURTESY OF THE AUTHOR

Robert Nelson is an associate professor at Monash University and art critic for *The Age* in Melbourne. His research interests lie in the intersection of the aesthetic and the moral.

IMAGE COURTESY OF THE AUTHOR

Sue Walker AM was the inaugural director of the Victorian (now Australian) Tapestry Workshop from 1976 to 2004. See her profile on page 125.

IMAGE COURTESY OF THE AUTHOR

Ian Were has written regularly for Australian art and culture journals — beginning, in the late 1970s, with *Preview* and the *Adelaide Review*. From 1996 to 2002 he edited 26 issues of *Object* magazine, and from 2002 to 2009 as senior editor at the Queensland Art Gallery he edited or co-edited many publications including *Artlines* magazine.

IMAGE BY MARK SHERWOOD

Bruce McLean is a member of the Wierdi people of the Birri Gubba Nation of Central Queensland. He is curator, Indigenous Australian art, at Queensland Art Gallery | Gallery of Modern Art. He has been a curator for the Asia-Pacific Triennial and Contemporary Australia series. He is also a songman, dancer and didgeridoo player.

IMAGE BY MARK SHERWOOD

Jason Smith is the director of Geelong Gallery. He was previously head of Australian art at the Queensland Art Gallery | Gallery of Modern Art and director of Heide Museum of Modern Art. He has curated more than 40 solo, group and thematic exhibitions and written widely on contemporary art.

IMAGE COURTESY OF THE AUTHOR

Peter Williams is founding director of WilliamsBoag Architects (WBa). He graduated from RMIT and was elected a Life Fellow of the AIA in 2007. Peter is a registered APEC architect. Under Peter's guidance, WBa has received more than 40 design awards, including the RAIA Architecture Medal in 1994.

FORTY YEARS OF TAPESTRIES

1976

Title: Emerald Hill Yellow
Artist: Alun Leach-Jones
Size: 2.5m x 2.3m
Weavers: Merrill Dumbrell, Cresside Collette, Marie Cook, Sara Lindsay, Liz Nettleton
Collection: Australian Tapestry Workshop

Title: Lattice
Artist: Guy Stuart
Size: 1.64m x 0.75m
Weavers: Merrill Dumbrell, Sara Lindsay
Collection: National Gallery of Australia, Canberra

1977

Title: F. J. Holden
Artist: All Australian Graffiti
Size: 0.79m x 0.59m
Weavers: Marie Cook, Sue Hick
Collection: Golden Fleece

Title: Paradise
Artist: Henri Bastin
Size: 1.42m x 2.67m
Weavers: Marie Cook, Irene Creedon, Sue Hick, Cheryl Thornton
Collection: Artbank, Sydney

Title: The Musicians 1 (suite of four tapestries)
Artist: Alan Weinstein
Size: 1.68m x 1.68m
Weavers: Merrill Dumbrell, Sara Lindsay, Liz Nettleton, Irja West
Collection: Saskatchewan Centre of the Arts, Canada

Title: The Musicians 2 (suite of four tapestries)
Artist: Alan Weinstein
Size: 5.33m x 1.22m
Weavers: Merrill Dumbrell, Cresside Collette, Marie Cook, Sara Lindsay, Liz Nettleton, Irja West
Collection: Saskatchewan Centre of the Arts, Canada

Title: The Musicians 3 (suite of four tapestries)
Artist: Alan Weinstein
Size: 2.44m x 2.74m
Weavers: Liz Nettleton, Cresside Collette, Sue Hick, Irja West
Collection: Saskatchewan Centre of the Arts, Canada

Title: The Musicians 4 (suite of four tapestries)
Artist: Alan Weinstein
Size: 3.05m x 4.52m
Weavers: Merrill Dumbrell, Sue Hick, Sara Lindsay, Cheryl Thornton
Collection: Saskatchewan Centre of the Arts, Canada

Title: Tricontinental Tapestry
Artist: Lady Primrose Potter
Size: 1.07m x 2.6m
Weavers: Cresside Collette, Kathy Hope, Irja West, Iain Young
Collection: Tricontinental Corporation

Title: Try Tapes
Artist: Richard Larter
Size: 3m x 1.6m
Weavers: Marie Cook, Cresside Collette, Merrill Dumbrell, Sara Lindsay, Liz Nettleton, Cheryl Thornton
Collection: Art Gallery of Western Australia

Title: Untitled
Artist: Mike Brown
Size: 1.45m x 1.04m
Weavers: Iain Young, Alan Holland
Collection: Australian Tapestry Workshop

Title: Victorian Coat of Arms
Artist: Unknown
Size: 1.89m x 1.5m
Weavers: Merrill Dumbrell, Cresside Collette, Irja West
Collection: House Committee, Parliament House, Victoria

Title: Watching the Brolgas, Western Australia
Artist: Eric Thake
Size: 0.83m x 0.67m
Weaver: Irja West
Collection: Australian Tapestry Workshop

1978

Title: Coromandel
Artist: Alun Leach-Jones
Size: 1.42m x 1.9m
Weaver: Alan Holland
Collection: National Centre for the Performing Arts, Bombay

Title: Directors Against the Sky
Artist: Jeffrey Smart AO
Size: 2.88m x 1.2m
Weavers: Marie Cook, Merrill Dumbrell, Sue Hick, Kathy Hope, Sara Lindsay, Cheryl Thornton
Collection: Commonwealth Bank of Australia

Title: Images
Artist: Roger Kemp OBE
Size: 2.35m x 3.08m
Weavers: Merrill Dumbrell, Sue Hick, Iain Young
Collection: National Gallery of Victoria

Title: Ring of Grass Trees
Artist: Robert Juniper
Size: 1.47m x 2.7m
Weavers: Sara Lindsay, Sue Carstairs
Collection: Parliament House, Perth

Title: Summer in the South
Artist: Alun Leach-Jones
Size: 10m x 1.2m
Weavers: Sara Lindsay, Sue Hick, Iain Young
Collection: Royal Automobile Club of Victoria

Title: The Performers
Artist: John Coburn
Size: 1.46m x 2.13m
Weaver: Sue Hick
Collection: Australian high commission, Wellington, New Zealand

Title: The Sun Tapestry
Artist: John Coburn
Size: 3.48m x 9.91m
Weavers: Irja West, Cresside Collette, Alan Holland, Kathy Hope, Andrea May, Jan Nelson
Collection: Parliament House, Brisbane

Title: The Winparrku Serpents
Artist: Kaapa Djambidjimpa
Size: 2.52m x 3.96m
Weavers: Sue Carstairs, Alan Holland, Kathy Hope, Andrea May, Cheryl Thornton, Irja West
Collection: Victorian Arts Centre, Melbourne

Title: Untitled
Artist: Rollin Schlicht
Size: 1.38m x 1.92m
Weavers: Cheryl Thornton, Alan Holland, Kathy Hope
Collection: Australian Tapestry Workshop

1979

Title: Australian Coat of Arms
Artist: Ron Brooks
Size: 4.62m x 2.24m
Weavers: Irja West, Gordon Cameron, Christine Harris, Nicole Johnson, Elizabeth Lipscombe
Collection: High Court of Australia, Canberra

Title: Home of Snake in Waterhole
Artist: Yala Yala Gibbs Tjungurrayi
Size: 3.48m x 3.97m
Weavers: Sue Carstairs, Mary Coughlan, Christine Harris, Valerie Kirk, Jan Nelson, Irja West
Collection: Victorian Arts Centre, Melbourne

Title: Pink Heath
Artist: Marie Cook
Size: 3.65m x 6.09m
Weavers: Marie Cook, Mary Coughlan, Sue Hick, Andrea May, Iain Young
Collection: Sofitel Melbourne

Title: Port Campbell
Artist: Jeffrey Makin
Size: 1.19m x 2.44m
Weavers: Kathy Hope, Christine Harris, Andrea May, Irja West
Collection: National Australia Bank

Title: Snakes and Ladders
Artist: Lesley Dumbrell
Size: 1.83m x 2.44m
Weavers: Sara Lindsay, Cresside Collette, Merrill Dumbrell, Alan Holland
Collection: National Australia Bank

Title: Star Type
Artist: Richard Larter
Size: 0.94m x 2.16m
Weavers: Alan Holland, Sue Carstairs, Nicole Johnson, Sara Lindsay, Cheryl Thornton
Collection: The University of Melbourne

Title: Untitled Tapestry
Artist: Guy Stuart
Size: 3.6m x 1.6 m
Weavers: Sara Lindsay, Mary Coughlan, Kathy Hope
Collection: Deakin University

Title: Wattle
Artist: Marie Cook
Size: 3.66m x 6.09m
Weavers: Marie Cook, Gordon Cameron, Ilona Fornalski, Kathy Hope, Jan Nelson, Cheryl Thornton, Wendy Webb, Irja West
Collection: Sofitel Melbourne

Title: West Melbourne
Artist: Jan Senbergs
Size: 1.67m x 2.43m
Weavers: Merrill Dumbrell, Gordon Cameron, Cresside Collette, Jan Nelson
Collection: National Australia Bank

1980

Title: Christmas in the Colonies
Artists: Murray Walker, Marie Cook
Size: 1.33m x 2.10m
Weavers: Alan Holland, Sue Carstairs
Collection: ANZ Banking Group, Melbourne

Title: Haymarket
Artists: Murray Walker, Marie Cook
Size: 2.1m x 3.27m
Weavers: Merrill Dumbrell, Sue Carstairs, Carol Dunbar, Pamela Joyce
Collection: ANZ Banking Group, Melbourne

Title: Liardet
Artists: Murray Walker, Marie Cook
Size: 2.1m x 2.3m
Weavers: Sue Batten, Andrea May
Collection: ANZ Banking Group, Melbourne

Title: Wiluna – Union Bank
Artists: Murray Walker, Marie Cook
Size: 2.1m x 1.85m
Weavers: Sara Lindsay, Sonja Hansen, Kathy Hope, Pamela Joyce, Iain Young
Collection: ANZ Banking Group, Melbourne

1981

Title: Arcadia
Artist: Alun Leach-Jones
Size: 1.5m x 3m
Weavers: Alan Holland, Dot Callender, Sue Carstairs
Collection: Ernst & Young, Melbourne

Title: Billy Tea
Artist: Mimmo Cozzolino
Size: 1.22m x 1.63m
Weaver: Sue Batten
Collection: Clemenger Harvey Pty Ltd

Title: City Geometry
Artist: John Coburn
Size: 3.63m x 0.91m
Weavers: Sue Carstairs, Alan Holland
Collection: New South Wales Permanent
Building Society

Title: Cottlesbridge Landscape
Artist: Dale Hickey
Size: 2.13m x 1.77m
Weavers: Sue Batten, Pamela Joyce
Collection: National Australia Bank

Title: Curlews in the Garden
Artist: Mirka Mora
Size: 1.77m x 2.44m
Weavers: Sara Lindsay, Ilona Fornalski,
Cheryl Thornton, Irja West
Collection: National Australia Bank

Title: Grevillea
Artist: Lesley Dumbrell
Size: 1.6m x 2.5m
Weavers: Iain Young, Sonja Hansen
Collection: Australian Tapestry Workshop

Title: House Banners
Artist: Cresside Collette
Size: 0.84m x 1.22m
Weavers: Cresside Collette, Irja West
Collection: Ivanhoe Grammar School,
Melbourne

Title: Key
Artist: John Firth Smith
Size: 2.44m x 2.44m
Weavers: Merrill Dumbrell, Sonja
Hansen, Cheryl Thornton
Collection: Private

Title: Light in the West
Artist: Alun Leach-Jones
Size: 2.27m x 4.8m
Weavers: Alan Holland, Sonja Hansen
Collection: District Court, Perth

Title: Melbourne University Coat of Arms
Artist: Ron Brooks
Size: 1.8m x 1.8m
Weavers: Sue Carstairs, Irja West
Collection: The University of Melbourne

Title: Myer Family Crest
Artist: Cresside Collette
Size: 1.17m x 0.91m
Weavers: Cresside Collette, Irja West
Collection: Private

Title: Port Campbell Series (2 tapestries)
Artist: Stephen Griffin
Size: 0.27m x 1m each
Weavers: Sara Lindsay, Ilona Fornalski,
Irja West
Collection: Ansett Airlines, Australia

Title: Rainbow Lorikeets (2 tapestries)
Artist: Patricia Moylan
Size: 0.27m x 1m each
Weavers: Merrill Dumbrell, Leonie
Bessant
Collection: Ansett Airlines, Australia

Title: Selectors
Artists: Marie Cook, Murray Walker
Size: 2.1m x 3.27m
Weavers: Marie Cook, Mary Coughlan,
Carol Dunbar, Sonja Hansen, Christine
Harris, Iain Young
Collection: ANZ Banking Group,
Melbourne

Title: The 'Little Prince' Series
Artist: Mirka Mora
Size: 0.27m x 1m
Weaver: Merrill Dumbrell
Collection: Private

Title: The Ivanhoe Tapestry
Artist: Murray Walker
Size: 1.68m x 3.65m
Weavers: Cresside Collette, Pamela
Joyce, Iain Young
Collection: Ivanhoe Grammar School,
Melbourne

Title: The Paella
Artist: John Olsen AO OBE
Size: 1.52m x 3.66m
Weavers: Alan Holland, Ilona Fornalski,
Pamela Joyce
Collection: Smorgan Consolidated
Industries, Victoria

Title: Tingari Dreaming at Mitukajirri
Artist: Charley Tawara Tjungurrayi
Size: 2.95m x 3.95m
Weavers: Andrea May, Sue Batten, Iain
Young
Collection: Victorian Arts Centre,
Melbourne

Title: Untitled
Artist: John Coburn
Size: 1.52m x 2.13m
Weavers: Pamela Joyce, Carol Dunbar
Collection: Private

Title: Untitled
Artist: John Neeson
Size: 2.07m x 3.03m
Weavers: Andrea May, Ilona Fornalski,
Alan Holland
Collection: Artbank, Sydney

Title: Untitled
Artist: Dale Hickey
Size: 1.22m x 0.84m
Weavers: Pamela Joyce, Alan Holland,
Kathy Hope
Collection: Artbank, Sydney

Title: Walter Burley Griffin Tapestry
Artist: Daryl Jackson
Size: 2.4m x 2.4m
Weavers: Merrill Dumbrell, Sue Carstairs,
Jan Nelson
Collection: National Capital Development
Commission, Canberra

Title: Western Landscape
Artist: Alun Leach-Jones
Size: 1.5m x 3m
Weavers: Leonie Bessant, Sonja Hansen
Collection: Fluor Australia

1982

Title: A Moment in the Great Game
Artist: Roy Churcher
Size: 1.85m x 2.73m
Weavers: Merrill Dumbrell, Merrin Eirth,
Alan Holland
Collection: Private, USA

Title: Blue Pacific
Artist: Alun Leach-Jones
Size: 1.78m x 3.04m
Weavers: Cresside Collette, Alan Holland
Collection: National Australia Bank

Title: Brumbys Creek, Tasmania
(2 tapestries)
Artist: Michael Shannon
Size: 0.27m x 1m each
Weavers: Cresside Collette, Cheryl
Thornton
Collection: Ansett Airlines, Australia

Title: Cottlesbridge Landscape II
Artist: Dale Hickey
Size: 1.02m x 0.79m
Weaver: Iain Young
Collection: Artbank, Sydney

Title: Currawong in Firewheel Tree
Artist: Les van der Sluys
Size: 0.9m x 0.9m
Weaver: Merrin Eirth
Collection: Artbank, Sydney

Title: Desert Carnival
Artist: John Coburn
Size: 1.54m x 2.5m
Weavers: Merrill Dumbrell, Leonie
Bessant
Collection: Hilton Hotel, Adelaide

Title: Desert Carnival II
Artist: John Coburn
Size: 1.5m x 2.2m
Weavers: Merrill Dumbrell, Sue Carstairs,
Irja West
Collection: National Australia Bank

Title: Land of Sweeping Plains
Artist: John Coburn
Size: 1m x 2.5m
Weavers: Merrill Dumbrell, Leonie
Bessant, Cresside Collette, Merrin Eirth
Collection: Hilton Hotel, Adelaide

Title: Moonlight
Artist: Michael Shannon
Size: 1.5m x 2.43m
Weavers: Cresside Collette, Pamela
Joyce, Cheryl Thornton
Collection: Artbank, Sydney

Title: Order and Direction
Artist: Roger Kemp OBE
Size: 3.34m x 2.5m
Weavers: Merrill Dumbrell, Leonie
Bessant, Irja West
Collection: Edith Cowan University,
Western Australia

Title: Paradise Garden
Artist: Alun Leach-Jones
Size: 1.5m x 3m
Weavers: Alan Holland, Sue Carstairs,
Irja West
Collection: Private

Title: Player of Pipes
Artist: Alan Weinstein
Size: 1.828m x 1.219m
Weaver: Dot Callender
Collection: Private, USA

Title: Pretty As
Artist: Richard Larter
Size: 2.895m x 4.735m
Weavers: Sara Lindsay, Cresside Collette,
Alan Holland, Pamela Joyce, Cheryl
Thornton
Collection: National Gallery of Australia,
Canberra

Title: Rosella
Artist: Lesley Dumbrell
Size: 2.925m x 4.66m
Weavers: Iain Young, Sonja Hansen
Collection: National Gallery of Australia,
Canberra

Title: Spirit of Fire
Artist: John Coburn
Size: 1.54m x 2.5m
Weavers: Sue Carstairs, Alan Holland,
Irja West
Collection: Hilton Hotel, Adelaide

Title: Springtime
Artist: Mirka Mora
Size: 0.91m x 1.43m
Weavers: Leonie Bessant, Sue Carstairs
Collection: Private

Title: Sun
Artist: Stephen Griffin
Size: 1.36m x 2.4m
Weavers: Sara Lindsay, Sonja Hansen
Collection: Artbank, Sydney

Title: Universal Oz
Artist: Jenny Kee
Size: 1.95m x 1.22m
Weavers: Pamela Joyce, Sue Carstairs
Collection: Koala Blue, USA

Title: Untitled
Artist: Mike Brown
Size: 2.19m x 2.75m
Weavers: Cheryl Thornton, Sonja Hansen,
Irja West
Collection: Ararat Gallery, Victoria

1983

Title: And the Land has Life
Artist: Rae Ganim
Size: Carpet Border: 3m x 7.25m
Weavers: Merrill Dumbrell, Merrin Eirth,
Irja West
Collection: Yulara Tourist Resort, Northern
Territory

Title: Early Days in the Goldfields
Artist: Albert Tucker
Size: 5m x 2.4m
Weavers: Iain Young, Leonie Bessant,
Sue Carstairs, Pamela Joyce
Collection: National Australia Bank

Title: Eucalypt Tapestry
Artist: Merrill Dumbrell
Size: 1.06m x 0.76m
Weaver: Merrill Dumbrell
Collection: The late Ken and Yasuko Myer

Title: In view of Heritage
Artist: Maurice Aladjem
Size: 1.96m x 1.29m
Weavers: Joy Smith, Kath Farmer
Collection: Artbank, Sydney

Title: Port Impressions
Artist: Mike Brown
Size: 1.5m x 5.5m
Weavers: Leonie Bessant, Chris Cochius, Merrin Eirth, Andrea May, Irja West
Collection: The Port of Melbourne Authority

Title: Port Reflections
Artist: Murray Walker
Size: 1.5m x 5m
Weavers: Sara Lindsay, Leonie Bessant, Sue Carstairs, Cheryl Thornton
Collection: The Port of Melbourne Authority

Title: Spring
Artist: John Coburn
Size: 2m x 1.5m
Weavers: Sara Lindsay, Irja West
Collection: Buchan Laird & Bawden Architects

Title: Summer
Artist: John Coburn
Size: 2.75m x 1.6m
Weavers: Sue Carstairs, Chris Cochius
Collection: Buchan Laird & Bawden Architects

Title: Tiwi Ritual Images
Artist: Declan Apuatimi
Size: 1.79m x 3.84m
Weavers: Sara Lindsay, Sue Carstairs, Cheryl Thornton, Irja West
Collection: Philip Morris International, USA

1984

Title: Autumn
Artist: John Coburn
Size: 2m x 1.5m
Weavers: Sara Lindsay, Pamela Joyce, Joy Smith
Collection: Buchan Laird & Bawden Architects

Title: Commonwealth Bank Tapestry
Artist: Murray Walker
Size: 1.38m x 3.81m
Weavers: Leonie Bessant, Chris Cochius, Cheryl Thornton
Collection: Commonwealth Bank of Australia

Title: Evolving Forms
Artist: Roger Kemp OBE
Size: 5m x 5.5m
Weavers: Leonie Bessant, Pamela Joyce, Irja West, Iain Young
Collection: National Gallery of Victoria, Melbourne

Title: Flowering White Gum
Artist: Philippa O'Brien
Size: 3m x 6m
Weavers: Cheryl Thornton, Sue Carstairs, Joy Smith
Collection: Perth Building Society

Title: French Pheasants
Artist: Ken Cato AO
Size: 1.5m x 1m
Weaver: Sue Batten
Collection: Mandarin Hotel, Singapore

Title: Harbour View
Artist: John Coburn
Size: 1.6m x 1.6m
Weaver: Kate Hutchinson
Collection: Private

Title: Langwarrin Landscape
Artist: Merrill Dumbrell
Size: 1.6m x 1.25m
Weaver: Merrill Dumbrell
Collection: McClelland Gallery, Langwarrin, Victoria

Title: Lights, Lights, Lights
Artist: Sara Lindsay
Size: 1.05m x 2.35m
Weavers: Sara Lindsay, Sue Carstairs
Collection: The University of Melbourne

Title: Lily Pond
Artist: John Olsen AO OBE
Size: 1.5m x 4.42m
Weavers: Iain Young, Chris Cochius, Sonja Hansen
Collection: Private

Title: Riding on a Sheep's Back
Artist: Leonie Bessant
Size: 1.37m x 2.28m
Weavers: Leonie Bessant, Sue Carstairs, Peta Meredith
Collection: Australian high commission, London

Title: Untitled
Artist: Michael Johnson
Size: 4m x 2.8m
Weavers: Andrea May, Sue Carstairs, Irja West
Collection: Waverley City Council, Melbourne

Title: Winter
Artist: John Coburn
Size: 2m x 1.5m
Weavers: Sara Lindsay, Merrin Eirth, Joy Smith
Collection: Buchan Laird & Bawden Architects

1985

Title: And the Sea
Artist: Colin Lanceley
Size: 2.69m x 1.86m
Weavers: Joan Baxter, Chris Cochius
Collection: State Bank of NSW

Title: Clouds (2 panels)
Artist: Merrill Dumbrell
Size: 3.5m x 3.5m each
Weavers: Merrill Dumbrell, Joan Baxter, Kate Hutchinson
Collection: Jetset Tours

Title: Coastal Industrial
Artist: Jan Senbergs
Size: 2.1m x 5.7m
Weavers: Cheryl Thornton, Sue Carstairs, Irene Creedon, Lindsay Pells
Collection: State Bank of NSW

Title: Mountains
Artist: Colin Lanceley
Size: 2.88m x 1.83m
Weavers: Chris Cochius, Kate Hutchinson
Collection: State Bank of NSW

Title: Reciprocal
Artist: Peter Clarke
Size: 2.45m x 4.7m
Weavers: Sara Lindsay, Irene Creedon, Irja West
Collection: Commonwealth Law Courts, Hobart

Title: Release
Artist: Roger Kemp OBE
Size: 3.8m x 4.09m
Weavers: Leonie Bessant, Pamela Joyce, Irja West
Collection: State Bank of Victoria

Title: Untitled
Artist: Les Kossatz
Size: 2.4m x 3m
Weavers: Cheryl Thornton, Chris Cochius, Joy Smith
Collection: Hamilton Art Gallery, Victoria

Title: Waratah Motif
Artist: Sue Batten
Size: 1.23m x 1.57m
Weaver: Sue Batten
Collection: Intercontinental Hotel, Sydney

1986

Title: ANZ Bank Collins Street
Artist: Murray Walker
Size: 1.5m x 2.13m
Weavers: Owen Hammond, Jos Windle
Collection: ANZ Banking Group, Melbourne

Title: Fly
Artist: Janenne Eaton
Size: 1.83m x 2.4m
Weavers: Robyn Daw, Meryn Jones
Collection: National Australia Bank

Title: Iris Motif
Artist: Helen Maudsley
Size: 2.03m x 1.52m
Weaver: Sara Lindsay
Collection: Private

Title: Port
Artist: Jan Senbergs
Size: 2.1m x 6.5m
Weavers: Cheryl Thornton, Irene Creedon, Helen Gibbs, Kate Hutchinson
Collection: State Bank of NSW

Title: Reception Hall Tapestry
Artist: Arthur Boyd AC OBE
Size: 9.18m x 19.9m
Weavers: Leonie Bessant, Sue Carstairs, Irene Creedon, Robyn Daw, Joanne Feder, Owen Hammond, Kate Hutchinson, Pamela Joyce, Peta Meredith, Robyn Mountcastle, Joy Smith, Jennifer Sharpe, Irja West, Iain Young
Collection: Parliament House, Canberra

Title: Untitled
Artist: John Olsen AO OBE
Size: 1.52m x 2.13m
Weaver: Cresside Collette
Collection: Walter & Eliza Hall Institute, Melbourne

1987

Title: Great Hall Tapestry
Artist: Arthur Boyd AC OBE
Size: 9.18m x 19.9m
Weavers: Leonie Bessant, Sue Carstairs, Irene Creedon, Robyn Daw, Joanne Feder, Owen Hammond, Kate Hutchinson, Pamela Joyce, Peta Meredith, Robyn Mountcastle, Jennifer Sharpe, Joy Smith, Iain Young, Irja West
Collection: Parliament House, Canberra

Title: Heraldic Landscape II
Artist: John Coburn
Size: 1.83m x 2.74m
Weavers: Jos Windle, Joanne Feder
Collection: Private

Title: Inland Industrial
Artist: Jan Senbergs
Size: 1.8m x 6.6m
Weavers: Cheryl Thornton, Irene Creedon, Sonja Hansen, Kate Hutchinson, Anne Kemp
Collection: State Bank of NSW

Title: Oz?
Artist: Martin Sharp
Size: 3m x 6m
Weavers: Jos Windle, Tim Gresham, Pam Ingram, Hannah Rother
Collection: State Library of New South Wales

Title: Pavilion Suite (4 tapestries)
Artist: Mary Macqueen
Size: 1.83m x 3.35m each
Weavers: Iain Young, Sonja Hansen, Joanne Feder, Joanne Mills
Collection: Victorian Arts Centre, Melbourne

Title: Rising Sun
Artist: John Olsen AO OBE
Size: 1.8m x 3.2m
Weavers: Cresside Collette, Tass Mavrogordato, Jennifer Sharpe
Collection: Private

Title: The Banksia Series (2 tapestries)
Artist: Rae Ganim
Size: 1m x 0.6m each
Weaver: Meryn Jones
Collection: Corporate collection

Title: The Barristers' Chambers
Artist: Murray Walker
Size: 1.8m x 4.8m
Weavers: Sonja Hansen, Robyn Mountcastle, Iain Young
Collection: Owen Dixon Chambers West, Melbourne

Title: Untitled
Artist: Susan Norrie
Size: 1.8m x 2.5m
Weaver: Sue Batten
Collection: IBM Australia Ltd

Title: Untitled
Artist: Sue Batten
Size: 1.52m x 3.05m
Weaver: Sue Batten
Collection: Reserve Bank, Sydney

1988
Title: Como Project
Artist: Murray Walker
Size: 2.45m x 5.6m
Weavers: Andrea May, Kate Hutchinson, Jos Windle
Collection: Como Hotel, South Yarra, Melbourne

Title: Cornflowers
Artist: Rae Ganim
Size: 1.83m x 1.83m
Weaver: Irja West
Collection: Private

Title: Figures and Grounds
Artist: John Peart
Size: 1.36m x 3.04m
Weavers: Peta Meredith, Jennifer Sharpe
Collection: ICI Melbourne

Title: Grampians Wildflowers
Artist: Marie Cook
Size: 1.4m x 3.75m
Weavers: Iain Young, Joanne Feder, Sonja Hansen
Collection: Private

Title: Guild Hall Tapestry
Artist: Murray Walker
Size: 4m x 2m
Weavers: Joanne Mills, Tass Mavrogordato
Collection: Guild Hall, London

Title: Keeping in Touch with the World
Artist: John Coburn
Size: 1.68m x 4.24m
Weavers: Jennifer Sharpe, Tim Gresham, Kate Hutchinson, Pam Ingram
Collection: Telstra Corporation

Title: Night Sky, Desert Sky Ablaze
Artist: Max Miller
Size: 1.43m x 2.81m
Weavers: Iain Young, Robyn Daw
Collection: Artbank, Sydney

Title: Paradise Garden
Artist: Colin Lanceley
Size: 2.31m x 3.38m
Weavers: Cresside Collette, Owen Hammond, Pamela Joyce, Hannah Rother
Collection: Private

Title: Reedy Creek Falls
Artist: Leonie Bessant
Size: 3.0m x 2.05m
Weavers: Leonie Bessant, Robyn Daw
Collection: Beechworth Arts Council, Victoria

Title: Revisited Objects
Artist: Alun Leach-Jones
Size: 2.25m x 1.98m
Weavers: Chris Cochius, Hannah Rother, Joy Smith
Collection: Australian Tapestry Workshop

Title: The Tradition of Law
Artist: Murray Walker
Size: 1.8m x 4.8m
Weavers: Cheryl Thornton, Anne Kemp, Meryn Jones
Collection: Owen Dixon Chambers West, Melbourne

Title: Untitled
Artist: Anatjari Tjampijinpa
Size: 1.83m x 1.83m
Weavers: Irene Creedon, Sonja Hansen, Bhanu Mistry
Collection: National Australia Bank

Title: Untitled
Artist: Garry Emery
Size: 2m x 4m
Weavers: Sara Lindsay, Joanne Feder, Tim Gresham
Collection: Museum of Victoria, Melbourne

1989
Title: Black and White
Artist: Rae Ganim
Size: 1.85m x 1m
Weaver: Joy Smith
Collection: Artbank, Sydney

Title: Cool
Artist: Michael Johnson
Size: 2.13m x 2.44m
Weavers: Robyn Daw, Sonja Hansen, Anne Kemp, Jennifer Sharpe
Collection: CGU, Melbourne

Title: Disaster at Sea
Artist: Murray Walker
Size: 3.5m x 5.4m
Weavers: Cresside Collette, Tim Gresham, Robyn Mountcastle, Joy Smith, Iain Young
Collection: Australian National Maritime Museum, Sydney

Title: Fan Tan
Artist: Lesley Dumbrell
Size: 1.74m x 2.67m
Weavers: Grazyna Bleja, Barbara Mauro
Collection: Private

Title: Light Playing with Evolution
Artist: John Olsen AO OBE
Size: 2m x 2.5m
Weavers: Andrea May, Peter Churcher
Collection: The University of Melbourne, Department of Zoology

Title: Night Cascade
Artist: David Slattery
Size: 1.275m x 1m
Weavers: Cresside Collette, Robyn Daw
Collection: Australian Tapestry Workshop

Title: Piano Movement
Artist: Roger Kemp OBE
Size: 5m x 5.5m
Weavers: Cheryl Thornton, Chris Cochius, Peta Meredith, Hannah Rother, Irja West
Collection: National Gallery of Victoria, Melbourne

Title: Shoalhaven
Artist: Arthur Boyd AC OBE
Size: 2.5m x 5m
Weavers: Robyn Daw, Chris Cochius, Peter Churcher, Irja West
Collection: Private

Title: St George Tapestry
Artist: John Coburn
Size: 6.89m x 2.5m
Weavers: Robyn Mountcastle, Sue Carstairs, Owen Hammond
Collection: St George Bank, Sydney

Title: Suns and Water
Artist: Lin Onus
Size: 0.92m x 1.53m
Weavers: Andrea May, Peter Churcher
Collection: Port of Melbourne Authority

Title: Symphony in Red and Blue
Artist: John Coburn
Size: 1.5m x 3m
Weavers: Cheryl Thornton, Grazyna Bleja, Barbara Mauro
Collection: Watermark Pty Ltd, Melbourne

Title: The Harbour
Artist: Mary Macqueen
Size: 1.7m x 2.38m
Weavers: Chris Cochius, Tim Gresham
Collection: Private

Title: Tied into Red
Artist: Helen Maudsley
Size: 2.25m x 1.5m
Weavers: Cresside Collette, Jennifer Sharpe
Collection: Private, USA

Title: Time and Tide
Artist: Mike Brown
Size: 2m x 2.37m
Weavers: Iain Young, Alan Holland
Collection: Australian Tapestry Workshop

Title: Warm
Artist: Michael Johnson
Size: 2.13m x 2.44m
Weavers: Sara Lindsay, Irene Creedon
Collection: CGU, Melbourne

1990
Title: Family Trust
Artist: Gareth Sansom
Size: 2.75m x 3.66m
Weavers: Andrea May, Peter Churcher, Hannah Rother, Jennifer Sharpe
Collection: Australian Tapestry Workshop

Title: I am Alpha, I am Omega
Artist: John Coburn
Size: 1.9m x 2.74m
Weavers: Tim Gresham, Barbara Mauro
Collection: Corporate Collection, Sydney

Title: Melbourne
Artist: Murray Walker
Size: 5m x 5.8m
Weavers: Andrea May, Sue Batten, Grazyna Bleja, Peter Churcher, Sonja Hansen, Barbara Mauro, Hannah Rother
Collection: Bourke Place foyer, Melbourne

Title: River Bank
Artist: Arthur Boyd AC OBE
Size: 3.3m x 2m
Weavers: Cresside Collette, Anne Sutton
Collection: Private

Title: Sister City Tapestry
Artist: Sara Lindsay
Size: 1.23m x 1.22m
Weavers: Sara Lindsay, Robyn Mountcastle
Collection: Department of the Premier and Cabinet, Melbourne

Title: Williamstown
Artist: Ross Moore
Size: 1.975m x 3m
Weavers: Tim Gresham, Joy Smith
Collection: Australian Tapestry Workshop

1991
Title: Aotea Tapestry
Artist: Robert Ellis
Size: 11.5m x 6.4m
Weavers: Irene Creedon, Chris Cochius, Anne Kemp, Irja West, Marete Tingstad, Iain Young
Collection: Aotea Centre, Auckland

Title: Creative Landscape: Darkness and Light
Artist: William Robinson
Size: 2.3m x 3m
Weavers: Grazyna Bleja, Tim Gresham, Hannah Rother
Collection: Art Gallery of New South Wales

Title: Crystal with Ultramarine
Artist: Christopher Pyett
Size: 1.2m x 3.8m
Weavers: Sue Batten, Jennifer Sharpe
Collection: BHP, Melbourne

Title: Droits de Place
Artist: Murray Walker
Size: 1.75m x 2.35m
Weavers: Sue Batten, Robyn Mountcastle, Jennifer Sharpe
Collection: Private, USA

Title: Heliotropical Rainforest
Artist: David van Nunen
Size: 2.32m x 2.2m
Weavers: Sara Lindsay, Barbara Mauro, Joy Smith
Collection: Private

Title: Household Name
Artist: Ann Newdigate
Size: 0.78m x 0.9m
Weaver: Hannah Rother
Collection: Private

Title: Organic Form
Artist: Roger Kemp OBE
Size: 5m x 5.55m
Weavers: Cheryl Thornton, Grazyna Bleja, Merrill Dumbrell, Robyn Mountcastle, Anne Sutton
Collection: National Gallery of Victoria, Melbourne

Title: Passacaglia I and Passacaglia II
Artist: Christopher Pyett
Size: 0.85m x 1.56m
Weavers: Merrill Dumbrell, Barbara Mauro, Hannah Rother
Collection: Private

Title: Rock at Obier
Artist: David van Nunen
Size: 4.5m x 4.5m
Weavers: Irene Creedon, Sonja Hansen, Cheryl Thornton, Irja West
Collection: Darwin Airport Authority

Title: Seated Poet and Sirens
Artist: Alun Leach-Jones
Size: 1.5m x 2.3m
Weavers: Andrea May, Irja West
Collection: Private

Title: Sydney, November 15, 1989
Artist: Patrick Heron
Size: 1.75m x 2.3m
Weavers: Anne Kemp, Barbara Mauro
Collection: Schindler Corporation, Switzerland

Title: Telecom 1
Artist: Michael Meszaros
Size: 4m x 4.5m
Weavers: Barbara Mauro, Heather Griffiths, Cheryl Thornton
Collection: Telstra Australia

Title: Untitled
Artist: Lesley Dumbrell
Size: 1.67m x 2.25m
Weaver: Robyn Mountcastle
Collection: Hamilton Art Gallery, Victoria

Title: Untitled
Artist: Gary Carsley
Size: 2m x 2.3m
Weavers: Merrill Dumbrell, Chris Cochius
Collection: Herald and Weekly Times, Melbourne

Title: Untitled
Artist: Dale Hickey
Size: 1.42m x 1.9m
Weaver: Anne Kemp
Collection: Australian Estate Management, Melbourne

Title: Verve
Artist: Kenneth Rowell
Size: 1.8m x 2.8m
Weavers: Chris Cochius, Iain Young
Collection: Australian Ballet, Melbourne

1992

Title: Cyclists in the Park
Artist: Colin Lanceley
Size: 2.22m x 3m
Weavers: Robyn Mountcastle, Tim Gresham
Collection: Private

Title: Earth and Clouds (2 tapestries)
Artist: Jude Bunn
Size: 1.4m x 2m each
Weavers: Chris Cochius, Joy Smith
Collection: Joonalup Court House, Western Australia

Title: Festival
Artist: Gordon Crook
Size: 1.5m x 1.8m
Weavers: Cheryl Thornton, Joy Smith
Collection: Australian Tapestry Workshop

Title: Shells No. 4
Artist: Based on a German lithograph
Size: 2m x 3m
Weavers: Merrill Dumbrell, Sue Batten, Grazyna Bleja, Irene Creedon
Collection: Private

Title: Telecom II
Artist: Michael Meszaros
Size: 4m x 4.5m
Weavers: Tim Gresham, Barbara Mauro, Jennifer Sharpe
Collection: Telstra Australia

Title: Terra Australis
Artist: Alun Leach-Jones
Size: 7m x 5m
Weavers: Andrea May, Sonja Hansen, Anne Kemp, Irja West
Collection: Sydney Airport Corporation

Title: Terra Australis
Artist: Martin Sharp
Size: 1.28m x 2.5m
Weaver: Iain Young
Collection: Australian high commission, London

Title: The Sun is the Source of Life
Artist: John Coburn
Size: 1.6m x 2.8m
Weavers: Peter Churcher, Joy Smith, Cheryl Thornton
Collection: Monash Medical Centre, Melbourne

Title: The Swan
Artist: Philippa O'Brien
Size: 1.7m x 7m
Weavers: Merrill Dumbrell, Claudia Lo Priore, Robyn Mountcastle, Liz Nettleton, Irja West
Collection: Federal Court, Perth

Title: The Swan
Artist: Philippa O'Brien
Size: 1.7m x 4m
Weavers: Cheryl Thornton, Anne Kemp, Joanne Mills, Hannah Rother
Collection: Federal Court, Perth

1993

Title: Autumn Tree of Life
Artist: John Coburn
Size: 1.3m x 2m
Weaver: Joy Smith
Collection: Private

Title: Awelye No 1
Artist: Gloria Petyarre
Size: 2m x 2.75m
Weavers: Grazyna Bleja, Barbara Mauro, Irja West
Collection: Private

Title: Celebrating the City
Artist: Simon Wong
Size: 2m x 3.3m
Weavers: Irene Creedon, Barbara Mauro, Lisa Stebbing
Collection: Raffles City Office Tower, Singapore

Title: Gas Bags
Artist: Geoffrey Ricardo
Size: 1.9m x 1.3m
Weavers: Irene Creedon, Claudia Lo Priore
Collection: Festival of Perth

Title: St Vincent's Hospital
Artist: Murray Walker
Size: 1.5m x 4m
Weavers: Merrill Dumbrell, Sue Batten
Collection: St Vincent's Hospital, Melbourne

Title: Sydney: November 11, 1989
Artist: Patrick Heron
Size: 1.38m x 2m
Weavers: Sue Batten, Barbara Mauro
Collection: Victoria and Albert Museum, London (on permanent loan)

Title: Untitled
Artist: Tibor Hubay
Size: 3.55m x 1.4m
Weavers: Irene Creedon, Claudia Lo Priore, Joy Smith
Collection: Private

1994

Title: Awelye No 2
Artist: Gloria Petyarre
Size: 2m x 2.75m
Weavers: Irja West, Claudia Lo Priore
Collection: Private, USA

Title: Banksia Robur
Artist: Celia Rosser
Size: 1.4m x 2m
Weaver: Sue Batten
Collection: Private

Title: City Life
Artist: Alun Leach-Jones
Size: 1.75m x 3m
Weavers: Irene Creedon, Barbara Mauro
Collection: Leader Community Newspapers

Title: Elephant Gingham
Artist: Geoffrey Ricardo
Size: 1.65m x 2m
Weavers: Claudia Lo Priore, Irja West
Collection: Private

Title: Happy Days
Artist: John Olsen AO OBE
Size: 1.96m x 3.6m
Weavers: Grazyna Bleja, Merrill Dumbrell, Barbara Mauro, Joy Smith
Collection: Corporate Collection, Sydney

Title: Jerusalem from the Judaean Desert
Artist: Franz Kempf
Size: 1.3m x 3.2m
Weavers: Irene Creedon, Jan Rizzo
Collection: Private

Title: Mazurka No. 35
Artist: Christopher Pyett
Size: 2.1m x 1.5m
Weavers: Lisa Stebbing, Barbara Mauro
Collection: Private

Title: Moon over the Flower Blossom
Artist: Goh Ben Kwan
Size: 1.65m x 2m
Weavers: Grazyna Bleja, Barbara Mauro
Collection: DBS Bank Ltd, Singapore

Title: St Peter
Artist: Christopher Pyett
Size: 1.14m x 1.54m
Weavers: Lisa Stebbing, Irja West
Collection: St Peter's College, Victoria

1995

Title: Mount Buffalo and the Great Divide
Artist: Leonie Bessant
Size: 1.8m x 4m
Weavers: Grazyna Bleja, Sue Batten, Barbara Mauro
Collection: Arrivals Hall, Melbourne Airport

Title: Ngak Ngak
Artist: Ginger Riley Munduwalawala
Size: 1.1m x 1.5m
Weaver: Irja West
Collection: Private, USA

Title: Observation de la nature
Artist: Alan Davie
Size: 1.7m x 2m
Weaver: Irene Creedon
Collection: Australian Tapestry Workshop

Title: Shoalhaven
Artist: Arthur Boyd AC OBE
Year: 1995
Size: 5m x 2m
Weavers: Irene Creedon, Irja West
Collection: Private

Title: Suburbanology
Artist: Dean Bowen
Size: 2.5m x 5m
Weavers: Merrill Dumbrell, Rebecca Moulton, Liz Nettleton, Lisa Stebbing
Collection: City of Melbourne

Title: The Dandenongs
Artist: Leonie Bessant
Size: 1.8m x 4m
Weavers: Grazyna Bleja, Sue Batten, Barbara Mauro
Collection: Arrivals Hall, Melbourne Airport

Title: The Murray River
Artist: Leonie Bessant
Size: 1.8m x 4m
Weavers: Grazyna Bleja, Merrill Dumbrell, Milena Paplinska, Irja West
Collection: Arrivals Hall, Melbourne Airport

Title: Tower Hill and the Great Ocean Road
Artist: Leonie Bessant
Size: 1.8m x 4m
Weavers: Grazyna Bleja, Sue Batten, Barbara Mauro
Collection: Federal Airports Corporation, Melbourne International Airport

Title: Untitled
Artist: Gloria Petyarre
Size: 1.8m x 4.5m
Weavers: Jan Rizzo, Lisa Stebbing, Irja West
Collection: Federal Law Courts, Brisbane

Title: Williamstown Hospital
Artist: David Slattery
Size: 1.35m x 2.1m
Weaver: Merrill Dumbrell
Collection: Williamstown Hospital, Melbourne

1996

Title: Banksia Serrata
Artist: Celia Rosser
Size: 2.2m x 3.05m
Weavers: Rebecca Moulton, Heather Griffiths, Caroline Tully
Collection: Monash University, Melbourne

Title: Midden
Artist: Judy Watson
Size: 3m x 5m
Weavers: Lisa Stebbing, Merrill Dumbrell, Owen Hammond, Hannah Rother
Collection: Queensland Art Gallery, Brisbane

Title: Ninety Mile Beach and the Gippsland Lakes
Artist: Leonie Bessant
Size: 1.8m x 4m
Weavers: Grazyna Bleja, Merrill Dumbrell, Barbara Mauro, Milena Paplinska, Irja West
Collection: Arrivals Hall, Melbourne Airport

Title: Raising the Flag
Artist: Algernon Talmage
Size: 1.85m x 2.5m
Weavers: Irene Creedon, Joy Smith
Collection: Royal Marines Museum, Hampshire, UK

Title: Suite of Maritime Tapestries (18 small tapestries)
Artist: Gordon Crook
Size: 0.1m x 0.1m each
Weaver: Sue Batten
Collection: Dowse Art Museum, Lower Hutt, New Zealand

Title: The Mallee
Artist: Leonie Bessant
Size: 1.8m x 4m
Weavers: Grazyna Bleja, Merrill Dumbrell, Milena Paplinska, Irja West
Collection: Arrivals Hall, Melbourne Airport

Title: The Smorgon Tapestry
Artist: Sue Batten
Size: 0.82m x 0.92m
Weaver: Sue Batten
Collection: Mercy Private Hospital, Melbourne

Title: Untitled
Artist: Sandy Jones
Size: 1.5m x 1.89m
Weavers: Rebecca Moulton, Merrill Dumbrell
Collection: Granada Group, London

Title: Untitled
Artist: Frank Stella
Size: 2.2m x 2.01m
Weavers: Hannah Rother, Sue Batten, Joy Smith
Collection: Private

1997

Title: A Gardener at Midnight: Day
Artist: Kristin Headlam
Size: 4.6m x 2.7m
Weavers: Lisa Stebbing, Wendy Owen
Collection: Crown Casino, Melbourne

Title: A Gardener at Midnight: Night
Artist: Kristin Headlam
Size: 4.6m x 2.7m
Weavers: Lisa Stebbing, Paula Bowen, Owen Hammond, Wendy Owen
Collection: Crown Casino, Melbourne

Title: Heidelberg Repatriation
Artist: Murray Walker
Size: 2.22m x 2.55m
Weavers: Cheryl Thornton, Owen Hammond, Joy Smith, Caroline Tully
Collection: Austin Repatriation Medical Centre, Melbourne

Title: Tree of Life
Artist: John Coburn
Size: 2.8m x 3.36m
Weavers: Grazyna Bleja, Georgina Barker, Abigail Howells, Joy Smith
Collection: Private

Title: Untitled
Artist: Emily Kame Kngwarreye
Size: 1.11m x 1.13m
Weavers: Grazyna Bleja, Milena Paplinska
Collection: Private, Paris

Title: Wamunga — My Mother's Country
Artist: Ginger Riley Munduwalawala
Size: 4m x 7.7m
Weavers: Merrill Dumbrell, Claudia Lo Priore, Amanda Markey, Milena Paplinska, Mark Thrush, Irja West
Collection: Department of Foreign Affairs and Trade, Canberra

1998

Title: 18th July 1995
Artist: Patrick Heron
Size: 1.55m x 2m
Weavers: Grazyna Bleja, Cheryl Thornton
Collection: Private

Title: 23rd July 1995
Artist: Patrick Heron
Size: 1.55m x 2.0m
Weavers: Claudia Lo Priore, Peta Fleming
Collection: Private

Title: 28 Views of the Opera House
Artist: Ken Done AM
Size: 2.86m x 3.98m
Weavers: Georgina Barker, Rebecca Moulton, Caroline Tully, Irja West
Collection: Powerhouse Museum, Sydney

Title: All that Jazz
Artist: John Coburn
Size: 1.3m x 3.2m
Weavers: Sue Batten, Paula Bowen, Claudia Lo Priore, Joy Smith, Irja West
Collection: Hyde Park Gallery Restaurant, Sydney

Title: Buddha's Curtain
Artist: Christopher Pyett
Size: 2.1m x 3.28m
Weavers: Merrill Dumbrell, Paula Bowen, Laura Mar
Collection: Buddhist Association of Shinnyo-En Australia

Title: Cafe Society
Artist: John Coburn
Size: 1.3m x 3.2m
Weavers: Sue Batten, Paula Bowen, Joy Smith, Irja West
Collection: Hyde Park Gallery Restaurant, Sydney

Title: Letters of the Law
Artist: Murray Walker
Size: 1.68m x 1.92m
Weavers: Sue Batten, Milena Paplinska
Collection: Law Council of Australia, Canberra

Title: Merton Hall Girls Grammar
Artist: Emily Collingwood
Size: 1.32m x 1.0m
Weaver: Paula Bowen
Collection: Melbourne Girls Grammar School

Title: Morning skies
Artist: Christopher Pyett
Size: 1.8m x 3.6m
Weavers: Hannah Rother, Peta Fleming
Collection: Private

Title: Oriental Village
Artist: Paul Selzer
Size: 1.6m x 2.0m
Weaver: Irja West
Collection: Private

Title: Portsea Tapestry
Artist: Merrill Dumbrell
Size: 1.6m x 2.4m
Weaver: Merrill Dumbrell
Collection: Private

Title: Rising Suns over Australia Felix
Artist: John Olsen AO OBE
Size: 4.0m x 7.77m
Weavers: Grazyna Bleja, Georgina Barker, Merrill Dumbrell, Owen Hammond, Claudia Lo Priore, Milena Paplinska, Cheryl Thornton
Collection: Department of Foreign Affairs and Trade, Canberra

Title: Salt Lakes of the Eastern Wheatbelt (2 tapestries)
Artist: Richard Woldendorp
Size: 1.2m x 1.8m and 0.65m x 0.65m
Weavers: Merrill Dumbrell, Laura Mar
Collection: Private

Title: Shoalhaven Saplings
Artist: Arthur Boyd AC OBE
Size: 2.27m x 3.75m
Weavers: Irene Creedon, Irja West
Collection: Royal Botanic Gardens, Melbourne

Title: Sydney Harbour (4 tapestries)
Artist: Ken Done AM
Size: 1.28m x 1.02m each
Weaver: Rebecca Moulton
Collection: Done Art and Design, Sydney

Title: Symbolism of Peace in the Green Vastness
Artist: James Fardoulys
Size: 1.12m x 2m
Weaver: Irja West
Collection: Private

Title: The Royal Marines
Artist: Algernon Talmage
Size: 0.76m x 0.54m
Weaver: Sue Batten
Collection: Private

Title: The Schiaparelli Project
Artist: Alun Leach-Jones
Size: 1m x 1m
Weaver: Irene Creedon
Collection: Paris Project

1999

Title: 22nd of July 1989
Artist: Patrick Heron
Size: 1.45m x 1.98m
Weaver: Cheryl Thornton
Collection: Private

Title: Acacia
Artist: Irene Creedon
Size: 0.72m x 0.92m
Weavers: Irene Creedon, Rebecca Moulton
Collection: Private, USA

Title: Celebration
Artist: David Larwill
Size: 2.85m x 4m
Weavers: Georgina Barker, Sue Batten, Merrill Dumbrell, Irja West
Collection: Commissioned by Victorian Arts Centre Trust as a gift to Esplanade Arts Centre, Singapore

Title: Christmas Gifts
Artist: Christopher Pyett
Size: 1.44m x 0.72m
Weaver: Sue Batten
Collection: Private

Title: Discovery
Artist: Christopher Pyett
Size: 2m x 3m
Weavers: Sue Batten, Heather Griffiths, Laura Mar, Katia Takla, Caroline Tully
Collection: CSIRO Plant Industry Division, Canberra

Title: Emblem
Artist: Geoffrey Ricardo
Size: 2m x 1.46m
Weaver: Claudia Lo Priore
Collection: Australian Tapestry Workshop

Title: Eternity
Artist: Martin Sharp
Size: 2m x 3.9m
Weavers: Cheryl Thornton, Georgina Barker, Merrill Dumbrell, Laura Mar, Katia Takla
Collection: Private

Title: Gift for Dame Elisabeth — Driveway at Cruden Farm
Artist: Merrill Dumbrell
Size: 0.46m x 0.33m
Weaver: Merrill Dumbrell
Collection: Dame Elisabeth Murdoch AC DBE

Title: Lorna's Rainbow Lorikeets
Artist: Les van der Sluys
Size: 1.2m x 1.2m
Weavers: Laura Mar, Katia Takla
Collection: Private

Title: Painters at Kaltukatjara
Artist: Mary McLean
Size: 2.75m x 2.04m
Weaver: Irene Creedon
Collection: Australian Tapestry Workshop

Title: Sydney Harbour (six tapestries)
Artist: Ken Done AM
Size: 1.28m x 1.53m each
Weavers: Georgina Barker, Caroline Tully, Irja West
Collection: Done Art and Design, Sydney

2000

Title: Blue Swimmer
Artist: Davida Allen
Size: 1.2m x 1.8m
Weaver: Claudia Lo Priore
Collection: Australian Tapestry Workshop

Title: Federation Tapestry: Ngak Ngak in Limmen Bight Country
Artist: Ginger Riley Munduwalawala
Size: 2.0m x 2.73m
Weavers: Grazyna Bleja, Irene Creedon, Milena Paplinska, Irja West
Collection: Museum of Victoria, Melbourne

Title: Garden of Life
Artist: John Coburn
Size: 2.7m x 3.8m
Weavers: Georgina Barker, Irene Creedon, Laura Mar, Milena Paplinska, Hannah Rother, Irja West
Collection: Australian Galleries Melbourne and Sydney

Title: Monaro Tapestry
Artist: Christopher Pyett
Size: 3m x 2.16m
Weavers: Irene Creedon, Rebecca Moulton, Hannah Rother
Collection: Elizabeth and John Fairfax

Title: Portrait of Dame Elisabeth Murdoch
Artists: Christopher Pyett, Normana Wight
Size: 1.47m x 1.2m
Weaver: Merrill Dumbrell
Collection: National Portrait Gallery, Canberra

Title: Shoalhaven Forest
Artist: Arthur Boyd AC OBE
Size: 1.8m x 2.74m
Weavers: Irene Creedon, Milena Paplinska
Collection: Private

Title: Tattersalls
Artist: Richard Goakes
Size: 2.1m x 5.0m
Weavers: Sue Batten, Laura Mar, Rebecca Moulton, Cheryl Thornton
Collection: Tattersalls, Melbourne

Title: Untitled
Artist: Stephan Reusse
Size: 1m x 2.13m
Weaver: Irja West
Collection: Private

Title: Untitled
Artist: Garry Emery
Size: 2m x 7.7m
Weavers: Irene Creedon, Milena Paplinska and Katia Takla
Collection: Stock Exchange

2001

Title: Alone in the Bush
Artist: Murray Walker: collage based on works by Reg Mombassa
Size: 2m x 1.94m
Weavers: Merrill Dumbrell, Laura Mar, Caroline Tully
Collection: Museum of Victoria, Melbourne

Title: And Now Exploration and Settlement are Under Way
Artist: Murray Walker: collage based on works by William Barak, Tommy McRae and a Groote Eylandt bark painting
Size: 2m x 6.16m
Weavers: Grazyna Bleja, Sue Batten, Sara Lindsay, Claudia Lo Priore, Laura Mar, Barbara Mauro, Rebecca Moulton, Caroline Tully, Gerda van Hamond, Irja West
Collection: Museum of Victoria, Melbourne

Title: Cavalcade
Artist: Murray Walker: collage based on works by Bruce Petty, Ron Tandberg
Size: 2m x 4.72m
Weavers: Grazyna Bleja, Irene Creedon, Pamela Joyce, Barbara Mauro, Milena Paplinska
Collection: Museum of Victoria, Melbourne

Title: Celebrations
Artist: Murray Walker: collage based on works by Martin Sharp
Size: 2m x 3.65m
Weavers: Cheryl Thornton, Grazyna Bleja, Merrill Dumbrell, Milena Paplinska
Collection: Museum of Victoria, Melbourne

Title: Federation Celebrations, Melbourne 1901
Artist: Murray Walker: collage based on works by Bruce Petty
Size: 2m x 3.65m
Weavers: Irene Creedon, Claudia Lo Priore
Collection: Museum of Victoria, Melbourne

Title: Heidelberg School
Artist: Murray Walker: collage based on works by Bruce Petty, Celia Rosser
Size: 2m x 3.89m
Weavers: Sue Batten, Chris Cochius, Milena Paplinska, Hannah Rother, Cheryl Thornton
Collection: Museum of Victoria, Melbourne

Title: Home Sweet Home
Artist: Murray Walker: collage based on works by Bruce Petty, Mirka Mora
Size: 2m x 3.82m
Weavers: Leonie Bessant, Rachel Hine, Pamela Joyce, Barbara Mauro, Alexis Simmonds, Irja West
Collection: Museum of Victoria, Melbourne

Title: Making Do
Artist: Murray Walker
Size: 2m x 4.4m
Weavers: Merrill Dumbrell, Cresside Collette, Claudia Lo Priore, Susan Mowatt, Milena Paplinska, Gerda van Hamond, Andrew Weekes
Collection: Museum of Victoria, Melbourne

Title: The Big Picture — a Convivial Gathering of Elements
Artist: Eng Tow
Size: 1.88m x 6m
Weavers: Sue Batten, Merrill Dumbrell, Miranda Legge, Laura Mar, Gerda van Hamond, Irja West
Collection: Ministry of Foreign Affairs, Singapore

Title: Untitled
Artist: Peter D. Cole
Size: 1.4m x 3.0m
Weaver: Hannah Rother
Collection: McClelland Gallery, Langwarrin, Victoria

Title: We All Live in Australia
Artist: Murray Walker
Size: 2m x 5.25m
Weavers: Claudia Lo Priore, Sue Batten, Laura Mar, Rebecca Moulton, Irja West
Collection: Museum of Victoria, Melbourne

2002

Title: Blue Interior
Artist: Mark Schaller
Size: 0.82m x 0.58m
Weaver: Milena Paplinska
Collection: Australian Tapestry Workshop

Title: Bush Suburbs
Artist: Reg Mombassa
Size: 1.8m x 2.92m
Weavers: Irja West, Merrill Dumbrell, Gerda van Hamond
Collection: Powercor Australia

Title: Disaster at sea — 2
Artist: Murray Walker
Size: 2m x 1.36m
Weavers: Merrill Dumbrell, Caroline Tully
Collection: Private, USA

Title: Disturbed Wolfman
Artist: Reg Mombassa
Size: 1.13m x 2m
Weavers: Laura Mar, Chris Cochius, Hilary Green
Collection: Nanjing Contemporary Art Museum, People's Republic of China

Title: Interior
Artist: Mark Schaller
Size: 0.82m x 0.59m
Weaver: Merrill Dumbrell
Collection: Australian Tapestry Workshop

Title: Late Evening by the Water
Artist: Christopher Pyett
Size: 1.8m x 1.38m
Weavers: Barbara Mauro, Gerda van Hamond
Collection: Private

Title: Ned Kelly approaches Albury in a Stolen Truck
Artist: Reg Mombassa
Year: 2002
Size: 0.63m x 0.82m
Weaver: Caroline Tully
Collection: Private

Title: Ned Kelly with Sunset and Truck-Cab Interior
Artist: Reg Mombassa
Size: 0.63m x 0.82m
Weaver: Caroline Tully
Collection: Private

Title: Riverbank Landscape
Artist: Jamie Boyd
Size: 1.8m x 1.2m
Weavers: Grazyna Bleja, Cheryl Thornton
Collection: Private

Title: Rocks on River
Artist: Jamie Boyd
Size: 1.8m x 1.65m
Weavers: Milena Paplinska, Barbara Mauro
Collection: Private

Title: St George and the Dragon
Artist: Based on a photographic image
Size: 1.15m x 0.9m
Weaver: Sue Batten
Collection: Private

Title: Summer Yachts
Artist: Christopher Pyett
Size: 1.2m x 0.73m
Weaver: Laura Mar
Collection: Private

Title: The Talk
Artist: David Larwill
Size: 1.71m x 2.2m
Weavers: Milena Paplinska, Irja West
Collection: Australian Tapestry Workshop

Title: Warrandyte Trees
Artist: Laura Mar
Size: 1.5m x 1.1m
Weaver: Laura Mar
Collection: Private

2003
Title: Black Tomato's Fleshy Heart
Artist: Merrin Eirth
Size: 1.78m x 1.23m
Weaver: Merrill Dumbrell
Collection: Australian Tapestry Workshop

Title: Harbour I
Artist: John Coburn
Size: 1.8m x 2.5m
Weavers: Sue Batten, Louise King
Collection: Private

Title: Harbour II
Artist: John Coburn
Size: 1.8m x 2.5m
Weavers: Sue Batten, Merrill Dumbrell
Collection: Private

Title: Landscape with Rainbow
Artist: Meg Benwell
Size: 0.92m x 0.88m
Weaver: Rachel Hine
Collection: Private

Title: Langley Landscape with Bridge,
Waterhole, Tree and Moon
Artist: Peter D. Cole
Size: 1.2m x 1.62m
Weavers: Chris Cochius, Hannah Rother
Collection: Private

Title: Melbourne Cricket Ground Tapestry
Artist: Robert Ingpen AM
Size: 2m x 7m
Weavers: Grazyna Bleja, Sue Batten,
Chris Cochius, Merrill Dumbrell,
Hilary Green, Pamela Joyce, Laura Mar,
Irja West, Caroline Tully
Collection: Melbourne Cricket Club

Title: Morning Skies II
Artist: Christopher Pyett
Size: 1.52m x 5.52m
Weavers: Milena Paplinska, Chris
Cochius, Rachel Hine, Barbara Mauro,
Caroline Tully
Collection: Private

Title: Morning Skies III
Artist: Christopher Pyett
Size: 1.52m x 2.52m
Weavers: Milena Paplinska, Chris
Cochius, Rachel Hine, Barbara Mauro,
Caroline Tully
Collection: Private

Title: Morning Skies IV
Artist: Christopher Pyett
Size: 1.52m x 1.88m
Weavers: Caroline Tully, Hilary Green
Collection: Private

Title: Sutherland Bicentennial Memorial
Tapestry
Artist: John Ralfs
Size: 2.1m x 1.5m
Weaver: Barbara Mauro
Collection: Sutherland Shire, NSW

Title: Sydney Harbour
Artist: John Coburn
Size: 1.6m x 2.06m
Weavers: Pamela Joyce, Hilary Green
Collection: Private

Title: The Cross
Artist: Roger Kemp OBE
Size: 5.4m x 4.05m
Weavers: Merrill Dumbrell, Cheryl
Thornton, Gerda van Hamond, Irja West
Collection: Monash University,
Melbourne

Title: Untitled (Blue Head)
Artist: Peter Walsh
Size: 0.57m x 0.51m
Weaver: Rachel Hine
Collection: Private

Title: Untitled (Orange Figure)
Artist: Peter Walsh
Size: 0.56m x 0.55m
Weaver: John Dicks
Collection: Private

Title: Untitled (Pink Heads)
Artist: Peter Walsh
Size: 0.55m x 0.53m
Weaver: Hilary Green
Collection: Private

Title: Untitled I
Artist: Margaret Stones
Size: 1.4m x 2.1m
Weavers: Chris Cochius, Louise King,
Irja West
Collection: Government House, Victoria

Title: Untitled II
Artist: Margaret Stones
Size: 1.4m x 2.1m
Weavers: Chris Cochius, Louise King,
Irja West
Collection: Government House, Victoria

2004
Title: Ace of Spades
Artist: Arlene Textaqueen
Size: 0.77m x 0.565m
Weaver: Hilary Green
Collection: Australian Tapestry Workshop

Title: Debney Park Secondary College
Tapestry
Artist: David Slattery
Size: 1.25m x 2m
Weavers: Sue Batten, John Dicks
Collection: Debney Park Secondary
College

Title: Dunkeld Tapestry
Artist: Christopher Pyett
Size: 1.5m x 5.4m
Weavers: Sue Batten, Chris Cochius, Peta
Fleming, Hilary Green, Rebecca Moulton
Collection: Royal Mail Hotel, Dunkeld,
Victoria (lost in a fire)

Title: Homage to Carl Philip Emmanuel
Bach
Artist: Jørn Utzon AC
Size: 2.67m x 14.02m
Weavers: Cheryl Thornton, Chris Cochius,
Pamela Joyce, Milena Paplinska
Collection: Sydney Opera House

Title: Jack of Hearts
Artist: Arlene Textaqueen
Size: 0.77m x 0.565m
Weaver: Rachel Hine
Collection: Australian Tapestry Workshop

Title: Lumpu Lumpu Country
Artist: Daisy Andrews
Size: 1.9m x 2.3m
Weavers: Irja West, Louise King
Collection: Tapestry Foundation of
Australia on loan to the Australian
embassy, Tokyo

Title: Mappamundi
Artist: Gulammohammed Sheikh
Size: 3.02m x 3.6m
Weavers: Cheryl Thornton, Amy Cornall,
Rachel Hine, Caroline Tully
Collection: Asialink, University of
Melbourne

Title: Papaya
Artist: Lin Utzon
Size: 1.47m x 2.12m
Weavers: Pamela Joyce, Milly Formby
Collection: Private

Title: Queen of Hearts
Artist: Arlene Textaqueen
Size: 0.77m x 0.565m
Weaver: Caroline Tully
Collection: Australian Tapestry Workshop

Title: The Diggers
Artist: David Larwill
Size: 2m x 3.0m
Weavers: Sue Batten, John Dicks, Dorota
Skoneczna
Collection: University of Ballarat, Victoria

2005
Title: Abstract Sequence
Artist: Roger Kemp OBE
Size: 5m x 5.84m
Weavers: Leonie Bessant, John Dicks,
Pamela Joyce, Laura Mar, Rebecca
Moulton, Cheryl Thornton, Irja West
Collection: National Gallery of Victoria

Title: Bairnsdale Hospital Tapestry
Artist: Geoffrey Ricardo
Size: 2.3m x 2.67m
Weavers: Sue Batten, John Dicks
Collection: Bairnsdale Hospital, Victoria

Title: Forest Noise
Artist: Ian Woo
Size: 1.4m x 2.46m
Weavers: Chris Cochius, Milly Formby,
Hilary Green
Collection: The Mint Museum, North
Carolina, USA

Title: Mutabolis
Artist: Christine Johnson
Size: 1.1m x 2.02m
Weavers: Milena Paplinska, Amy Cornall
Collection: CASPAR Care

Title: Open World
Artist: John Young
Size: 3.3m x 3.65m
Weavers: Milena Paplinska, Amy Cornall,
Rachel Hine, Caroline Tully
Collection: Nanjing Library, Nanjing,
China

Title: Pwoja Pukamuni Body Paint Design
Artist: Pedro Wonaeamirri
Size: 1.2m x 2.3m
Weavers: Milena Paplinska, John Dicks
Collection: Tapestry Foundation of
Australia on loan to the Australian
embassy, Beijing

Title: Tonga Station, Mansfield
Artist: Meg Benwell
Size: 1.48m x 2.1m
Weavers: Louise King, Milly Formby
Collection: Private

Title: Victorian Racing Club Tapestry
Artist: Melinda Coombes
Size: 2m x 3m
Weavers: Sue Batten, Milly Formby,
Louise King, Rebecca Moulton
Collection: Victorian Racing Club,
Melbourne

2006
Title: Birds of the Clarence
Artist: Robert Ingpen AM
Size: 1.27m x 0.99m
Weaver: Chris Cochius
Collection: Private

Title: Circus V
Artist: Ken Whisson
Size: 2.53m x 3.3m
Weavers: Rachel Hine, Laura Mar,
Rebecca Moulton
Collection: National Institute of Circus
Arts, Melbourne

Title: Glyphs
Artist: G. W. Bot
Size: 0.9m x 3.97m
Weavers: Cheryl Thornton, Amy Cornall,
Emma Sulzer
Collection: Private

Title: Good Heavens
Artist: Eng Tow
Size: 2.1m x 2.2m
Weavers: Rebecca Moulton, Amy Cornall
Collection: Private, Singapore

Title: It Was Not I Who Looked At
The Forest
Artist: Angela Brennan
Size: 2.16m x 2.6m
Weavers: Sue Batten, Amy Cornall,
Pamela Joyce, Rebecca Moulton
Collection: Private

Title: Let Me Put My Love into You
Artist: Nell
Size: 1.61m x 3.0m
Weavers: Sue Batten, John Dicks,
Pamela Joyce
Collection: Deutsche Bank, Sydney

Title: Mater Misericordiae
Artist: Christopher Pyett
Size: 2.4m x 2.4m
Weavers: Cheryl Thornton, Amy Cornall,
Rachel Hine
Collection: Mary, Mother of Mercy
Chapel and Crematorium, Rookwood,
Sydney

Title: Northern View from Wirilda
Artist: Kristin Headlam
Size: 0.7m x 1.2m
Weavers: Caroline Tully, Milly Formby,
Cheryl Thornton
Collection: Private

Title: Two Houses
Artist: Rosella Namok
Size: 1.41m x 2m
Weavers: Pamela Joyce, Caroline Tully
Collection: Private

Title: Unity in Space
Artist: Roger Kemp OBE
Size: 5m x 3.3m
Weavers: Cheryl Thornton, Chris Cochius,
Louise King, Pamela Joyce, Rebecca
Moulton
Collection: National Gallery of Victoria,
Melbourne

2007

Title: Abstract Structure
Artist: Roger Kemp OBE
Size: 5m x 3.6m
Weavers: Sue Batten, Amy Cornall, John
Dicks, Pamela Joyce, Caroline Tully
Collection: National Gallery of Victoria,
Melbourne

Title: Dulka Warngiid (Land of All)
Artists: Mirdidingkingathi Juwarnda
Sally Gabori, Rayarriwarrtharrbayingathi
Mingungurra Amy Loogatha,
Birmuyingathi Maali Netta Loogatha,
Thunduyingathi Bijarrb May
Moodoonuthi, Wirrngajingathi
Bijarrb Kurdalalngk Dawn Narranatjil,
Kuruwarriyingathi Bijarrb Paula Paul and
Warthadangathi Bijarrba Ethel Thomas
Size: 1.99m x 6.1m
Weavers: Cheryl Thornton, Amy Cornall
and Rebecca Moulton
Collection: Melbourne Recital Centre

Title: Research and Respond
Artist: Merrin Eirth
Size: 2m x 4m
Weavers: Chris Cochius, Louise King,
Rebecca Moulton, Emma Sulzer
Collection: Royal Melbourne Hospital

Title: Untitled (Kiwirrkurra Women's
Painting)
Artist: Nanyuma Napangarti
Size: 3.05m x 1.98m
Weavers: Cheryl Thornton, Mala Anthony,
Louise King, Milena Paplinska
Collection: Tapestry Foundation of
Australia on loan to the Australian high
commission, New Delhi

Title: Wilkinkarra
Artist: Pauline Sunfly
Size: 1.12m x 0.56m
Weaver: Cheryl Thornton
Collection: Private

2008

Title: Alice Bayke
Artist: Yvonne Todd
Size: 3m x 2.4m
Weavers: Sue Batten, Amy Cornall
Collection: Queensland Art Gallery,
Brisbane

Title: At the Box
Artist: David Larwill
Size: 1.59m x 2.24m
Weavers: Chris Cochius, Mala Anthony,
Caroline Tully
Collection: Foxtel, Sydney

Title: Birds of the Clarence II
Artist: Robert Ingpen
Size: 1.35m x 0.99m
Weavers: Caroline Tully, Jennifer Sharpe
Collection: Private

Title: Into the Light
Artist: Leonie Bessant
Size: 7.1m x 3.4m
Weavers: Leonie Bessant, Mala Anthony,
Pamela Joyce, Louise King
Collection: Wangaratta Cathedral, Victoria

Title: Kimberley Under the Stars
Artist: Trevor Nickolls
Size: 1.34m x 2.9m
Weavers: John Dicks, Milly Formby,
Louise King
Collection: Tapestry Foundation of
Australia on loan to the Australian
embassy, Washington DC

Title: The Visitor
Artist: Jon Cattapan
Size: 1.5m x 7.7m
Weavers: Chris Cochius, John Dicks,
Milly Formby, Emma Sulzer
Collection: Xavier College, Melbourne

2009

Title: Cavan
Artist: John Wolseley
Size: 0.81m x 1.5m
Weavers: Pamela Joyce, John Dicks
Collection: Private, USA

Title: Creek Bed
Artist: Elizabeth Marks Nakamarra
Size: 1.82m x 2.72m
Weavers: Pamela Joyce, Chris Cochius,
Louise King
Collection: Tapestry Foundation of
Australia on loan to the Australian
embassy, Paris

Title: Kong Fu — Our Dream 1
Artist: Song Ling
Size: 1.46m x 3.57m
Weavers: Amy Cornall, Emma Sulzer
Collection: Deakin University, Melbourne

Title: The Games Children Play
Artist: Robert Ingpen AO
Size: 1.5m x 4.2m
Weavers: Sue Batten, John Dicks,
Emma Sulzer
Collection: Royal Children's Hospital
Foundation

Title: Myer Tapestry
Artist: Based on historic photograph
Size: 0.99m x 1.3m
Weavers: Emma Sulzer, John Dicks
Collection: Myer Building, Docklands,
Melbourne

Title: Park No. 2
Artist: Yvonne Boag
Size: 1.5m x 2.28m
Weavers: Cheryl Thornton, Milly Formby,
Caroline Tully
Collection: International School, Sharjah

Title: Untitled
Artist: David Noonan
Size: 2.28m x 2.93m
Weavers: Cheryl Thornton, Sue Batten,
Amy Cornall
Collection: Private

2010

Title: Birds and Leaves and We Ourselves
Come Forth in Perfect Harmony
Artist: Nell
Size: 1m x 2m
Weavers: John Dicks, Sue Batten
Collection: Private

Title: Celebrated Light
Artist: Lara Merrett
Size: 1.35m x 1.09m
Weavers: Pamela Joyce, Cheryl Thornton
Collection: St Michael's Uniting Church,
Melbourne

Title: Fire and Water — Moths, Swamps
and Lava Flows of the Hamilton Region
Artist: John Wolseley
Size: 2m x 3m
Weavers: Chris Cochius, Milly Formby,
Pamela Joyce
Collection: Hamilton Art Gallery, Victoria

Title: Ngarrgoorroon
Artist: Patrick Mung Mung
Size: 1.8m x 2.16m
Weavers: Cheryl Thornton, John Dicks,
Milly Formby
Collection: Tapestry Foundation of
Australia on loan to the Australian
embassy, Dublin

Title: Ngayuku Ngura
Artist: Nyankulya Watson
Size: 1.85m x 2.72m
Weavers: Louise King, Amy Cornall,
Emma Sulzer, Caroline Tully
Collection: Tapestry Foundation of
Australia on loan to the Australian
embassy, Rome

Title: Puli Murpu
Artist: Ruby Williamson
Size: 1.6m x 1.28m
Weavers: Sue Batten, Emma Sulzer
Collection: Private collection, USA

Title: Spring Street End
Artist: Ben McKeown
Size: 4.2m x 3.26m
Weavers: Pamela Joyce, John Dicks,
Milly Formby, Milena Paplinska, Jennifer
Sharpe, Emma Sulzer, Cheryl Thornton
Collection: Tapestry Foundation of
Australia gifted to the State Library of
Victoria, Melbourne

2011

Title: Allegro
Artist: Yvonne Audette
Size: 1.19m x 1.5m
Weavers: Chris Cochius, Sue Batten
Collection: Lyceum Club, Victoria

Title: Eye Desire
Artist: Sally Smart
Size: 4.84m x 2.75m
Weavers: Sue Batten, Chris Cochius
Collection: Tapestry Foundation of
Australia gifted to the Royal Women's
Hospital, Melbourne

Title: Finding Kenneth Myer
Artist: John Young
Size: 2.3m x 3.02m
Weavers: Cheryl Thornton, John Dicks,
Milena Paplinska
Collection: National Library of Australia,
Canberra

Title: Kunawarritji to Wajaparni
Artists: Clifford Brooks, Jeffrey
James, Putuparri Tom Lawford, Peter
Tinker, Richard Yukenbarri Tjakamarra,
Charlie Wallabi Tjungurrayi, Helicopter
Tjungurrayi, Patrick Tjungurrayi
Size: 1.66m x 4m
Weavers: Pamela Joyce, Sue Batten,
Chris Cochius, Milly Formby, Emma
Sulzer
Collection: Tapestry Foundation of
Australia on loan to the Australian
embassy to the Holy See at the Vatican

2012

Title: Concerning the Wading Birds of the
Warrnambool Wetlands
Artist: John Wolseley
Size: 1.8m x 1.9m
Weavers: Chris Cochius, Pamela Joyce,
Milena Paplinska
Collection: Tapestry Foundation of
Australia gifted to Warrnambool Base
Hospital, Victoria

Title: Facing North
Artist: Bern Emmerichs
Size: 1.5m x 4m
Weavers: Emma Sulzer, Sue Batten
Collection: Tapestry Foundation of
Australia gifted to the Northern Hospital,
Victoria

Title: Kungkarrakalpa (The Seven Sisters)
Artist: Anmanari Brown
Size: 1.7m x 2.46m
Weavers: Pamela Joyce, John Dicks,
Milena Paplinska, Emma Sulzer
Collection: Private, UK

Title: Rome
Artist: Brent Harris
Size: 1.6m x 1.18m
Weaver: Sue Batten
Collection: Private

Title: Untitled
Artist: David Noonan
Size: 2m x 1.63m
Weavers: Emma Sulzer, Cheryl Thornton
Collection: Private

2013

Title: Diamond Jubilee Tapestry
Artist: Nusra Latif Qureshi
Size: 1m x 1.5m
Weavers: Sue Batten, Chris Cochius
Collection: Private, USA

Title: Point Addis
Artist: Angela Brennan
Size: 1.8m x 2m
Weavers: Milena Paplinska, Sue Batten,
Chris Cochius
Collection: Private

Title: Polo
Artist: Based on an image by Andrew
Calvert Jones
Size: 0.7m x 1.1m
Weaver: Chris Cochius
Collection: Private

Title: Sorry
Artist: Juan Davila
Size: 4.2m x 3.26m
Weavers: Pamela Joyce, Sue Batten,
Milena Paplinska, Cheryl Thornton
Collection: State Library of Victoria,
Melbourne

Title: Sunrise on the Washpool
Artist: Bronwyn Bancroft
Size: 1.05m x 1.27m
Weavers: Pamela Joyce, Sue Batten,
Cheryl Thornton
Collection: Private

2014

Title: Catching Breath
Artist: Brook Andrew
Size: 1.9m x 1.5m
Weavers: Chris Cochius, Pamela Joyce,
Milena Paplinska
Collection: Australian Tapestry Workshop
on loan to Australian high commission in
Singapore

Title: Everything has Two Witnesses, One
on Earth and One in the Sky
Artist: Sangeeta Sandrasegar
Size: 1.64m x 0.9m
Weaver: Sue Batten
Collection: Australian Tapestry Workshop

Title: Rufiji River from Mbuyuni Camp,
Selous Game Reserve, in Tanzania
Artist: HRH The Prince of Wales
Size: 1.37m x 1.73m
Weavers: Pamela Joyce, Chris Cochius
Collection: Private

Title: Sun over the You Beaut Country
Artist: John Olsen AO OBE
Size: 1.6m x 2.8m
Weavers: Sue Batten, Chris Cochius,
Pamela Joyce, Milena Paplinska, Cheryl
Thornton
Collection: Private

2015

Title: Avenue of Remembrance
Artist: Imants Tillers
Size: 3.27m x 2.83m
Weavers: Chris Cochius, Sue Batten,
Leonie Bessant, Pamela Joyce, Milena
Paplinska, Laura Russell, Cheryl Thornton
Collection: Australian War Memorial,
Canberra

Title: Bush Foods
Artist: Sheena Wilfred
Size: 1.84m x 2.15m
Weavers: Pamela Joyce, Chris Cochius,
Cheryl Thornton
Collection: Private

Title: Graeme Acton Memorial Tapestry
Artist: Based on a photographic image
Size: 1.5m x 0.99m
Weavers: Pamela Joyce, Jennifer Sharpe
Collection: Private

2016

Title: Gordian Knot
Artist: Keith Tyson
Size: 2.4m x 2.4m
Weavers: Chris Cochius, Sue Batten,
Pamela Joyce, Milena Paplinska
Collection: Private

Title: Life Burst
Artist: John Olsen AO OBE
Size: 1.1m x 5.5m
Weavers: Pamela Joyce, Sue Batten,
Chris Cochius, Jennifer Sharpe, Cheryl
Thornton
Collection: Peter MacCallum Cancer
Centre through the Tapestry Foundation
of Australia

Title: Perspectives on a Flat Surface
Artist: John Wardle Associates
Size: 1.9m x 3.8m
Weavers: Chris Cochius, Pamela Joyce,
Jennifer Sharpe and Cheryl Thornton
Collection: Judith Neilson AM

REFERENCES

'Art on the loom' by Grace Cochrane

Grace Cochrane, *The Crafts Movement in Australia: A History*, UNSW Press, Kensington, NSW, 1992.

Sue Walker, *Artists' Tapestries from Australia 1976–2005*, The Beagle Press, Sydney, 2007.

Sue Walker, *Tapestry and the Australian Painter*, National Gallery of Victoria, Melbourne, 1978.

Ian Were (ed.), *Contemporary Australian Tapestries*, Australian Tapestry Workshop, South Melbourne, 2010.

VTW News and *ATW News*, later *At the Workshop*: Australian Tapestry Workshop annual bulletins, 2009–2015.

Notes: The Craft Association of Victoria, 1971, known from 1978 as the Crafts Council of Victoria, then Craft, now Craft Victoria; Crafts Council of Australia, later Craft Australia, 1971–2012. The Victorian Ministry for the Arts was renamed Arts Victoria in 1998 and is now Creative Victoria. The Edinburgh Tapestry Company was established in 1912, and tapestries were woven in the Dovecot Studio, which was incorporated into the company in 1946. Familiarly known throughout as Dovecot, in 2001 it was re-established as the Dovecot Tapestry Studio.

'Lit from within' by Sasha Grishin

Deborah Hart, *John Olsen*, Craftsman House, Sydney, 2000, p. 161.

Patrick McCaughey, 'John Olsen and Jeffrey Smart', in Maudie Palmer (ed.), *Encounters with Australian Modern Art*, Macmillan Art Publishing, Melbourne, 2008.

John Olsen, *Drawn from Life*, Duffy & Snellgrove, Sydney, 1997, p.55. Three further tapestries were made in Portalegre in 1966: *Nude with Clock*, *Yellow Summer* and *Verdure*.

'A cartography of love' by Reuben Keehan

Alfred Hiatt, 'Maps of empires past', in Barbara Buchenau and Virginia Richter (eds.), *Post-Empire Imaginaries? Anglophone Literature, History and the Demise of Empires*, Brill Rosdopti, Leiden and Boston, 2015.

Geeta Kapur, *When Was Modernism? Essays on Contemporary Cultural Practice in India*, Tulika, New Delhi, 2000.

Kumkum Sangari, in '(Im)mortal maps', *Gulammohammed Sheikh: Mappings*, exhibition catalogue, The Museum Gallery, Mumbai, 2004.

Gulammohammed Sheikh, 'Among several cultures and times', artist statement from *Place for People*, exhibition catalogue, Bombay and New Delhi, 1981, quoted in Chaitanya Sambrani, *Edge of Desire: Recent Art in India*, Asia Society, New York, and Art Gallery of Western Australia, Perth, 2005.

'Sombre lament for loss' by Sasha Grishin

Deborah Hart (ed.), *Imants Tillers: One World Many Visions*, National Gallery of Australia, Canberra, 2008.

Ferdinand Hodler, *Autumn Evening*, 1892, oil on canvas, 110 x 130cm, Musée d'art et d'histoire, Neuchatel, Switzerland.

Thomas Bernhard, *Gargoyles*, transl. Richard Winston and Clara Winston, New York, Random House, 2006.

'Unapologetically confronting the past' by Jason Smith

www.australia.gov.au/about-australia/our-country/our-people/apology-to-australias-indigenous-peoples

Juan Davila, artist's statement in Nikos Papastergiadis (ed.), *Art & Design Magazine*, no.43: *Art and Cultural Difference: Hybrids and Clusters*, Academy Group Ltd, London, 1995.

'Beauty and darkness in suburbia' by Julie Ewington

Sue Batten, telephone conversation with the author, 17 March 2016.

Robert Leonard, at http://robertleonard.org/yvonne-todd-cult-appeal, originally published in *Yvonne Todd: Creamy Psychology*, Victoria University Press, Wellington, 2014.

Ruth McDougall, 'Yvonne Todd and the Victorian Tapestry Workshop: Alice Bayke', *Unnerved: The New Zealand Project*, Queensland Art Gallery, Brisbane, 2010.

Yvonne Todd, interview, at https://www.facebook.com/notes/national-gallery-of-victoria/unnerved-artists-yvonne-todd/471810973850/ 2 December 2010.

'New art from an ancient culture' by Bruce McLean

Nicholas Evans, '*Dulka warngiid*: A place of our own', in *The Heart of Everything: The Art and Artists of Mornington & Bentinck Islands*, Woomera Aboriginal Corporation/ Mornington Island Arts and Craft, Gununa, Qld, and McCulloch and McCulloch Australian Art Books, Victoria.

Note: King Alfred is the father of Rayarriwarrtharrbayingathi Mingungurra Amy Loogatha, Warthadangathi Bijarrba Ethel Thomas and Birrmuyingathi Maali Netta Loogatha, brother to Mirdidingkingathi Juwarnda Sally Gabori and a close relative of the other women.

'Balanced dualities' by Julie Ewington

The Fabric of India, Victoria and Albert Museum, London, 2015.

'Friends talk: Everything has two witnesses: Sangeeta Sandrasegar and Sue Batten in conversation', at https://www.youtube.com/watch?v=tGhoPrMeaiw

Phillip Morrissey, about David Mowaljarlai (1928–1997), Kimberley region Aboriginal artist, in 'Two witnesses', *Australian Book Review*, September 2002.

http://sangeetasandrasegar.blogspot.com

Note: a timelapse of the tapestry's making is at https://www.youtube.com/watch?v=TMycP8O-ZX4

'Visionary philanthropist' by Jason Smith

Carolyn Barnes, 'Towards a layered imaginary', *John Young*, Craftsman House (Thames and Hudson), 2005.

Thomas J. Berghuis, 'John Young: situational ethics', *Art & Australia*, vol. 48, no. 3, Autumn 2011.

Yasmin Nguyen, 'Through the eyes of the wolf: John Young interview', *Vault*, issue 3, April 2013.

'Love and harmony' by Julie Ewington

Architecture Australia, vol. 95, no. 6, November 2006.

'New works: Nell', *Australian Tapestry Workshop News*, issue 26, August 2010.

'A scrupulous weave' by Robert Nelson

Leon Battista Alberti, *Della pittura 2*.

Charles Baudelaire, 'Le squelette laboureur', *Les fleurs du mal*.

Giambattista Marino, *Siringa, Idilli favolosi*.

Friedrich Nietzsche, *Götzen-Dämmerung*, Streifzüge eines Unzeitgemässen.

Giorgio Vasari, *Vite* 1.9, 1.15, Proemio 2.

'Tapestry's global reach' by Ian Were

At the Workshop, Australian Tapestry Workshop bulletins, nos 28 (2012), 29 (2013), 30 (2014) and 31 (2015).

Sue Walker, *Artists' Tapestries from Australia 1976–2005*, The Beagle Press, Sydney, 2007.

Sue Walker, *Modern Australian Tapestries from the Victorian Tapestry Workshop*, The Beagle Press, Sydney, 2000.

Ian Were (ed.), *Contemporary Australian Tapestries*, Australian Tapestry Workshop, South Melbourne, 2010.

'Adventure and ambition' by Kay Lawrence

Tim Ingold, *Making*, Routledge, New York, 2013.

Ann Lane Hedlund, *Gloria F Ross and Modern Tapestry*, Yale University Press in association with Arizona State Museum and the University of Arizona, 2010.

David Pye, *The Nature and Art of Workmanship*, Cambridge University Press, Cambridge, 1968.

Sue Walker, *Artists' Tapestries from Australia 1976–2005*, The Beagle Press, Sydney, 2007.

Note: all weaver quotations are drawn from personal communication with the author in late February 2016.